402641

Illustrated Hieroglyphics Handbook

Ruth Schumann-Antelme
Stéphane Rossini

Sterling Publishing Co., Inc.
New York

To Professor Christiane Desroches Noblecourt in thankful remembrance of my first contact with hieroglyphics under her scientific direction and of the years passed at her side to serve the Pharaohs. — R.S.A.

To Madame Christiane Desroches Noblecourt who, in my youth and through Tutankhamen's permanent one, has unrolled for me the great papyrus of ancient Egypt. L.H.F — S.R.

The publisher wishes to thank Professor Ruth Schumann-Antelme, for her very gracious, tireless, and most useful help in the preparation of the English language edition of this book.

Editorial Advisor
Christiane Hachet

Translation by Joseph Blain
Phonetic equivalents and transliterations by Heather Guerrero Bonikowski.

Library of Congress Cataloging-in-Publication Data available

Published by Sterling Publishing Co., Inc.
387 Park Avenue South, New York, N.Y. 10016
Originally published under the title *Lecture illustrée des hieroglyphes*
©1998 by Éditions du Rocher, Paris, France
English translation © 2002 by Sterling Publishing Co., Inc.
Distributed in Canada by Sterling Publishing
% Canadian Manda Group, One Atlantic Avenue, Suite 105
Toronto, Ontario, Canada M6K 3E7
Distributed in Great Britain and Europe by Cassell PLC
Wellington House, 125 Strand, London WC2R 0BB, England
Distributed in Australia by Capricorn Link (Australia) Pty. Ltd.
P.O. Box 704, Windsor, NSW 2756 Australia

Sterling ISBN 1-4027-0025-3

TABLE OF CONTENTS

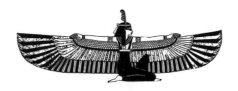

INTRODUCTION

One's first visit to Egypt is always a shock. Upon leaving the dizzying hustle and bustle of the larger urban centers, the traveler discovers spectacular landscapes. The countryside goes far beyond the horizon into which it gradually merges. Against the horizon appears a long aquatic strip, bordered on both sides by fields of emerald green. The changing colors of the mountainous desert region create a singular, spellbinding, and almost timeless atmosphere, the dimensions of which are in constant flux, like the intense solar vibrations mirrored in the movement of the water.

From antiquity right up to the middle of the twentieth century, this life-giving water submerged the countryside once a year, depositing its fertile silt. This is a vision that belongs to the past, but without it, it is impossible to comprehend Egypt and its unique civilization, born from an exceptional geographical context. It helped shape the minds of the inhabitants of the Nile region, which found concrete expression in a writing that has no equal.

Whether carved, painted, or molded on glazed ceramic surfaces, hieroglyphics provided ornaments for the walls of temples, palaces, and funeral monuments on which they were used as figurative décor. Egypt was transformed into an immense book of vividly colored illustrations that recounted the entire history of Creation, thus becoming the "natural history" of the country. This catalogue is unique of its kind. In any other illustrated work, the pictures are accompanied by texts that explain them. The form and the shape of the characters in the text, regardless of the language or script used, are fundamentally different from the image or picture. However, nothing similar exists in ancient Egypt, where iconography is explained by means of other icons that use the same "font" as the pictorial illustration. Even today, the interactive dynamic is easy to grasp, even by untrained visitors, almost

unconsciously. It is well suited to our age, where the image has become universal. The themes it evokes resonate with those that concern us today: the environment, a balance between life, survival, and the beyond; the place of the individual in society, and an order that, on a cosmic scale, respects the roots of humanity on the earth. There is another intriguing similarity: for the ancient inhabitants of the Nile, the image was equated with the reality. Barely a half century ago, such a thought would have provoked snickers, but today — as we find ourselves immersed in a virtual world the full impact of which we do not fully understand — our thinking has changed and we find ourselves obliged to engage in healthy meditation.

Equally surprising are the appearance and the continuity of hieroglyphic writing. The ritual palette and stelae of the 4th millennium B.C.E. are the oldest known specimens. Their archaic symbols may have become increasingly refined, but their basic form remained unchanged for over 3,000 years. As early as the first dynasties, parallel to the emergence of the sacred glyphs, ink-based writing developed the hieratic (sacred) script, which became more rapid as it became more simplified. Toward the end of the 6th century B.C.E., the demotic script, a more popular form, was used, reflecting social and linguistic evolution. The signs used in these cursive scripts advanced considerably from the hieroglyphic model. The famous Rosetta Stone demonstrated the coexistence of different types of writing, which to the ancients, were sacred images, revealed by Thot (Djehuty), the divine inventor of writing.

Let's go back to the first forms of writing. What were the texts used on the ancient funerary stelae? The inscriptions merely enumerate the names and titles of the tombs' owners — kings, magistrates, priests, and priestesses. They are the first signs of an ordered hierarchy in society, which seems to have emerged almost from the void, but was undoubtedly a long time in the making. The signs used are almost exclusively syllabic (bi- or triliteral). The custom of inscribing names and titles on stone slabs, statues, and objects continued right up to the end of the Age of the Pharaohs. These short written inscriptions were the only vestiges of writing for nearly half a millennium after their appearance. Then to the amazement of the archaeologists who made the discoveries, there was an explosion of texts uncovered in the pyramids, dating from the 5th dynasty. The newly discovered texts revealed advanced metaphysical thinking and a complex system of writing used to express a perfectly structured language. Almost nothing remains of the intermediate stages. While the spoken language evolved, the language used in the texts of the pyramids had become by the time of the New Kingdom a classical language, used and understood only by the elite. The chasm separating the classical and the

daily business language increased until the two were totally different, setting religious treatises distinctly apart from secular writings. The only exception was literature, which remained classical for many years.

From at least the beginning of the 5th Dynasty there also appeared a script that was full of graphic word plays, cryptograms, rebus, and reverse writing. The code continued to be functional and reached its zenith during the reign of the Ptolemies. The system began its decline under the Roman emperors, who became the new pharaohs.

Despite the decree by Theodosius I outlawing pagan cults in 384, the cults of Isis and Osiris continued in the temple of Philae, where the last hieroglyphic inscription, dating from 394, was found. It was the last gasp of a dying civilization. The temples were finally closed or transformed into Christian churches by order of Justinian in 543. Although the demotic language continued until about 450, the veil of forgetfulness soon fell upon the most beautiful, the most unique, and the most speakable form of writing ever created.

The Magic Palettes of Thot

In the 18th century, travelers resumed their interest in Egypt, but it was Napoleon's expedition in 1798–1799 that gave rise to Egyptomania. For the first time in history, a military leader brought with him on campaign, not only his soldiers, but also some of the finest minds and scholars of his time, who were assigned to study, describe, and map the country he intended to conquer. He did not quite succeed, as we know, but this original initiative laid the foundation for new institutions and a rich heritage of French culture in Egypt that continues to flourish today.

The works of this Commission of Scholars were published in the monumental work titled the *Description of Egypt,* which gives a full account of the country at the dawn of the 19th century. Without the legacy of this literary masterpiece, the military adventure, however exceptional, would have been no more than another episode in the history of ongoing and turbulent relationships between the West and the Middle East.

Even before they were published, texts and drawings were widely circulated among the intelligentsia of Europe, and some of the prominent thinkers of the time, including the British physicist, Thomas Young, and the Swedish diplomat, Johann Akerblad, an acclaimed specialist in Middle Eastern studies, along with others launched into the work of deciphering the hieroglyphics. They managed to obtain

some preliminary results, but the sacred images were reserved for the one who alone seemed predestined to breathe new life into this language after 14 long centuries of catalepsy. His name was François Champollion. Since childhood, he had been mesmerized by Egyptian hieroglyphics and had sworn that one day he would decipher them. As a philologist, he had few equals; he was a relentless worker and a precocious scholar. He approached the task with method, supported by his brother and mentor, Jacques-Joseph. At a very young age, while still in school, he had mastered the three classical languages, Hebrew, Greek, and Latin, and learned Arabic and Coptic, which was still spoken in his time and today survives as the liturgical language of Christians in Egypt. Coptic is the last form of ancient Egyptian writing and uses Greek letters and a few additional signs that derive from the hieratic language. The major advantage of Coptic is that it denotes vowels, which is not the case for Semitic languages. Egyptian belongs to the Hamitic branch of the Semitic family of languages.

Bolstered by his knowledge, Champollion began to examine the copies of the three fragmentary inscriptions — hieroglyphic, demotic, and Greek — of the Rosetta Stone, which had been unearthed by French military engineers during their work in 1799 and named in honor of the place where it was discovered at Fort Rashid. The slab of basalt stone, now in the British Museum in London, was soon to become the cornerstone of Egyptology. It came from a decree promulgated in 196 B.C.E. by Ptolemy V Epiphanes, and what made it so important was the presence of the corresponding text, not only in Egyptian hieroglyphics, but in demotic writing, and also in Greek. Champollion believed, in accordance with the hypothesis of Father Barthélemy, that the names of royalty were encircled in an oval-shaped figure, called a cartouche. Thus in the hieroglyphic text he was able to identify and translate, with the help of the Greek text, the name of Ptolemy. Then, in 1815, William Bankes uncovered an obelisk on the island of Philae, which was inscribed in hieroglyphics and on the base of which was the corresponding Greek equivalent. The Greek version contained the name of Ptolemy VIII Euergetes II, and his wife Cleopatra III. By comparing the cartouches containing the names of the two Ptolemies, Champollion was able to decipher with certainty the sounds *p, t, o, l, i, m,* and *s* and to identify them with their corresponding hieroglyphic equivalents. The cartouche containing the Queen's name gave him the letters *k, a, d/t* and *r.* He applied these first rudiments of an alphabet to other royal names of foreign origin that were written in Greek and hieroglyphics and was able to decipher such names as Alexander and Trajan: each new attempt at deciphering confirmed his interpretation. He was making progress, but had no solution to a whole host of non-

alphabetic signs. His intuition was that they might have been word-signs or ideograms — signs representing several sounds, known as pluriliterals, which represent the syllabic elements. This was the major step forward that put him on the path that would lead to his great breakthrough.

An architect named Huyot had made imprints of several bas-reliefs in the temples of Nubia and Upper Egypt, and Champollion obtained copies of these. A sign that he had seen over and over again caught his attention: 𓄟. With the true intuition of genius, he found a parallel between this sign and the Coptic word *mose*, meaning "to be born" or "to give birth to." On his copy, it was placed between the image of the sun and the letter *s* standing out in the word Ptolmys (Ptolemy).

He knew that the sun was the sign of the god, Ra. Therefore Ra-mose-s? Ramses! He feverishly searched for a similar name and found a sheet that bore the cartouche of the ibis, the sacred bird of Thot. In this cartouche, the ibis was also followed by the sign *mos/mes* Thot-mes, rendered in Greek as Thutmosis. Finally on September 14, 1822 he had deciphered the magic palette, the palette of Thot. He was thunderstruck by emotion for five days. When he emerged from his trance, he was finally able to define the hieroglyphic system, which he described in detail in a long "Letter to Mr. Dacier," secretary for life of the Academy of Inscriptions and Literature. This letter was to become the charter and cornerstone of Egyptology.

Let us summarize this structure, which is composed of:
◇ single phonemes or phonograms — the *uniliterals* or "letters"
◇ *pluriliterals (bi- and triliterals)* or syllabic signs
◇ *determinatives,* mute signs placed at the end of words to clarify their meaning. Like all languages, Egyptian also has homophones, words which have the same sound but different meanings. We will see how some determinatives and pluriliterals are sign-words or ideograms that are pronounced, but which do not change in the least the principle by which they are employed.

Modern Scribes

Exhausted by his ceaseless work and living conditions that were often difficult, Champollion died at the age of 42. We are forced to admire the monumental work left by this genius in such a short space of time. He inspired many vocations and

his disciples throughout the world have continually striven to perfect the science of which he laid the foundations. Their efforts have also allowed a deeper understanding of the text-images and their authors, the ancient dwellers of the Nile region. The method we have chosen will follow the same pattern. Our intention is to allow the reader to acquire the fundamentals of hieroglyphics through the use of signs, vocabulary, and semantics. This introductory work is neither a book of grammar nor a true dictionary. Part of its appeal lies in the artistic presentation of the hieroglyphics and the remainder in the semantic commentary. The contour and scale of the hieroglyphics are in strict proportion to the ancient models, but they have been drawn so that they can speak and reveal their very essence in much the same way that the semantic portion reveals their intimate links and takes the reader into the mysterious paths of Egyptian thinking. By questioning the hieroglyphics, these "divine words" invented by Thot, and by discovering the links that are woven between the signs and the words that they construct, the reader will be able to embark on a virtual voyage to ancient Egypt. This is meant as well to be an interactive journey: the Sphinx will assist the disciple in this arduous quest, by providing the vocabulary needed to glean an understanding of the intrinsic richness of this ancient language and its graphic glyphic expression. Thus this book has been placed under the symbolic tutelage of Thot, of the goddess Seshat, who extends the quill to future scribes, and of Maat, the goddess of cosmic and spiritual balance.

THE STRUCTURE OF THIS BOOK

International Conventions for the Pseudo-Alphabet

The distinguished philologists who developed the pseudo-alphabet for ancient Egyptian based their work on the order of sounds in the Semitic languages. Although this is quite suitable to the ancient language, it is very different from our alphabetic classification. Since we intended to write this book for the general public, we decided to make it easier for the reader by establishing the closest possible correspondence between the order of linguistic signs in the ancient language and the order in modern Western alphabets. Other difficulties to note:

♦ vowels in ancient Semitic languages are treated as half-consonants, which changes their place in the alphabet

♦ Ancient Egyptian has sounds that do not exist in English (nor in most modern languages) and vice versa.

Special signs therefore had to be created, known as *diacritics,* to distinguish these specific signs. This method is recognized by Egyptologists the world over. At the end of this volume you will find a comparative table of the "alphabets."

Lastly, we had to find a way to express the proper pronunciation of all these consonants and half-consonants. By international convention, the letter *e* is sometimes put between two consonants, when necessary, although such a letter did not exist in Ancient Egyptian.

As we mentioned earlier, Coptic was the last form of Ancient Egyptian and was written in Greek letters. This is a valuable resource for correct vocalization,

11

although it does not provide with certainty the exact pronunciation of words during the different phases of evolution of Ancient Egyptian. Transliterations (transcribing using the Roman alphabet) are merely proposed pronunciations that are generally accepted among Egyptologists.

The Different Sections of This Book

We have divided this book into four major sections, which deal in order with the uniliterals, the biliterals, and the triliterals. The last section contains a random choice of various words, presented on twenty-nine additional plates. Here you will be able to put your knowledge to the test and discover new combinations for word signs, for unsuspected semantic links, and for clever and surprising homophones.

All the signs in the first three sections have been numbered in the order in which they have been presented in the book:

- ◇ Uniliterals from U 1 to U 26
- ◇ Biliterals from B 1 to B 83
- ◇ Triliterals from T 1 to T 30

At the end of the book there is a summary table of the entire group, identified by the respective numbers that are used within the commentaries.

Additional plates are numbered from S 1 to S 29; there are no commentaries for them. You are free to engage in your own research and reflections.

For each of the first three sections, U, B, and T, the key hieroglyphic signs are found on the left-hand page, which gives the definition, the phonetic guide, an explanation of the writing, a numbered translation of the sample words, and semantic commentaries. On the right-hand page you'll find a sampling of several words (an average of four), which includes the key hieroglyph given on the left. This is the practical application of the elements of the writing. Above each term, there is a proposed guide to the pronunciation, the translation or translations, and the transcription using the international conventions and symbols.

This method of mirroring the hieroglyphs with their definition, semantic translation, and their application, seems to us the best way of breathing new vitality into the signs of this language and to facilitate learning it. The whole work is an experiment in interactive concordance between the specific sounds and forms that are unique to this brilliant civilization.

GENERAL CONSIDERATIONS ON HIEROGLYPHIC WRITING

The reader who opens this book for the first time, and who has no previous knowledge of hieroglyphs, will be surprised on several levels. After all, when you see a quail that is as big as a sitting man, a sculptor's chisel as large as an elephant, or a duck that takes up as much space as a woman, you might think that you're reading *Alice in Wonderland!* Yet these signs, which to us seem totally lacking in proportion, are used in some of the most serious texts. Each hieroglyph is exactly proportioned to itself, whatever its dimensions. It is inserted into a word, according to specific rules, based on the use of a quadrate. A quadrate is a virtual square, which although not drawn, guides the hand of the scribe. Hieroglyphs must be aesthetically positioned within the quadrate and their size must be proportioned accordingly. They form groups that are pleasing to the eye and based on the laws of balance.

The text continuously unfolds with no word separations or punctuation marks. The end of a noun (substantive) is usually indicated by its determinative — the final image in the word. In glyphic writing, the inscriptions that accompany monumental scenes can be written from left to right or right to left, in lines or in columns, also in either direction, but always in the direction that the persons or creatures in the text are facing. Reading, however, proceeds in the opposite direction to the glyphs. If, for example, the animated signs in a text (human, animals) are facing left, then the reading must proceed from left to right, which corresponds to our reading habits. However, on papyrus scrolls with no iconographical constraints, texts are written in lines that go from right to left. This is the direction that is still used in Semitic languages.

A word may be written entirely with the so-called "alphabetic" signs, to which a final determative is added. This is rather rare. In general, the written symbol is composed of one or more syllabic signs, to which are added uniliteral phonetic complements to clarify and contextualize the sign, as well as a determative.

The metathesis of respect, also known as the honorary ante-position, is a unique feature of hieroglyphic writing. The signs used to represent "God" and "King" as well as their adjectives, and the proper names of the divinities, are written at the head of a word or expression, although when read or spoken, they may be pronounced in a different order. This inversion of the signs is frequently used in royal cartouches and in the titles of eminent public ministers and priests. A few examples can be found in this book.

You now have the basic information required to embark upon the study of hieroglyphics.

UNILITERALS

As we follow with utmost respect and modesty in the footsteps of the great Champollion, we shall begin our study of hieroglyphs with the uniliterals, the letter-symbols that Egyptologists have collected into an "alphabet" — a notion that was totally unknown to the ancients. In the previous chapter of general considerations, we explained why this list, even though it does contain 26 symbols, is only an artificial adaptation of our alphabet. You will immediately see that there are two letters for *a*, two for *d,* four for *h,* and so on, while on the other hand there are letters that are absent, especially the letter *e (as mentioned above):* in our classification we have tried to take international transcription into account and the order is based on that system.

We will review signs or symbols that represent only a single phoneme in this section, particularly because we will need to refer to them when we define the sounds associated with pluriliterals, under the heading "phonetics and writing." The two concepts are closely intertwined, because phonetics is the study of the sounds that make up a language, while the phonemes are classified and expressed in written transcriptions.

a (aleph)

Uniliteral: Egyptian vulture.

PHONETICS AND WRITING

1. akh — The papyrus stand. Two phonemes are used: *a,* expressed by the vulture and the guttural *kh,* represented by the stylized image of the placenta. The stand of papyrus reeds is itself the figurative determinative.

2. akhakh — The verb to turn green, to flower, is derived through duplicating the preceding noun. The same determinative applies to both terms.

3. am — To burn, to be consumed is a combination of the vulture for *a* and the owl for the sound *m.* The determinative at the end is a lamp seen both from plain view and in projection with its burning wick.

4. amem — Grasp, seize hold of, attack is written with the same two phonemes *a* and *m* as above. The determinative is an extended fist, which perfectly illustrates the meaning of this verb.

SEMANTICS

The words to "turn green" and "papyrus reeds" are similar, both semantically and graphically. The papyrus reed has roots that plunge into the stagnant water of the wetlands, which are teeming with life and a great variety of organisms. The stand of papyrus reeds represents the prenatal existence that precedes the emergence of life. "To turn green" suggests the burgeoning that is rendered all the more relevant by the repetition of the root *akh.*

In *am* all life disappears and turns to ashes: the owl replaces the placenta and the half-burned wick replaces the exuberant greenery.

Amem — "To grasp" seems to belong to a different level. However, we still encounter the double consonant and the two winged predators, which are followed by the thrust fist: a sinister image.

akh the papyrus stand *3ḫ*

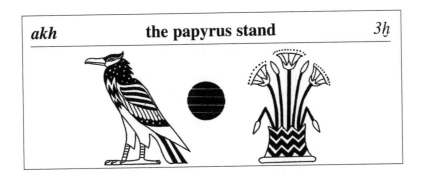

akhakh to turn green, flower *3ḫ3ḫ*

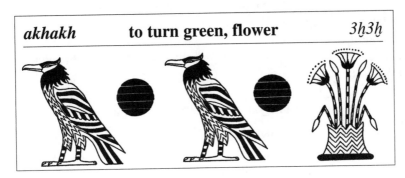

am to burn *3m*

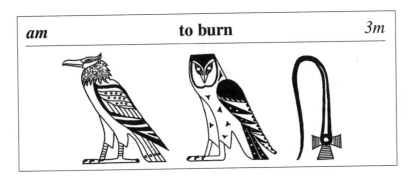

amem to grasp, seize *3mm*

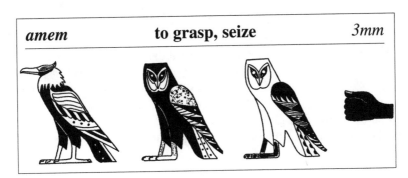

ah (aïn) *c*

Uniliteral: Human arm and hand: left or right, unspecified.
Ideogram for "arm" or "limb."

PHONETICS AND WRITING

The sound *aïn* exists in Germanic languages and is very prevalent in Semitic languages, as well, though not in languages derived from Latin. In Germanic languages it is picked up by the ear, but there is no graphic representation for the sound (in German it is known as the "knacklaut"). On the other hand *aïn* is a fully distinct consonant and letter in Semitic and other related languages. It appears at the beginning or in the middle of a word. It is often described as a glottal stop, with the throat almost closed. Ancient Egyptians represented this sound by the image of the natural human tool — the arm and hand.

1. ah-py — Winged solar disk, usually flanked on either side by the double uraeus (cobra goddess): The glyph combines the forearm – hands, the woven mat (stool) for *p* and the flowering reed for *i,* and the verb to fly (bird).

2. ah-ah-uey — To sleep and sleep (verb and noun) written with the two forearm-hands = *ahah*, the quail = *w*, and two strips (or oblique bars) for *y.* The same letter can also be represented by two reeds. The determinative is quite surprising, the open human eye.

3. ahndjoo — Dawn, radiance of the sun. Written with the forearm-hand = *ah*, the little wavelets = *n,* the hand = *d* (in older times *dj,* the serpent) and the quail. The determinative is the radiant sun, either the solar disk rising over the symbol for the sky, or the sun alone.

4. ah-ah-ret — Uraeus. The written representation with the two forearm-hands is a variation on the classical form and is probably always pronounced *iâret* and not *ââret.*

SEMANTICS

If the hand-forearm appears in the graphic symbol of the winged solar disk, it might suggest that the wings are the arms of the sun. "To sleep" and "dawn" follows from the same association of ideas. The two arms make us think of the arms of Morpheus, god of sleep and dreams. The eye is open: an allusion to the paradoxical idea of sleep, which unfolds in the presence of the inner eye. *Andoo* or *ahndjoo* is the emergence from this type of sleep, the rebirth of nature at the first glimmer of dawn: the symbols speak for themselves.

Ah-ah-ret, the uraeus, has neither arms nor hand, but the poison of the cobra has a stupefying effect. Certain cobras, like the *naja nigricolis,* can even spit venom out of their mouths: "they spit fire," to borrow an expression from the ancients.

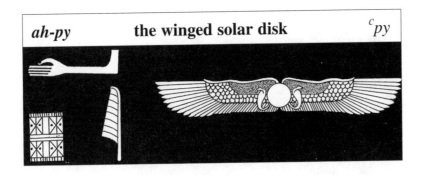

ah-py **the winged solar disk** $^c py$

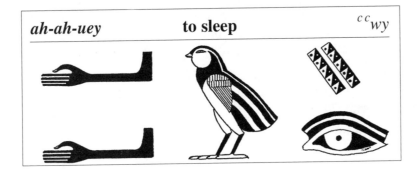

ah-ah-uey **to sleep** $^{cc} wy$

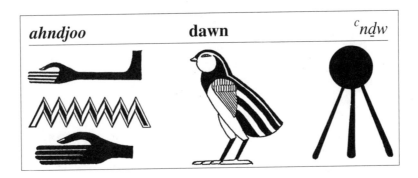

ahndjoo **dawn** $^c n\underline{d}w$

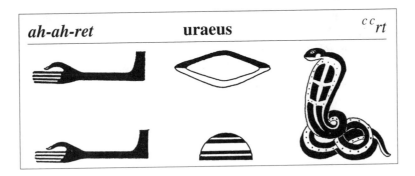

ah-ah-ret **uraeus** $^{cc} rt$

b *b*

Uniliteral: Human leg and foot, unspecified.
Ideogram for "place" or "location."

PHONETICS AND WRITING

1. beek — The falcon. *b* = leg, *i* = flowering reed, *k* = basket. Determinative: the bird. The whip — or shoot of a plant — held by the bird under its wing, indicates that it is a sacred animal.

2. benet — The harp. The term refers to the great harp, which is placed on the ground while being played. Phonetically written with *b* = leg, *n* = wavelets and vibrations, and *t* = bread. Determinative: harp.

3. benoo — The mythical phoenix is also the heron. The phonetic script includes the uniliterals *b*, *n*, and *w* as well as a biliteral, the globe-shaped vase. Determinative: phoenix.

4. benbenet — The cap or the tip of a pyramid or obelisk, is a word written only with uniliterals — *b, n,* and *t.* The determinative speaks for itself.

SEMANTICS

All words that are related to the falcon belong to either the sacred, royal, or divine order, except when they designate the animal itself. The "falcon" is frequently used as a symbol of the king, of the god Horus, and when used in the feminine plural, of the goddesses. The phoenix symbolizes a long life, but one that has a saturating effect, causing self-destruction. At the same time, it offers a message of hope, because the bird is reborn from its ashes — and the cycle resumes. Death gives life by mutation.

Let's come down to the earth, where the same sublime forces are at work, but in a much more physical and concrete way. Thus by a mere change of determinative, the bird of fire becomes the monkey! From the word baboon is derived *benoo,* lustful or libidinous, the epithet of the god Set, whose scandalous adventures are retold in mythology.

Benbenet, the luminous summit of the sacred stone of *Heliopolis,* the *benben* has the same semantic features. The pointed bread loaf, by changing the determinative, can go from a pleasant taste to mean enjoying, pleasure-seeking, coitus, or the rushing waters of the Nile emerging from its grotto (used figuratively it means overflowing, abundant, and excess of all kinds). As you see, the basic idea remains the same.

The *n,* represented by the image of waves and vibrations, is also used in the word *benet,* the harp, whose strings vibrate to give pleasure to both men and gods.

bik	**falcon**	*bik*

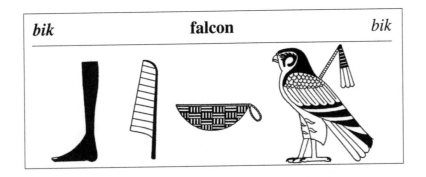

benet	**harp**	*bnt*

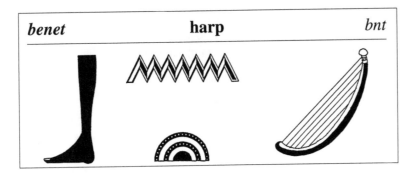

benoo	**phoenix**	*bnw*

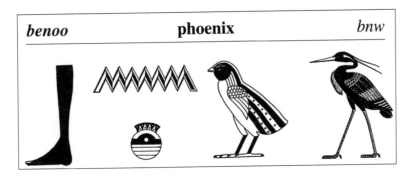

benbenet	**cap or tip of a pyramid**	*bnbnt*

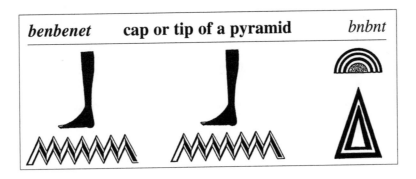

d *d*

Uniliteral: A human hand, right or left. Solely a phoneme.

PHONETICS AND WRITING

1. dep — To taste. The verb "to taste" is written with two phonemes, representing the sounds *d* = the hand and *p* = the woven mat, to which are added two mute determinatives: the image of the tongue and the image of a man raising his hand to his mouth.

2. debdeb — The heartbeat. Onomatopoeia expressed by two groups of repetitive phonemes: the hand = *d* and the leg = *b*, as well as the man-determinative bringing his hand to his mouth.

3. depet — The boat. Three phonemes: hand = *d,* the mat = *p* and bread = *t,* followed by the picture of the determinative: the boat.

4. depy — The crocodile. Three uniliteral phonemes: the hand, the woven mat, and two bars = *y*, as well as the determinative, the crocodile.

SEMANTICS

The tongue and the man, bringing his hand to his mouth, clearly define this verb, as well as the corresponding name, "taste," the word for which is *depet*, with the tongue serving as determinative. The same sign is used to depict the heartbeat, because for the ancients, the "heart beats in all the limbs of the body." The language for the heart is determined by the image of the man bringing his hand to his mouth. This sign is also used for the verbs "to speak," "to think," "to eat," "to drink," etc.

The uniliteral *d* is used extensively, as are all the single phonemes that are explained in the first section of this book.

There is a semantic link between the boat and the crocodile, because they share the same semantic root — the element in which they thrive. *Depet*, "taste," and *depet*, "boat," are written in the same way, the determinative being the only graphic difference between the two.

Several semantic families begin with *d*. For example, many words begin with *da*, which often has a connotation of violence: "knock down," "kill with the blows of a hammer"; the sinister *dat* of the infernal regions, etc. On the other hand, the root *dua* suggests hymns of praise to the gods.

24

dep	to taste	*dp*

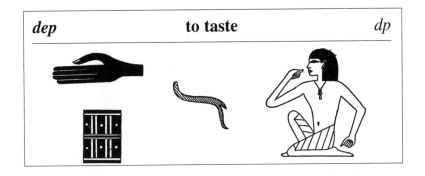

debdeb	heartbeat	*dbdb*

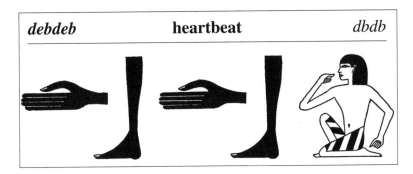

depet	boat	*dpt*

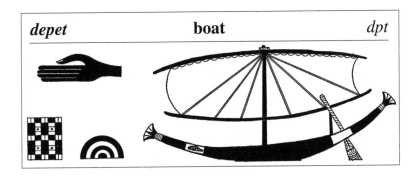

depy	crocodile	*dpy*

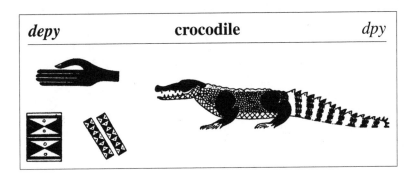

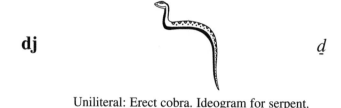

dj *ḏ*

Uniliteral: Erect cobra. Ideogram for serpent.

PHONETICS AND WRITING

1. Djehooty — Egyptian form for the name of Thot, god of knowledge; the name is written only with phonemes: *dj* = the serpent, *h* = the wick of the lamp, *w* = the quail, *t* = bread, *y* = the two oblique bars and, as a determinative, the ibis-like god himself (he may also be represented by a baboon).

2. djet — Eternity on earth (see also *h*). Serpent and bread provide the pronunciation; the hieroglyph for the earth determines the meaning of the word. The same glyph is used for other nouns. It is the pronunciation and context that made the differences clear.

3. djed — To speak. The serpent and the hand (*d*) are pronounced; the determinative of the man bringing his hand to his mouth says it all.

4. djah — Wind, storm. The serpent and the choked "a" sound, combine for the task of producing the written glyph and for the even more difficult task of pronunciation. The full sail of the determinative leaves no doubt as to the meaning of this term.

5. djet — The body or form of a person. Written with some of the same elements used to express eternity; only the determinative changes: it is a mere dash — to avoid all confusion with the written word.

6. djed —The pillar (or the column). As in the verb "to speak" (above), the serpent and hand are used in the written glyph, but the determinative clearly indicates that the word refers to a tower.

SEMANTICS

The six words on this page begin with the image of the serpent, which is used to introduce the enigmatic name of the god of all knowledge, Thot. Knowledge? This is reminiscent of a certain mythological tree, and of the serpent who was the mysterious creature of Genesis. Ophidians (serpents), which are still quite numerous on the shores of the Nile, held an important place in the religious practices and the daily life of ancient Egypt. It has also been said that their venom was used for medicinal purposes.

Two of the next four words refer to the Earth, which for the ancients was immovable and eternal, and to the perishable beings that the Earth has engendered since time immemorial.

On the other hand, "to speak" and "storm" refer to the air and to the breath of man or the cosmic breath.

Lastly, stability, which is acquired through knowledge and the work of human hands, is revealed in the structure of the *djed*.

| *Djehooty* | **Thot** | *Ḏḥwty* |

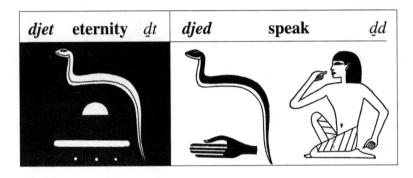

| *djet* | **eternity** | *ḏt* | *djed* | **speak** | *ḏd* |

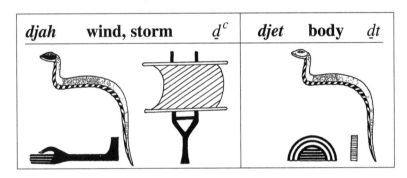

| *djah* | **wind, storm** | *ḏ^c* | *djet* | **body** | *ḏt* |

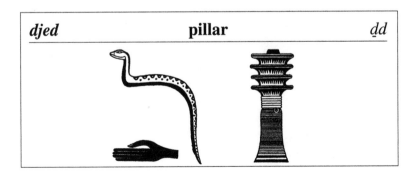

| *djed* | **pillar** | *ḏd* |

f *f*

Uniliteral: Horned viper *(Cerastes cornutus)*,
one of the most poisonous serpents in the world.

PHONETICS AND WRITING

1. fah-ey — To lift. *f* = the serpent, *a* = the vulture, *i* which is not written: the sign of the infinitive. The determinative: the strong arm and the man carrying a load.

2. fat — Seat, raised throne. The serpent = *f* and the vulture = *a*, as well as bread = *t* are the basis of the phonetic structure. Determinative: the stairs and the hieroglyph for the house.

3. fekhfekh — Unbind, reject, destroy. The serpent = *f*, and the placenta = *kh* are emphatically repeated, followed by the determinative, which is also double: the rope and the legs in motion.

4. fenedj — Nose. Previously written with the cobra *dj,* subsequently with the hand *d*. The serpent = *f* and the wavelets = *n* complete the phonetic writing. The calf's head is a mute determinative, but it is read as *fenedj*: it is a word-sign or ideogram.

SEMANTICS

The first three words are related to human activities, which can be either constructive or destructive. You must lift loads to build. But destruction through neglect (where you unbridle yourself of obligations or responsibilities) or through the nefarious impact of man or nature is also suggested.

Fenedj, which is determined by the calf's head, is surprising; we would have expected to see the nose of a dog!

fah-ey	**lift**	**f3i**

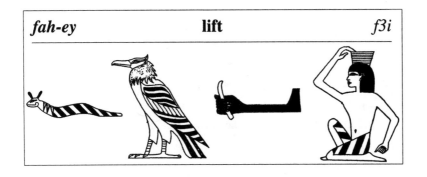

fat	**seat, raised throne**	**f3t**

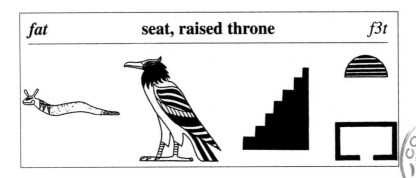

fekhfekh	**break, destroy**	**fḫfḫ**

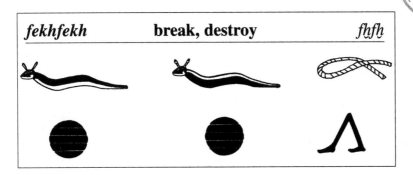

fenedj	**nose**	**fnḏ / fnd**

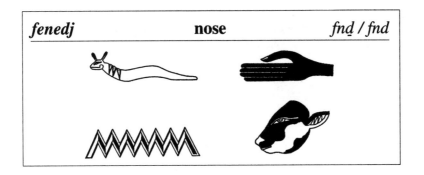

29

g *g*

Uniliteral: Jar with its base, seen both in plain view and in projection, a "double" perspective, very much appreciated by the ancients and surprisingly modern.

PHONETICS AND WRITING

1. gereh — The night. The jar for *g,* the mouth for *r,* and the wick for *h.* The determinative is composed of the hieroglyph of the sky and of a (shooting) star.

2. ger — To be silent, quiet, calm. The same root as for night (above) and the same writing. The determinative is mute, the man bringing his hand to his mouth.

3. Geb — God of the Earth. Jar and leg are combined in writing the word. The determinative is the image of the god.

4. gehes — The gazelle. We have already seen two of the graphic letters (the third is U 20), and the graceful animal is the determinative.

5. gaga — To cackle, to giggle. Noun: cackling. The jar and vulture join in emphatic onomatopoeia. Note that the same determinative is used to express silence and noise: the man with his hand to his mouth.

SEMANTICS

Silence, cosmic calm and that of humans are expressed by the same root *ger.*

The god Geb and the noun "cackling," contrary to appearances, are situated in the same semantic register. In fact, the name of the god is frequently written with the hieroglyph used for the gander. *Gebeb* and *gaga* are used precisely in reference to the gaggling of geese.

The gazelle is not related semantically. As an animal, it is furtive, but, when wild, it lives in a flock. The jar and the wick have a somewhat artificial link to the idea of domestication.

gereh	**night**	*grḥ*

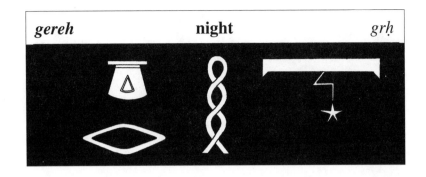

ger	**silent**	*gr*	***Geb***	**the god Geb**	*gb*

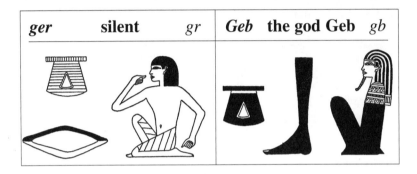

gehes	**gazelle**	*gḥs*

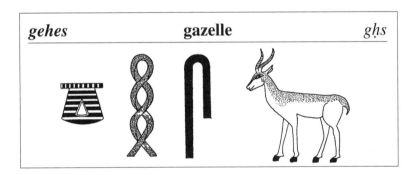

gaga	**giggle, cackle**	*g3g3*

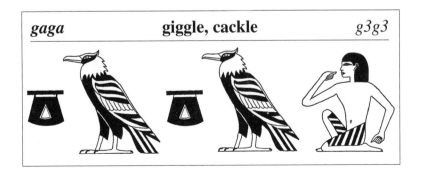

h *h*

Uniliteral: The plan of a house with recessed entrance and court.

PHONETICS AND WRITING

This hieroglyph is used to denote the lightest form of the letter *h*.

1. heby — Ibis: the plan of the house, the leg = *b* and the two oblique bars for *y*. The ibis is the determinative.

2. hemhemet — War cries and shouts. We have already seen the uniliteral signs *h* and *m,* and as seen previously, they are repeated to provide emphasis. The god Set and the forearm with weapon are the determinatives.

3. heroo — Day. The phonetic expression is composed of three uniliterals, *h, r,* and *w;* the star is the determinative.

4. hee — Husband. The two phonemes *h* and *i* can be used to express other words, which makes the determinative essential. The phallus shows clearly the primary function of a husband.

SEMANTICS

Each word on this page has its own specific semantics. The long-legged ibis has to have the letter *b* in its name.

Hemhemet. The very writing of this word depicts violence: the nocturnal predator, which appears to be attacking the houses, is associated with the god of tempests, but it is also the king's master of arms. The arm bearing a weapon is a symbol of war.

Hee. The two determinatives demonstrate that the husband is the necessary link for the establishment of a hearth, a lineage.

heby	**ibis**	*shby*

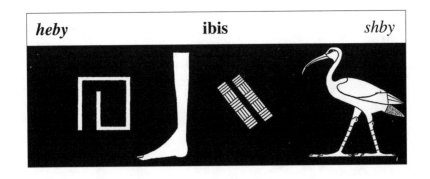

hemhemet	**war cries**	*shmhmt*

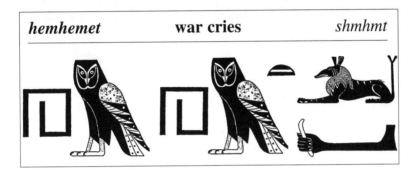

heroo	**day**	*hrw*

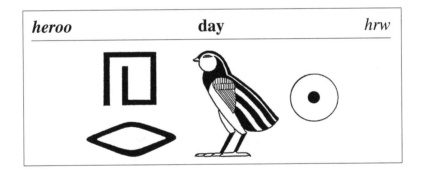

hee	**husband**	*hi*

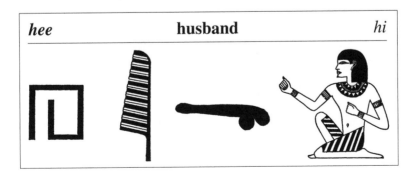

h *ḥ*

Uniliteral: The wick of an oil lamp.

PHONETICS AND WRITING

1. Hahpy — The guardian spirit of the flooding. Four uniliterals are used to write the expression, along with three determinatives: the basin, the triple water sign, and the guarding spirit. Even if you can't read hieroglyphs, the meaning is clear.

2. heh — Eternity (compare also with *djed*), for which the sun is the determinative.

3. heb — Feast, celebration, ritual. The two phonemes are completed by the alabaster bowl.

4. hema — Ball. Three uniliterals, which we have already seen, and a pretty and appropriate determinative.

5. hezep — Garden. The wick = *h*, the lock (or bolt) = *z*, the mat (or stool) = *p* and the water basin is the determinative.

SEMANTICS

The first two words are related to natural events: the annual flooding of the Nile, which in full summer affected all of Egypt, providing it with the water of life and its rich silt soil. The phenomenon was interpreted as being linked to the immovable cycle of the sun. The sun also serves as a determinative for cosmic eternity. The renewal of the beloved Earth was prolonged through festivals and rites in honor of the gods and the deceased. The ritual vessel (the alabaster bowl) is a symbol of this same idea. The ball is also connected with festivities and entertainment.

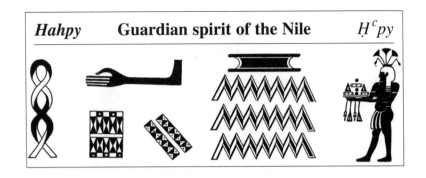

Hahpy **Guardian spirit of the Nile** *Ḥ ᶜpy*

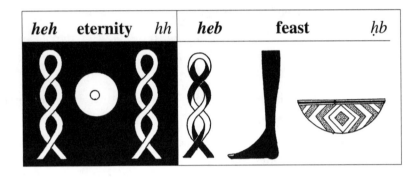

heh eternity *ḥḥ* **heb** feast *ḥb*

hema ball *ḥm3*

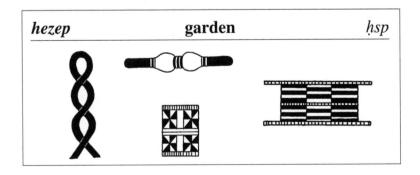

hezep garden *ḥsp*

kh *ḥ*

Uniliteral: Stylized representation of a human placenta.

PHONETICS AND WRITING

This hieroglyph, *kh*, is pronounced like the *j* in Spanish; it is guttural.

1. khepesh — The constellation of Ursa Major, the Big Bear. *Kh* = the placenta, *p* = the mat/stool and *ch* = the basin. The determinative is another word-sign representing a calf's leg. The star and the god clarify the meaning.

2. kheperer — The scarab. We have already seen the four uniliterals. Determinative: the image of the scarab.

3. khebeb — To dance. Two phonemes, the second of which is doubled, give the cadence to this word. A dancer in motion is the determinative.

4. kherep — To administer. We have already seen the three phonetic signs. The determinative (an arm bearing the functional scepter-cane) leaves no doubt as to the meaning.

SEMANTICS

The Big Bear and the scarab both have religious significance. The *khepesh* was a funeral offering, representing the symbolic return of the deceased into the stellar cycle, where he will encounter a new life, represented by the divine force of the scarab.

Khebeb is quite amusing with its two legs. Can you imagine dancing without them? An expression of vitality.

Kherep is full of symbolic connotations. The placenta represents potential life, birth, heredity, and the notion of blossoming in general. The mouth is used to issue orders, and the stool elevates the one standing on it. Lastly, the scepter, held in a firm hand, is most explicit.

khepesh	**Big Bear**	ḫpš

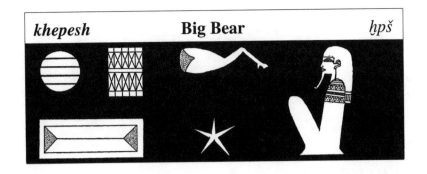

kheperer	**scarab**	ḫprr

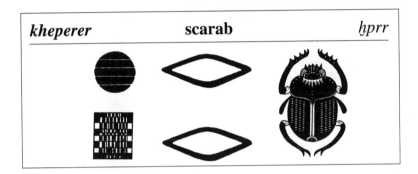

khebeb	**to dance**	ḫbb

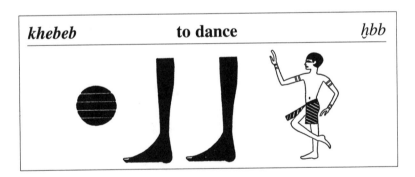

kherep	**to administer**	ḫrp

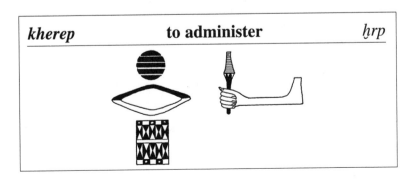

kh *ḥ*

Uniliteral: Highly stylized drawing of the belly of a female mammal showing teats and tail.

PHONETICS AND WRITING

This symbol represents a guttural/shushing sound, unknown in English.

1. khered — Child. In addition to the new sign given here, two other phonemes — the mouth and the hand, combine to make this word. The naked child with its hand to its mouth is a very explicit determinative.

2. khepow — The umbilical cord, the navel. The uniliterals are all familiar, but there is a double determinative, the upper one representing a blister, the lower one a piece of skin.

3. khahm — To approach, to go forward. Three uniliterals with legs in walking motion.

4. khepen — Fat. The head of the antelope is the determinative for this hieroglyph written with three uniliterals.

SEMANTICS

The newborn is received into the world at the hands of the midwife, who extracts the child from the maternal womb. The latter, like the mouth, is opened. The mouth serves to nourish and calm the child. It replaces the umbilical cord, which had been the conveyer of nourishment and oxygen, but has become unnecessary, like the morsel of flesh that is its determinative.

Khahm is a highly resonant word expressed in guttural sounds. It represents the will "to go forward."

The fat of the animal, obtained particularly from the belly of certain animals, was widely used for medicinal purposes.

khered	**child**	*ẖrd*

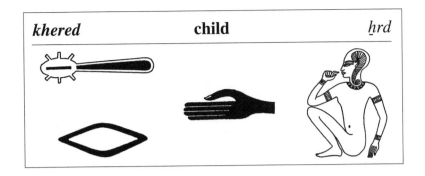

khepow	**navel**	*ẖp3w*

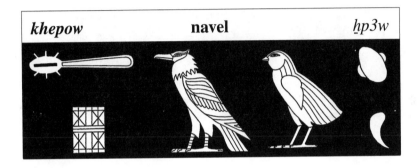

khahm	**to approach**	*ẖcm*

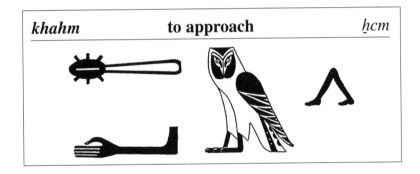

khepen	**fat**	*ẖpn*

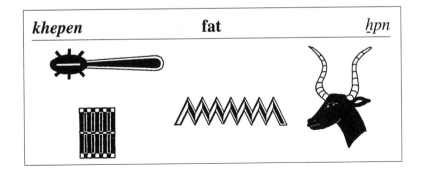

i (ee)

i

Uniliteral: Flowering reed.

PHONETICS AND WRITING

1. eeyah-h — Moon. Three phonemes plus an image resembling the earth's satellite graphically depict this word.

2. eenpooh — Anubis, the dog-god, whose face is the determinative for the four uniliterals.

3. eebee — To thirst. Two signs, *t* and *b*, give the graphic depiction of the sound, and the man with his hand to his mouth is the determinative.

4. eeb — Heart. Same phonetic writing, but the difference is indicated by the determinative.

5. eeteroo — River. We are already familiar with all these signs; the canal (or channel) is the determinative.

SEMANTICS

The five words shown on this page are, in a certain way, all linked to liquids, or at least to the idea of flow. The symbolism of the moon that governs the ebbing tides and the flow of human emotions is clear. The wick of the lamp is a charming little wink of the eye. The sign for the wavelets, representing the divine embalmer, is also relevant, as his craft is to see to the draining of bodily fluids in order to transform the deceased into a divine Osiris, destined for rebirth.

Eebee, to thirst and *eeb*, the heart, are both linked to the body's vital circulation.

Eeteroo, the regularly flowing river, is seen as a channel, as it becomes the guardian spirit of flooding.

eeyah-h **moon** *iᶜḥ*

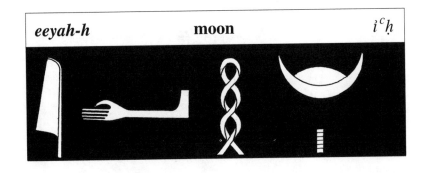

eenpooh **Anubis** *Ỉnpw*

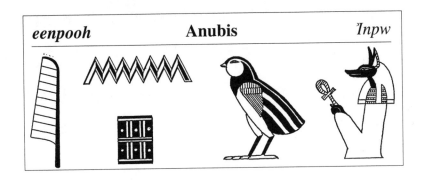

eebee **to thirst** *ib(i)* **eeb** **heart** *ib*

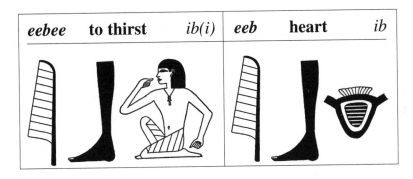

eeteroo **river** *itrw*

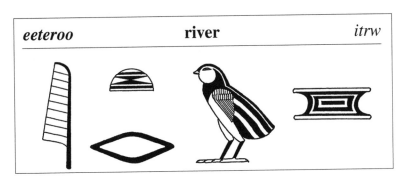

k *k*

Uniliteral: Fine wicker basket with handle.

PHONETICS AND WRITING

1. kekoo — Shades, shadows. All the elements have been explained previously — the baskets, quail, and the sky with a star as determinative.

2. ka — To think. Basket-vulture-man — the same action is used to express the ideas of speaking, remaining quiet, drinking, eating, and thinking!

3. ky — Monkey. The monkey is the onomatopoeia-determinative.

4. kehkeh — To grow old. The emphatic repetition of two phonemes and a strikingly realistic determinative.

SEMANTICS

For the ancients, the Shades were living beings: male and female, they formed part of the Ogdoad, a group of eight primordial elements that were venerated at Heliopolis, the city near the top of the Nile Delta.

The Egyptians were fascinated by thinking, a mental process that they nonetheless found difficult to express in written form. *Ky* is an example of onomatopoeia, but the term stands out because it can also mean "the other" or "an other" — with a different determinative. The monkey is "an other" that is close to man.

To grow old is cruelly expressed both by the sound and the image. The *keh-keh* is a graphic depiction of the hesitant gait of the elderly, leaning on a cane. It is almost as if we can hear his painful cough.

kekoo	shadows	kkw

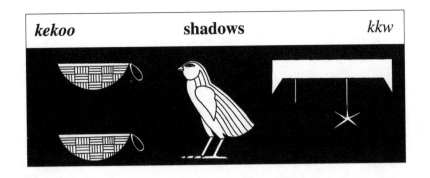

ka	to think, reflect	k3

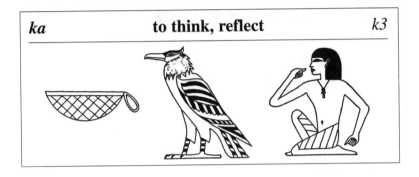

ky	monkey	ky

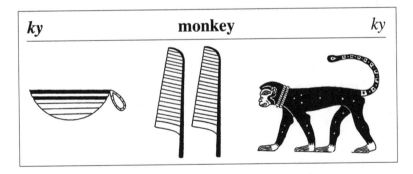

kehkeh	to grow old	khkh

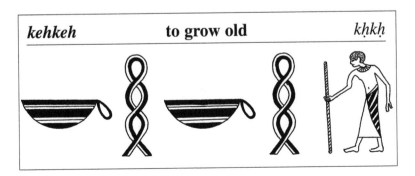

k/q

ḳ

Uniliteral: A sand dune or a sandbank.
Pronunciation: an emphatic *k*, as in "kit."

PHONETICS AND WRITING

1. keri — Storm or tempest. Three phonemes, all of which have been explained, and the determinative is a stormy sky.

2. keres(oo) — The sarcophagus has as its determinative the object itself. The first two uniliterals have already been defined. The third is U 20.

3. kek —To eat. The determinative is well known, lending itself to many meanings.

4. keny — Courageous, active, powerful, brave. Plural: all these words are written phonetically in the same way, with the determinative distinguishing between them.

5. kebehoo — Refreshing water, coolness. Both terms are homonyms; only the determinatives vary.

SEMANTICS

The root *ker* is identified with two cataclysms: one cosmic and the other human. The sky throws open its flood gates (its mouth) from which rain and lightning pour forth. The earth can also open up and swallow humans. The meaning of the word "sarcophagus" is "the flesh eater" for the Greeks; the ancient Egyptians seemed to share the same concept.

With *keny*, human violence is an extension of natural violence.

In another vein, eating and drinking, in this country of perpetual thirst, is a pleasant counterpart to the unchained elements of Destiny.

keri storm *ḳrỉ*

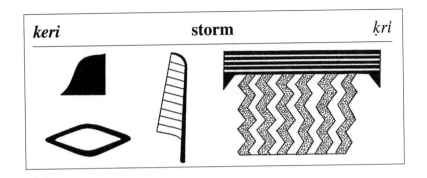

keres(oo) sarcophagus *ḳrś(w)*

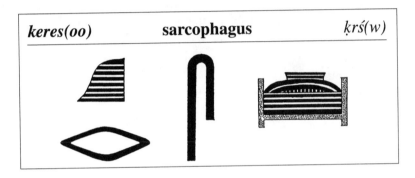

kek to eat *kk* **keny** courageous *ḳnỉ*

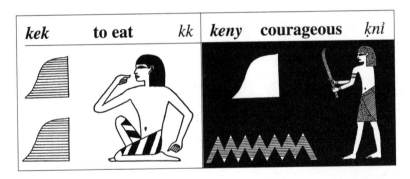

kebehoo fresh water *ḳbḥw*

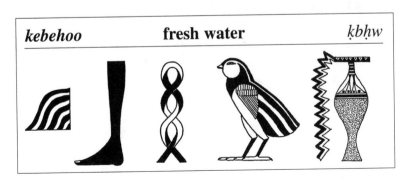

l *l*

Uniliteral: The lion represents the sounds *r,* and later *l.* Ideogram for "lion."

PHONETICS AND WRITING

The ancients had several words to express "lion," the most common were *maï* and *ru.* The lion symbol is both an ideogram and the uniliteral for the sound *r.* The shift from *r* to *l* and vice versa, as well as the confusion between these two sounds occurs in many languages. The reasons for this phenomenon go beyond the scope of this work.

The Egyptians did not have the *l* sound. This sound only began to appear in hieroglyphic transcriptions of names of foreign pharaohs. This situation didn't arise until the time of the Greek pharaohs, as none of the names of their predecessors contained the letter *l.*

In 25th Nubian (Ethiopian) Dynasty cartouches, the lion represented the sign *r,* replacing the *mouth* sign. Under the Persian occupation, the names of Darius and Xerxes almost invariably contained the image of the lion to represent the *r.* The cartouche for Darius, given on the facing page, reads "Tariush" and not in our opinion "Taliush," as some have suggested.

But while the king of the animals undoubtedly was used for *l* in the names Alexander, Ptolemy, and Cleopatra, it also was used alternately for *l* and *r* in the last cartouche of Ptolemy — Cesarion. In Cleopatra's name, the lion was always used for the *l* and the *r* was represented by the hieroglyph for the mouth. On some other cartouches, the lion was used for the phonetic sound *r,* especially the cartouches containing the names of Roman pharaohs.

SEMANTICS

Is there a semantic link between these two cartouches? We think so. It is a potentially controversial position. However, it must be remembered that the priests and scribes who composed the inscriptions never did so at random. Therefore, why did they introduce the lion, with its double consonance, in these names? The image, which is both an ideogram and a biliteral, was used mainly to write the name of the two divine lions, the Rooty, known as Shoo and Tefnoot. The same image also appears in a few architectural motifs. In general, *root* is the door, the pivot between the inside and the outside. *Rooty,* written with uniliterals and not with the lion, is the outside, and a *rooty* is a person from outside, an outsider, or stranger. We should also add that the transitive verb *rooy* means to leave, to go away. Its intransitive meaning is to expel, chase out…The Egyptian enjoyment of word play is well known: malice was often hidden behind the veneer of respect for royalty.

Taryoosh (Talyoosh) Darius *T3ryws (T3lywš)*

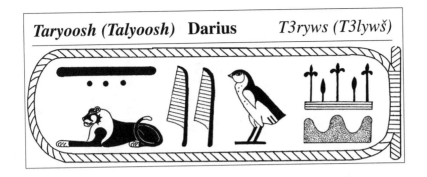

Alekzinderez Alexander *3lksindrs*

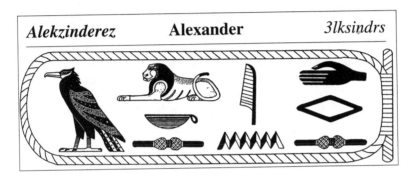

Petulemoose Ptolemy *Ptwlmyś*

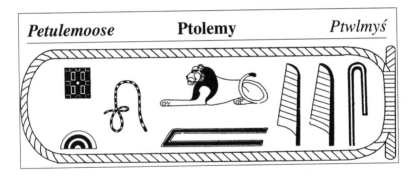

Kliupaderat Cleopatra *Ḳlỉwp3dr3t*

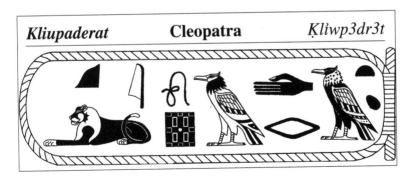

m

m

Uniliteral: The owl.

PHONETICS AND WRITING

1. mesheroo — Evening. The owl = *m*, the basin = *sh,* the mouth = *r* and the quail = *w* combine to compose the word; the determinative is the setting sun.

2. mefkat — Turquoise. All the "letters" are familiar; the pretty colored beads are the determinative.

3. moot — Death. The pronunciation *mout* has been claimed, but has not been noted in most of these words. The determinative is most explicit.

4. mesi — Birth. The archaic form of the written word, in which three fox skins attached together are still a determinative before becoming a biliteral.

5. medoo — Stick. In this case, the determinative precedes the three phonemes, because it is also a word-sign (ideogram).

SEMANTICS

This nocturnal bird rules as "terminator" in the various processes expressed by the words on this page. They all belong to very closely related semantic registers: the sun, which casts its last rays before it is swallowed up by the mouth of Nut; the brilliance of the turquoise, ripped from the entrails of Mother Earth. Its blue-green color is the symbol of air and of life. Death, expressed here as a suicide, also connotes a spiritual experience, such as the opening of the third eye and access to a new existence at a different level. The sticks are a different matter: *medoo* is also used to express "words" that can hit hard.

mesheroo evening *mšrw*

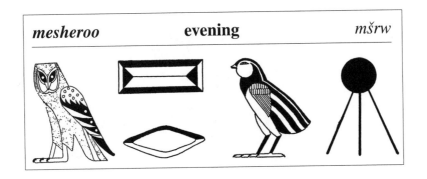

mefkat turquoise *mfk3t*

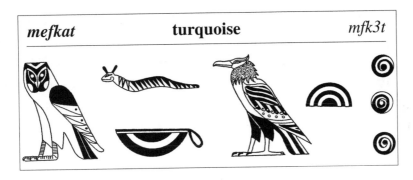

m(oo)t death *m(w)t* **mesi** give birth to *msỉ*

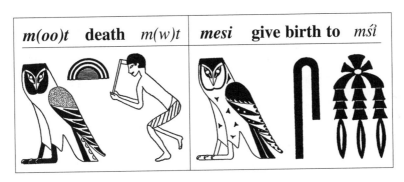

medoo cane, stick *mdw*

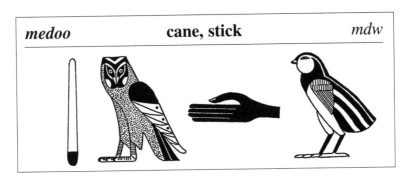

n *n*

Uniliteral: Wavelets or vibrations.

PHONETICS AND WRITING

1. netjer — God. Three phonemes and a determinative: the staff and pennant, a sacred object of unknown origin.

2. nehet — Sycamore. Three phonemes. One determinative: an image of the sycamore.

3. nehi — To swim. Water, legs, and arms are necessary for this activity; the graphic depiction speaks for itself.

4. nekhakha — Whip. This is the abbreviated written form of *nekhakha.*

SEMANTICS

The concept of vibration dominates these images: the radiance of the divine, which is nourished and expressed by the mouth; the mythical tree, the seat of the divinities; and the whip, a divine and royal attribute, expressing strength and vitality.

The vibration and the movement of water, as it is churned by the swimmer, forms a concrete and realistic whole, and also suggests the quest of a goal to be reached.

netjer	god	*nṯr*

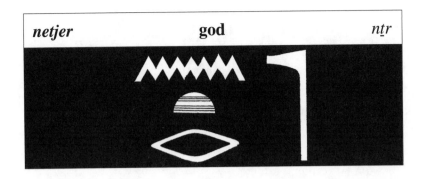

nehet	sycamore	*nht*

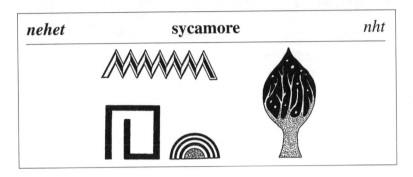

nebi	swim	*nbi*

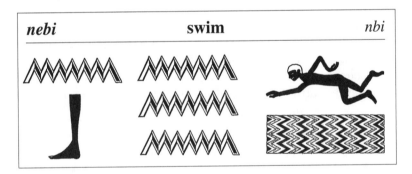

nekhakha	whip	*nḫ3ḫ3*

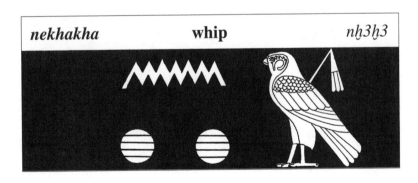

51

p

p

Uniliteral: Originally, the symbol represented a mat placed on a stool, and then by extension, it came to represent the stool itself.

PHONETICS AND WRITING

1. pet — Sky. Two letter-signs and a word-image determinative.

2. pat — Nobility, humanity. Three written phonemes, and a fourth that is understood. Determinative: a nobleman and woman.

3. penite — Cataract. Five uniliterals (including one that is double) and two determinatives: the channel and the water.

4. pekhed — To be overturned, overthrown. Three phonemes and one determinative, which is as clear as it is naïve.

SEMANTICS

You may find a similarity between the sky, divine elevation, and the aristocracy, which is the highest social class. Likewise, the impetuous momentum from the water spilling over the cataracts might prove to be overthrowing. These associations of words with different roots may be somewhat artificial, but with a little imagination you can see how flexible and graphically expressive the language is.

pet	sky	*pt*

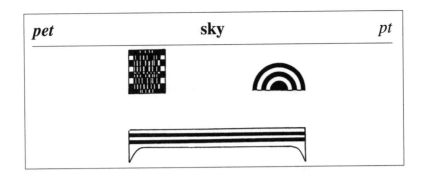

pat	**nobles, humanity**	*pct*

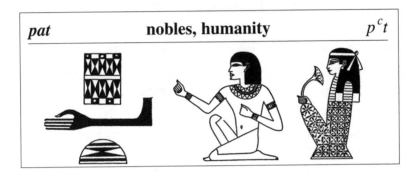

penite	cataract	*pncyt*

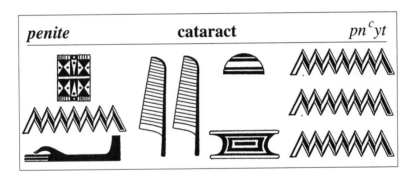

pekhed	**to be overthrown**	*pḫd*

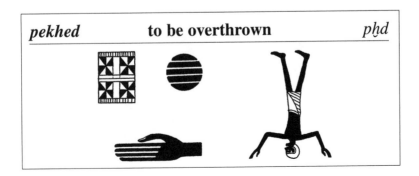

r r

Uniliteral: Open mouth without teeth.

PHONETICS AND WRITING

1. remi — To cry. The "letters" are followed by the determinative, an eye from which tears are flowing.

2. ren — The name. The particular feature of this word is that it has no determinative.

3. rah — The sun. The writing for this word needs only a single comment: the determinative of the sun is followed by a vertical dash, indicating that the word represents the sun and not a god.

4. remetch — Men, humanity, the Egyptians. A written form that is typically defective: the *m* is rarely written. Determinative: humankind.

5. rem — Fish. No comment needed.

SEMANTICS

The first four words on the next page are closely linked. According to legend, humanity was born from the tears of Rê, the sun god — which imparted the name to humankind. But *rematch(et)* is also synonymous with the Egyptians — to whom the rest of humanity was not quite human! The Greeks had similar ideas. Since they could not understand the sounds from foreign languages, they used a scornful onomatopoeia to designate them: barbarians!

The fish is not part of this group.

remi	cry	*rmi*

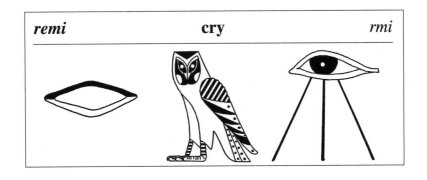

ren	name	*rn*	**rah**	sun	*rc*

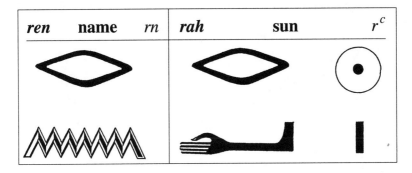

remetch	humanity	*rmṯ*

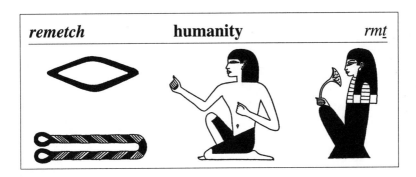

rem	fish	*rm*

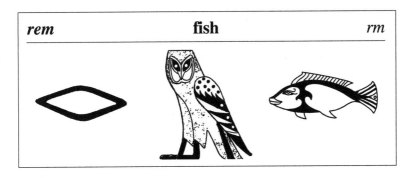

S

ś

Uniliteral: A folded cover thrown over the back of a chair to make it more comfortable.
The sound is the *s* heard in "sand."

PHONETICS AND WRITING

1. seba — Star. The three phonemes are followed by two determinatives, the images of a star and of the sun, which indicate the idea of brilliance.

2. ser — Predict, make known, provoke. Two "alphabetic signs" followed by two determinatives: giraffe and man.

3. sedjem — Hear. This verb is written with three "letters." They are followed by a determinative in the shape of a calf's ear.

4. sesemet — Horse. Neither the writing nor the determinative requires any comment.

SEMANTICS

The words on this page are replete with sibilant sounds! The remote star is an enticement to prophecy. The giraffe who can see in the distance and the man who is sitting, with hand to his mouth, are good reflections of these words. Who can hear if he has no ears? Serpents, of course, who pick up vibrations in the environment, similar to our modern sensor devices. The double *s* permits us to hear the rhythm of the horses, galloping in the wind.

seba	star	śb3

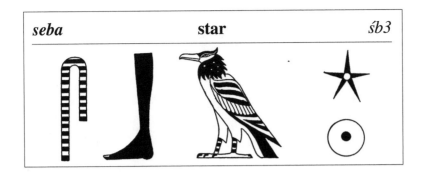

ser	predict	śr

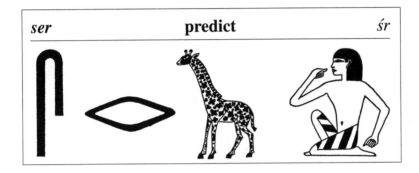

sedjem	hear	śḏm

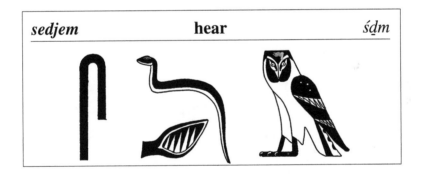

sesemet	horse	śśmt

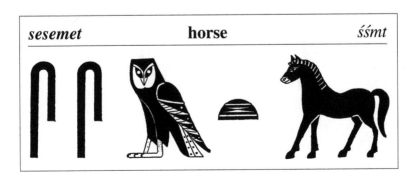

s / z s

Uniliteral: The bolt, representing the sibilant resonant *s*, like our *z*.

PHONETICS AND WRITING

1. zeh — Man. Phoneme and determinative.

2. zet — Woman. Two phonemes (the *t* of the feminine) and the determinative.

3. zah-h — Mummy. Three uniliterals and the determinative is the mummy itself.

4. zesheshet — Tambourine, drum (Egyptian timbrel). Three uniliterals, one of which is doubled for emphasis: onomatopoeia imitating the percussion of the tambourine, which is shown as the determinative.

5. zekhem — Sanctuary. Three phonemes and two determinatives: the arms held in a gesture of adoration or of abnegation, and the image of the house; if the latter determinative were absent, the word would be *sekhem,* to "ignore."

SEMANTICS

This page is all "locked up." Men and women are placed in their universe, where they live before going on to the realm of the dead. The funeral rites revive their senses, and the coffins and tombs are opened, as they are for the gods at the sound of the timbrel. The rattling sound of this rhythm instrument is reminiscent of the stand of papyrus reeds, symbols of a fetal existence. The rites are conducted mainly in sanctuaries, which are protected by stout brick walls, keeping the uninitiated ignorant of sacred mysteries.

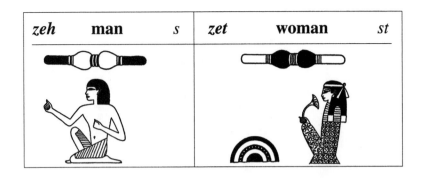

| zeh | man | s | zet | woman | st |

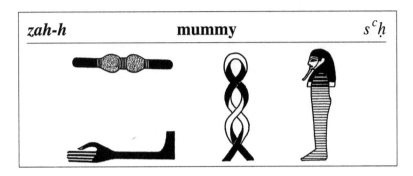

zah-h **mummy** $s^c\underline{h}$

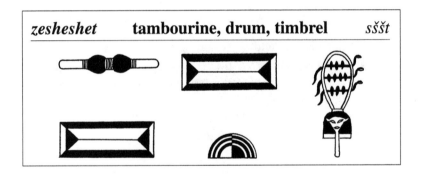

zesheshet **tambourine, drum, timbrel** *sššt*

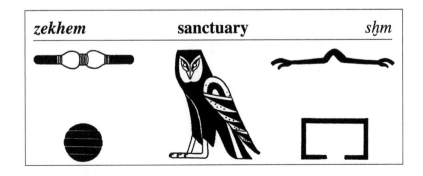

zekhem **sanctuary** *s\underline{h}m*

sh š

Uniliteral: A basin filled with water.

PHONETICS AND WRITING

1. shemoo — Summer. One of the three seasons of the Egyptian calendar shown by the sign *sh*, followed by the biliteral *mou*, water. The sun is the determinative.

2. shem — Walk briskly, travel. Determinative: legs in motion.

3. shepes — Veneration. Three phonemes and the picture of a powerful dignitary as determinative.

4. sheboo — Food, sacred offerings. Three uniliterals and a loaf of bread, followed by the three signs of the plural.

SEMANTICS

The four words each have their own semantic meaning. Summer clearly leads to the harvest, and by merely replacing the determinative of the sun with a barrel of grain, the word *shenoo*, meaning summer and its flooding, becomes the "harvest," which also supplied the sacred offerings. Another parallel: during the Nile flooding season, all agricultural work was interrupted while the entire population traveled across the great expanse of water to feast and celebrate. It is essential to have someone to direct and watch over Nature and a people in movement: the person invested with these duties needs to have his authority respected.

shemoo	**summer**	*šmw*

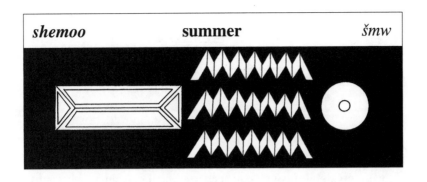

shem	**go**	*šm*

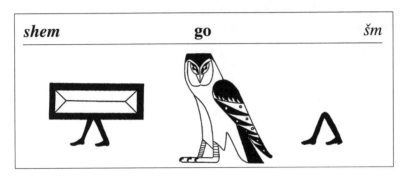

shepes	**venerable**	*špś*

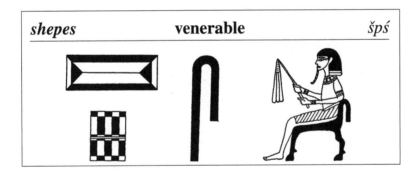

sheboo	**food, offerings**	*šbw*

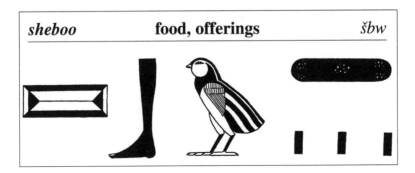

t

t

Uniliteral: A little bread roll.

PHONETICS AND WRITING

1. temet — A wooden sleigh (as you can see from the determinative branch) slides across the sands of the necropolis, the city of the dead. The picture of the sleigh is not a determinative, but rather the biliteral, *tem*, in between the phonetic components.

2. teka — Torch, which appears as the determinative. The *ka* is both a letter and a biliteral.

3. toot — Statue, image. This is a very famous group of three phonemes, as it appears in the cartouche of Tutankhamun. The determinative speaks for itself.

4. Tay — Bread. One phoneme, two pictures of bread as determinatives, followed by the three dashes, which are the sign of the plural noun.

5. tekhen — Obelisk. This written symbol needs no comment.

6. tefen — Joy, celebration. Three "letters" and the lotus (or the nose!) as determinative.

7. tekhen — One of the words used to designate the "musician." The arm is the determinative, as it performs the actions.

SEMANTICS

The sleigh on which the catafalque (coffin-like structure sometimes used in funerals for the lying-in-state of the body), *Ka*, is loaded. The entity that reveals itself in the darkness of death like the glimmering of a new source of energy; the ritually animated statue; bread, real sustenance and sublime; and the sacred stone of Heliopolis — all are related. Music and joy belong to the same register, but not in the same way.

temet	sleigh	*tmt*

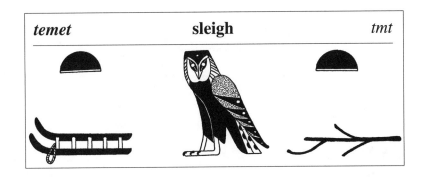

teka	torch	*tk3*	*toot*	statue	*twt*

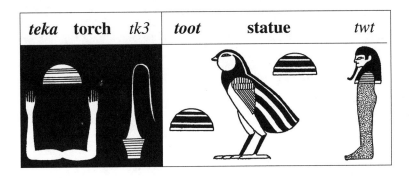

Tay	bread	*t*	*tekhen*	obelisk	*tḫn*

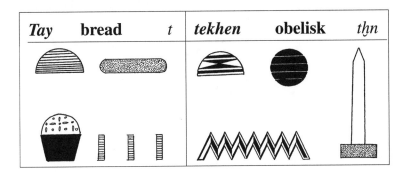

tefen	joy, celebration	*tfn*	*tekhen*	musician	*tḫn*

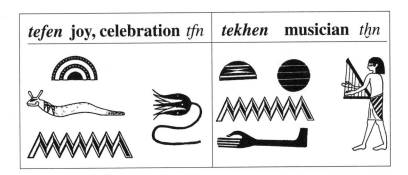

tsh _t_

Uniliteral: Stylized yoke or bridle for animals representing the emphatic _t_ and pronounced _tsh_.

PHONETICS AND WRITING

1. tshesem — Dog. Phonemes that we have seen before and a determinative that speaks for itself.

2. tshitshi — To trot. The phonemes are repeated, which is quite appropriate for onomatopoeia, and a logical determinative — legs in motion.

3. tsheboo — Sole of the foot. Three phonemes and a determinative.

4. tshebooty — Two sandals. Three phonemes are used to write this term (the elision of the _ou_ sign is frequent). Determinative: two sandals.

SEMANTICS

The bridle is well placed in this word: it is not only used for cattle, but also for dogs and horses. Lift the cord and everyone will trot.

The sandal is designed to protect the foot, but it not only protects — it also isolates the foot: it breaks the bond between humans and the earth.

tshesem	**dog**	*t̯sm*

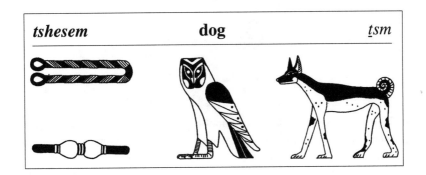

tshitshi	**trot**	*t̯it̯i*

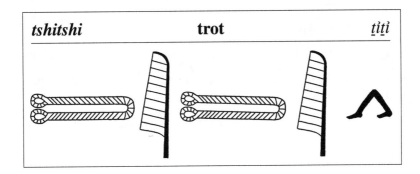

tsheboo	**sole of the foot**	*t̯bw*

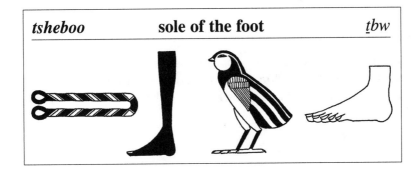

tshebooty	**sandals**	*t̯bwty*

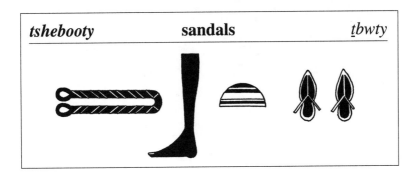

oo/w *w*

Uniliteral: The quail is the main written symbol for the sound *oo/w*. It can be replaced by the spiral. These two figures correspond to the *waf* of Semitic languages.

PHONETICS AND WRITING

1. ooben — To be elevated, to shine. Three phonemes and a classic determinative.

2. oot — Embalmer. Two phonemes and two determinatives: a blister (previously seen with the navel) and the man.

3. ooahb — Priest for purification. Three phonemes and a very demonstrative determinative.

4. ooeya — Sacred bark. Three phonemes, already seen, and a determinative that represents the object.

SEMANTICS

This page depicts funeral rites and the rites of transformation. The role of the embalmer is to prepare the body for the afterlife, under the priest, whose role is to purify. The ritual bark will take the new Osiris off to unknown shores, where like Re, he hopes to be elevated forever and ever.

ooben	**to be elevated, to shine**	*wbn*

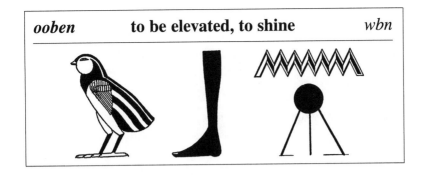

oot	**embalmer**	*wt*

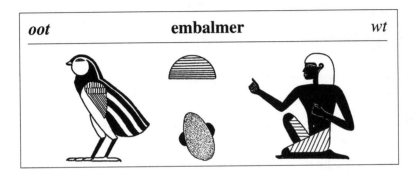

ooahb	**priest for purification**	*w^cb*

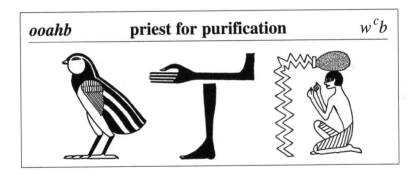

ooeya	**sacred bark**	*wi3*

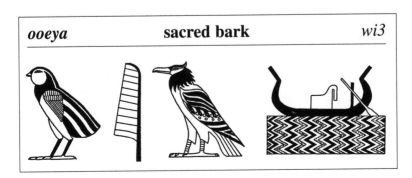

y *y*

Uniliteral: The two flowering reeds represent *y*, which is a doubling of the *i*.

PHONETICS AND WRITING

1. yh! — Hey! Over here! (exclamation). Two phonemes; one determinative that indicates movement.

2. Ihy — The child-god, player of the tambourine. The phoneme is well-known and the determinative self-evident.

3. ya — Ya! (exclamation). Here the uniliterals are logically determined by the man with his hand to his mouth.

4. youmah — proper geographical name: sea or great lake in Asia Minor. It is most likely a foreign name, transcribed into hieroglyphics. The water determinative is essential here.

SEMANTICS

Exclamations are related to everyday living. They often appear on the bas-reliefs of tombs as in the speech bubble of a cartoon. The child-god, who uses the tambourine to summon Isis-Hathor, his mother, is the symbol of prenatal life, which is suggested by the stand of full rushes. The name of the great expanse of water belongs to the same line of thinking.

yh !	hey! Over here	*yh !*

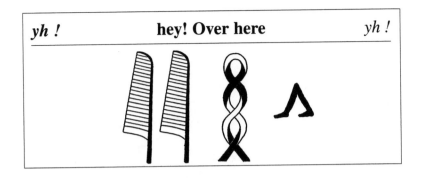

Ihy	The god Ihi, who plays the sistrum	*Iḥy*

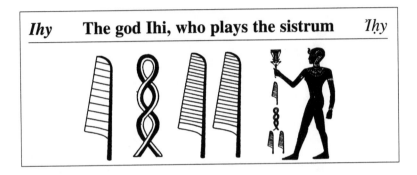

ya	ya	*y3*

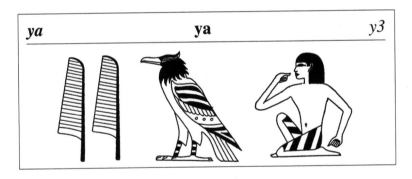

youmah	the great sea	*ywm*^c_c

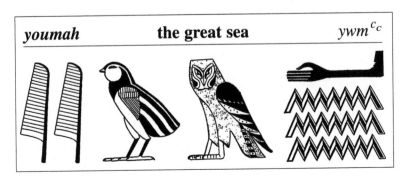

BILITERALS

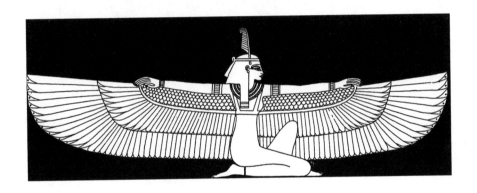

The dual root signs constitute the largest group in the ancient system of writing. We have selected 83 of the most representative word-signs. They are varied, interesting semantically, and chosen from different eras, in order to give an idea of the evolution of writing. These examples, in several cases, demonstrate word compositions that are far from ordinary.

The classification of the biliterals corresponds to the classification used for uniliterals. Here is a typical example: the two letters for *a* — *aleph* and *aïn* — are two different "letters." Biliterals beginning with *aleph* come before biliterals beginning with *aïn*. Thus the biliteral *akh* comes before the biliteral *ah-oo*. The order is determined by Egyptian symbols.

Several of the biliterals are homophones (the same root used for different words), the two *hem*, for example. Others are polyphones (the same word common to different roots), *ab/mer*, for example. The classification used is not, however, random. Keep in mind that these signs always represented two phonetic sounds for the ancients, even if the transliteration requires three or even four letters from the modern alphabet.

The guide to pronouncing biliterals is given by means of uniliterals, the sounds of which were explained in detail. Using this method, it is possible to learn and to memorize the sounds and images of the basic signs. You will see on the pronunciation line "vulture and leg" for the biliteral *ab*, for example; "skin of a mammal and wavelet," for the biliteral *khen*, and so on. As in the previous section, the determinatives are given for each word.

ab

3b

Biliteral: An engraving tool or sculptor's chisel. *(see also mer)*

PHONETICS AND WRITING

Pronunciation: vulture and leg.

1. and **2. aboo — Elephant,** as well as **ivory,** with the determinative serving to distinguish the two words.

3. aby — To desire, wish. The determinative: the man with his hand to his mouth.

4. aby — Panther. The meaning is indicated by the determinative, with no differentiation as to species.

SEMANTICS

This sign connotes an impression of stability, which is heavy and almost awkward. The feline paw of the determinative adds a note of agility. The verb "to desire" is both revealing and intriguing, with the man with his hand to his mouth as determinative. The first desire of humans as children is food, which enters by way of the mouth, and throughout human life will remain an important organ of physical and emotional exchange, and even spiritual exchange through the word. (The doubly emphatic *abab* means "enchanted," "in awe.")

aboo	elephant	*3bw*

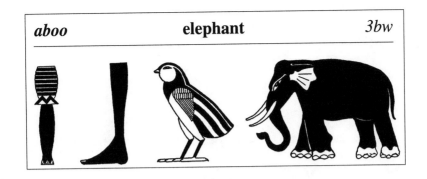

aboo	ivory	*3bw*

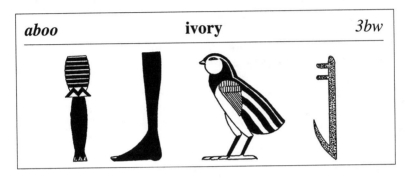

aby	to desire, wish	*3b(i)*

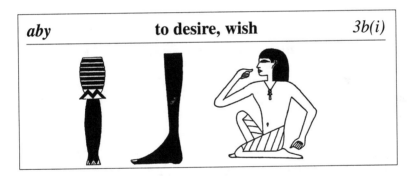

aby	panther	*3by*

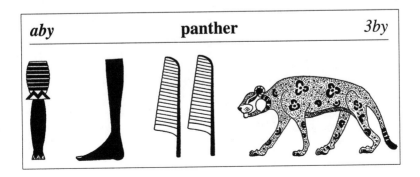

75

akh

3ḫ

Biliteral: The *ibis*.
Also an ideogram that expresses the divine element in man.

PHONETICS AND WRITING

For pronunciation, compare "percnopterus," specifying "vulture," and placenta, which occur frequently as phonetic components.

1. akhoo — The spirits of the blessed. In this archaic notation, the three birds denote the plural; only the final image is followed by a phonetic complement. The determinative, which would be a person of importance, is unnecessary in this archaic written expression.

2. akhet — Horizon, a very old written form of this expression taken from the pyramids with the Earth as the determinative. It would soon be replaced by the word sign for the horizon.

3. akhet(oo)y — The two eyes, the moon and the sun. Determinative: eyes.

4. akhoo — Omnipotence (divine, royal, etc.). Determinative: papyrus roll (sign of an abstract idea).

SEMANTICS

The elegant bird with its brilliant plumes that ruffled at the slightest breeze was for the Egyptians the very image of all that was ethereal, glorious, good, noble, and beyond the lowly sphere of Earth — therefore, something cosmic and divine.

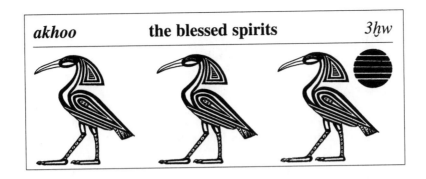

akhoo	**the blessed spirits**	*3ḫw*

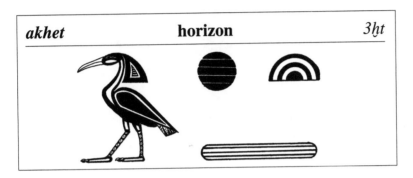

akhet	**horizon**	*3ḫt*

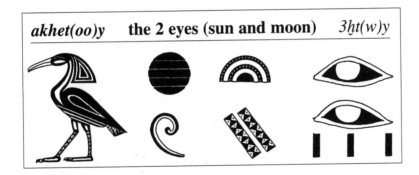

akhet(oo)y	**the 2 eyes (sun and moon)**	*3ḫt(w)y*

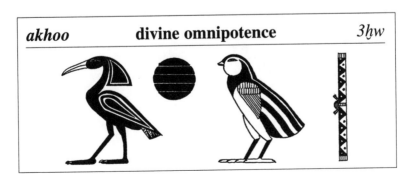

akhoo	**divine omnipotence**	*3ḫw*

77

ah-oo

3w

Biliteral: A highly stylized representation of the ribs and the spinal column, from which some bone marrow emerges.

PHONETICS AND WRITING

Pronunciation: vulture and quail.

1. ah-oot — Long period of time. Determinative: the papyrus roll (sign of an abstract idea).

2. ah-oo — Long measure of space, without a determinative.

3. ah-oo — Death (noun and adjective). Determinative: the sign is derived from hieratic writing that showed a man who was a prisoner, fallen, or entombed, with his staff against his forehead.

4. ah-oot — Gifts, offerings. This written term is from the high era, including a triple determinative: two vases on either side of a round loaf of bread.

SEMANTICS

A very material sign: a rich meat-based food, implying slaughter; *ah-oot* also means "great knife." *Ah-oo-ee* means to cause violence, indicated by an outstretched arm bearing a weapon. The food is vital and is therefore offered as a generous gift, both in Earth-space and in time-space: it appears among the offerings on tables and altars for the benefit of gods and the deceased: this is the positive side of the outstretched hand that gives.

| *ah-oot* | length (of time) | *3wt* |

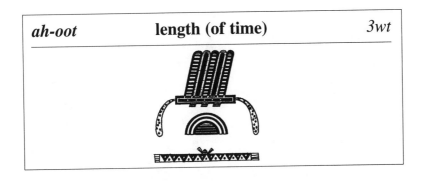

| *ah-oo* | length (of space) | *3w* |

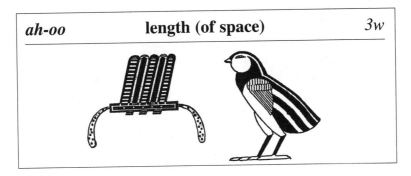

| *ah-oo* | death | *3w* |

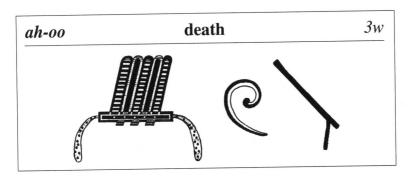

| *ah-oot* | offerings | *3wt* |

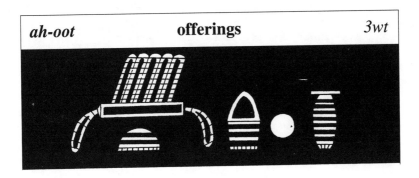

ah-a

c3

Biliteral: A column or a pillar, derived from the combination of *aïn* and *aleph*.

PHONETICS AND WRITING

Pronunciation: arm and vulture.

1. ah-a — Great and greatness, and related concepts. The sign is accompanied by its two phonemes, and the determinative, the papyrus roll (sign of an abstract idea).

2. ah-a — Column, pillar; word-sign. Determinative: the branch.

3. Apep — Apophis: malevolent serpent-god. Determinative: the same serpent.

4. ah-a-ah — Seed, bad influence, cause of sickness. Determinative: the phallus.

SEMANTICS

It is astounding to see how many ordinary words use this sign, the biliteral for the column lying on its side: it is very rarely shown standing. This is probably for graphic and esthetic reasons.

Aside from the primary meaning, which is "column," this hieroglyph is related to everything that can be inflated, exaggerated, displayed, spread out, and overflowing, both literally and figuratively.

Some related terms also contain the notion of protection (guardian, gateway), but what surprises us is the lack of support for this column.

ah-a	great	c3

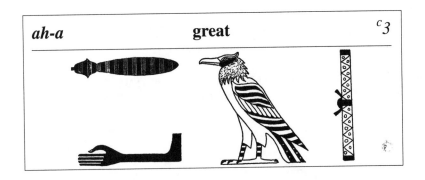

ah-a	column, pillar	c3

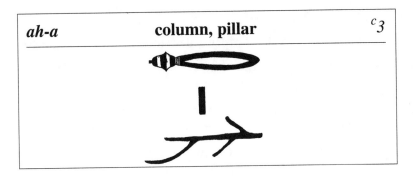

Apep	Apophis, the serpent	c3pp

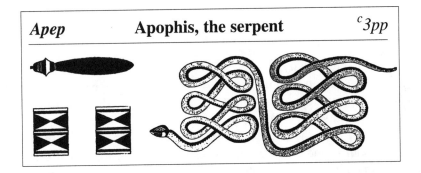

ah-a-ah	seed, bad influence	$^c3^c$

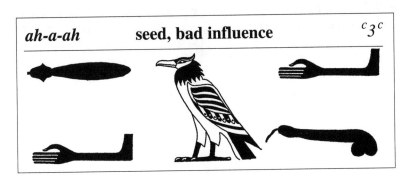

81

ahdj ^c*d̲*

Biliteral: A bobbin, spool, or reel used for various functions, especially for repairing fish nets. Ideogram for "reel."

PHONETICS AND WRITING

Pronunciation: arm and cobra.

1. ahdj — Bobbin, spool, or reel. Word-sign: determinative: wood (branch).

2. ahdj — To find shelter, safety. The biliteral, in this case, is preceded by its phonetic complements. The determinative: the papyrus roll (sign of an abstract idea).

3. ahdj — To chop up, break into small pieces, destroy. The phonetic complement is the letter *d*; two determinatives: a knife and an arm bearing a weapon.

4. ahdj — Riverbank or strip of land between the desert and an irrigated valley. Despite the phoneme *d*, the word was undoubtedly pronounced with a *dge* at the end. Determinative: house.

SEMANTICS

Of the words selected here, only one has an abstract meaning. All the others are related to the activities of daily life, in both their positive and negative aspects.

The range is wide open, and the connections are sometimes disconcerting. How do you explain such divergent meanings for *ahdj* as to be in good health, to be in good shape (the fishnet, the boat), to take shelter, to cut up, to destroy, to provoke carnage? The latter meanings apply both to the butchery of domestic cattle and to the carnage wrought on one's enemies and on their cities, whether by war or by natural catastrophe. Depending on the determinative, *ahdj* may mean to burn, roast, or grease the fat of an animal. The root *ahdj* is also found in such words as wrongs, lies, guilt and . . . jubilation and rejoicing!

| *ahdj* | reel | $^c\underline{d}$ |

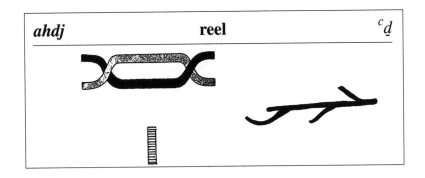

| *ahdj* | to find shelter, safety | $^c\underline{d}$ |

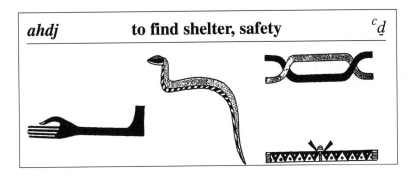

| *ahdj* | to chop up | $^c\underline{d}$ |

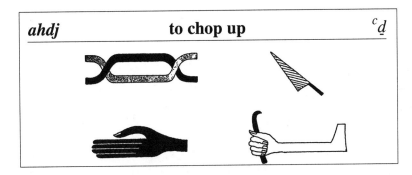

| *ahdj* | riverbank | $^c\underline{d}$ |

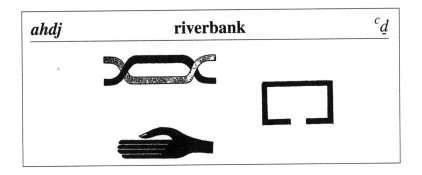

ahk

$^{c}\underset{.}{k}$

Biliteral: The cormorant.

PHONETICS AND WRITING

Pronunciation: arm and sand dune.

1. ahk — To enter (a door, a game, a system, a function). Determinative: legs.

2. ahkoo — Friends. Two determinatives: a man, a woman and three dashes for the plural form.

3. ahk-eeb — Close friend. Biliteral, having as its complement the legs and the heart (which here is pronounced). Determinative: the man.

4. ahkoo — Nourishment, provisions, collecting, end. Plural, as is indicated by the three dashes in the determinative.

SEMANTICS

The words chosen here illustrate how many applications of the concept "to enter" can be written using this bird, which is the very image of abundance, but with a connotation of insolence: entering someone's dwelling unannounced is seldom appreciated.

Those who are welcome when they arrive and who enjoy free access are undoubtedly friends. And a close friend is someone we take into our hearts.

Evidently, all the good things that enter a house are accumulated as provisions and riches for the human clan, just as the bird carries provisions to its young in the nest.

ahq	**to enter**	$^c\underline{k}$

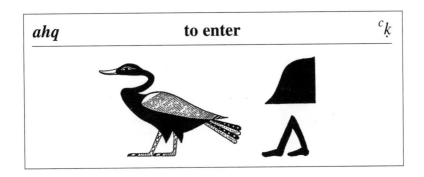

ahkoo	**friends**	$^c\underline{k}w$

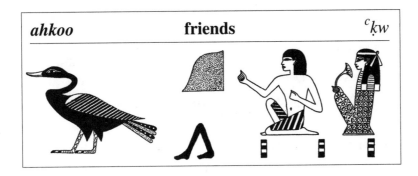

ahk-eeb	**close friend**	$^c\underline{k}$-*ib*

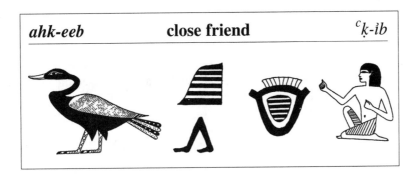

ahkoo	**nourishment**	$^c\underline{k}w$

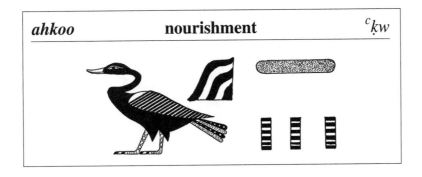

bah

b3

Biliteral: The soul. Bird-soul, the jabiru *(ephippiorhynchus senegalensis)*.
Ideogram for the soul.

PHONETICS AND WRITING

Pronunciation: leg and vulture.

1. bahka — The next day. Determinative: star.

2. bah — Leopard or cheetah skin, with two determinatives, the head and the skin of the feline.

3. bah — Soul, with no determinative.

4. baht — Emblem of the goddess Bat/Hathor, who appears as the determinative.

5. bahk — To work, pay taxes, to subjugate. Determinative: the arm bearing a weapon.

SEMANTICS

This sign offers a rich palette of meanings. Through it are expressed concepts as subtle as the soul and abstract ideas that arise from the observation of nature (of swift predators, particularly), from cultural symbols and divine emblems as well as the harsh reality of daily living.

bahka	the day after	*b3k3*

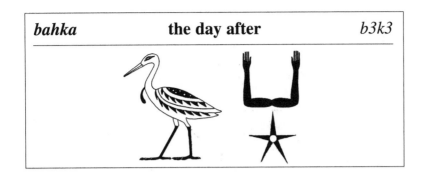

bah	leopard skin	*b3*	*bah*	soul	*b3*

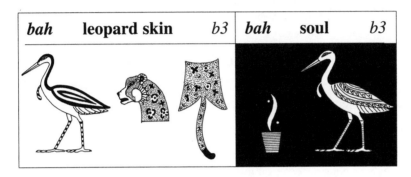

baht	emblem of the goddess Hathor	*b3t*

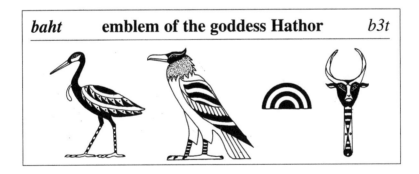

bahk	to work	*b3k*

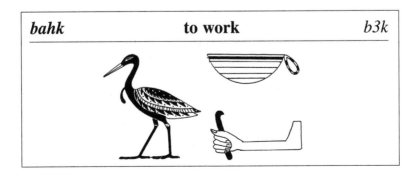

beh/hoo *bḥ / ḥw*

Biliteral: Polyphone representing an elephant tusk.

PHONETICS AND WRITING

Pronunciation: Two possibilities: *beh* (leg and wick), which is the most frequent, and *hoo* (wick and quail), which is rather rare. Finally, *tebeh* is the word-sign for tooth and laugh only.

1. Hoo — The spirit (God) of the Word. Determinative: the image of the divinity.

2. Behedet — Edfu (a city of Upper Egypt and also of the Delta). Determinative: a cross-section of the city, showing intersections.

3. behes — Calf. The determinative: the image of the calf.

4. behes — To hunt, pursue. The writing is purely phonetic; the biliteral is blocked out. Determinative: arm bearing weapon and legs in motion.

SEMANTICS

The usage of this polyphone sign does not seem to be governed by semantic rules, except, perhaps, for *Hoo* and *behes,* from which it was eliminated. It seems its destiny was certainly to act as a double agent!

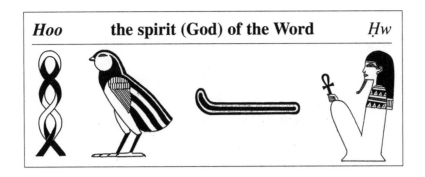

Hoo **the spirit (God) of the Word** *Ḥw*

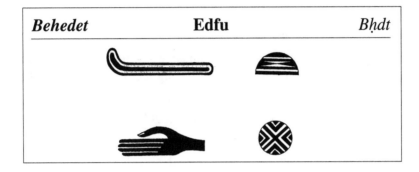

Behedet **Edfu** *Bḥdt*

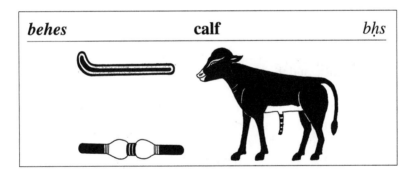

behes **calf** *bḥs*

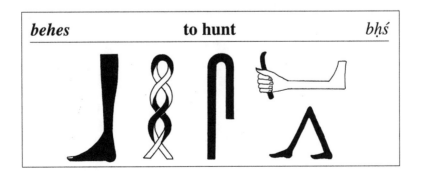

behes **to hunt** *bḥś*

dja

ḏ3

Biliteral: Wood used to make a fire. Ideogram for "forest."

PHONETICS AND WRITING

Pronunciation: cobra and vulture.

1. djotjot —Judges, magistrates. Two determinatives: a sign, which is also a polyphone but silent in this instance, that probably represents agricultural property, followed by the man and the three dashes that mark the plural.

2. djahdjah — Head. Written expression that is highly emphatic, as is clear from the double biliteral. Determinative: human head.

3. djah-is — Civil war. Determinative: warrior with shield.

4. djahdjah — Lyre. Emphatic writing. Determinative: wood

SEMANTICS

The head, the magistrates, and the tribunal suggest positions of authority. Civil war can be understood as the opposition to authority.

With the lyre, we enter into a gentler universe, but one that also has its passions.

The word "boat" is linked to the concept of timber, and from this springs the idea "to navigate" or "to cross a body of water." The latter term also appears in the description of the celestial Nile, which is crossed by the mythical solar bark.

djotjot	judges	<u>d</u>3<u>d</u>3t

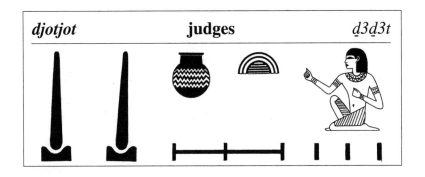

djahdjah	head	<u>d</u>3<u>d</u>3

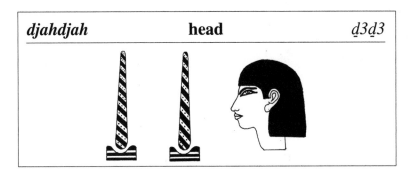

djah-is	civil war	<u>d</u>3í<u>s</u>

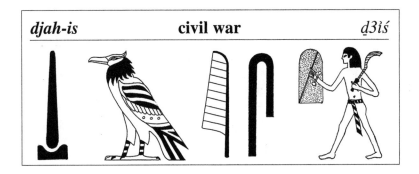

djahdjah	lyre	<u>d</u>3<u>d</u>3

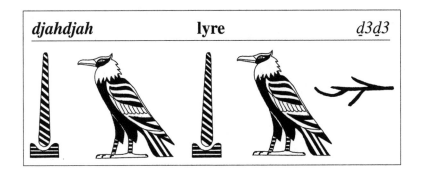

djed

ḏd

Biliteral: The "pillar" Djed, which was a column.

PHONETICS AND WRITING

Pronunciation: cobra and hand.

1. djed — The Djed itself, which is a word-sign without a determinative.

2. Djedoo — Busiris, a city of the Delta. Determinative: cross-view of the city.

3. Djed — A god of Memphis; expressed by the emphatic repetition of the biliteral, as in the previous example. The second *djed* is not pronounced. Determinative: the god.

4. djedoo — Stable, enduring. Determinative: the papyrus roll (sign of an abstract idea).

SEMANTICS

The sacred emblem, which is also a primitive architectural motif made from wood, was assimilated with Osiris' spinal column. The god of the dying, whom he resembles by undergoing a transformation, was worshiped at Busiris and in Abydos.

The *djed* represents a hope for rebirth, redress, and stability.

The god, Djed, was absorbed by Ptah, the ruler of the deep underworld, who was venerated in Memphis. The transfer of identity reveals some other ideas linked to *djed*.

djed	**the pillar**	*ḏd*

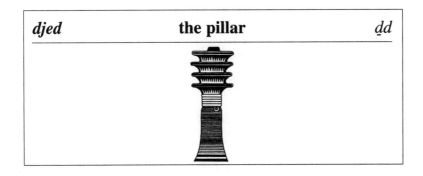

Djedoo	**Busiris**	*Ḏdw*

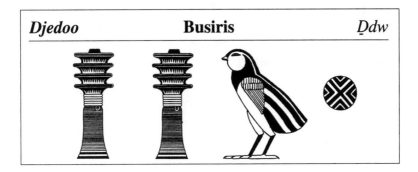

Djed	**Djed**	*Ḏdy*

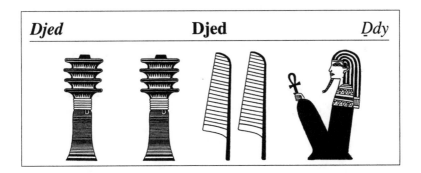

djedoo	**stable**	*ḏdw*

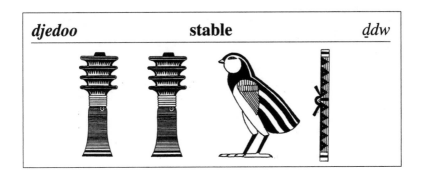

djer

ḏr

Biliteral: A small basket of fruit. *(see also mer)*

PHONETICS AND WRITING

Pronunciation: cobra and mouth.

1. djeroo — Frontier, limit, end. The determinative depicts a route that has been measured and traced out.

2. djertyoo — Ancestors. A triliteral, the bird, is used in this glyph. The determinative is the depiction of a high dignitary.

3. djerdjeri — Foreigner. Determinative: a man with Asian features, dressed in oriental garb.

4. djeri — Strong, intense. Determinative: arm with weapon.

SEMANTICS

The semantic link between fruit and the mouth is clear enough, but as for the other words shown here, we wonder by what possible association, other than phonetic, the ideas of frontier, limit, end, foreigner, and force are built on this base. Nonetheless, there is a semantic link between these word forms, as can be seen in other words that have *djer* as their root — hence, the concepts of end, finality, and even of eternity, "forever and ever."

djeroo	**frontier**	*ḏrw*

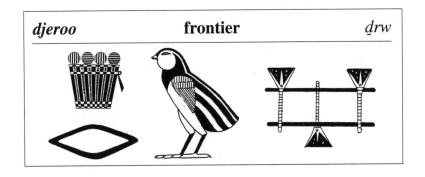

djertyoo	**ancestors**	*ḏrtyw*

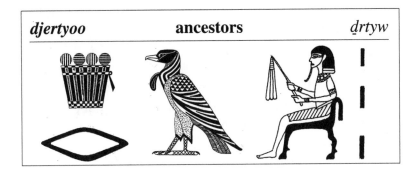

djerdjeri	**foreigner**	*ḏrḏrỉ*

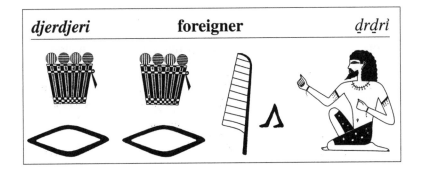

djeri	**strong**	*ḏrỉ*

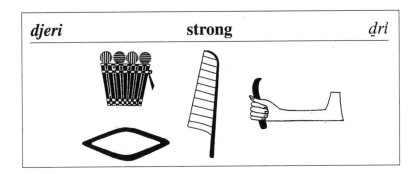

djoo _ḏw_

Biliteral: A mountain. It is also the ideogram for "mountain."

PHONETICS AND WRITING

Pronunciation: cobra and quail.

1. djoo — Mountain. Determinative: rock.

2. djoot — Evil, sadness. Determinative: bird of ill omen (sparrow).

3. djoo-ee — To call upon a divinity, or other force, or helpful person, invoke, invocation. Determinative: person in adoration.

4. djoo-yoo — Jar, which is also used as a determinative. The calf, another biliteral, is pronounced _iou_.

SEMANTICS

The root _djoo_, on the whole, is rather negative. Mountains in this region of the world are barren and hostile, conducive to sadness. Travelers exposed to danger in such regions are likely to invoke divine assistance and protection.

The jar containing the milk of which the newborn calf is deprived falls within the same semantic range.

djoo	**mountain**	*ḏw*

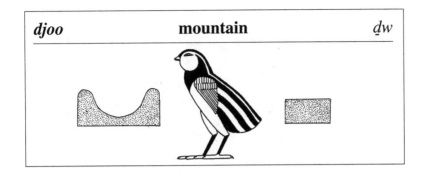

djoot	**evil**	*ḏwt*

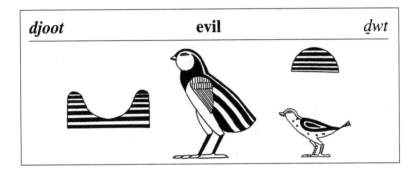

djoo-ee	**invocation**	*ḏwỉ*

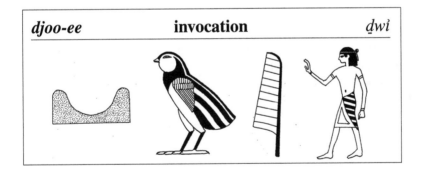

djoo-yoo	**jar**	*ḏwỉw*

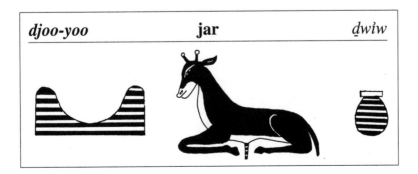

gem

gm

Biliteral: The stork or the black ibis *(plegadis falcinellus).*

PHONETICS AND WRITING

Pronunciation: base of the jar and owl.

1. gemeh — To perceive, to scrutinize, to view, to discover, regard. Determinative: eye.

2. gem — To find. Determinative: arm bearing weapon.

3. gemgem — To destroy, break, tear. Onomatopoeia with emphatic spelling. Determinative: mathematical sign.

4. gemeh — Foliage. Determinative: tree.

SEMANTICS

The bird pecking for its pittance, and the predator silently gliding as it perceives its prey at night, are part of a semantic group with threatening overtones, well adapted to the various meanings that flow from them.

The foliage offers a shelter to winged creatures and beasts.

gemeh	**to perceive, discover**	*gmḥ*

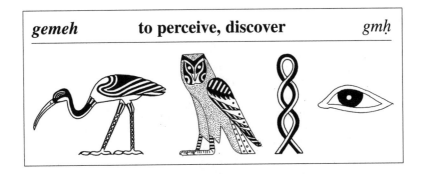

gem	**to find**	*gm*

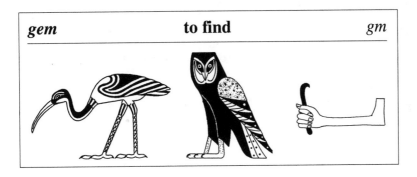

gemgem	**to break**	*gmgm*

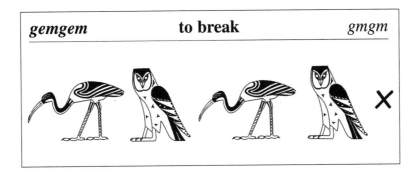

gemeh	**foliage**	*gmḥ*

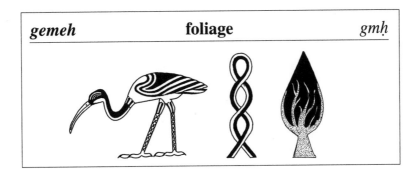

ha *ḥ3*

Biliteral: The papyrus plant with leaves.

PHONETICS AND WRITING

Pronunciation: lamp wick and vulture.

1. ha — Behind; someone's back; back (of head in general, but also buildings).

2. ha-oo — The entourage, the inhabitants of the Nile; the brothers of the islands; neighbors. Determinative: people (man and woman and the three dashes for plural).

3. hot — Tomb. Determinative: house.

4. hom — To fish, catch. Determinative: arm bearing a weapon (at times a fish).

SEMANTICS

The back or the reverse side, anything behind you (time as well as space), that which surrounds you, hence your neighbors, and lastly the tomb: all these concepts are in the same semantic range.

The reference to the aquatic element, to wetlands, is also evident, because the neighbors referred to are usually the inhabitants of the north (the Delta wetlands), and by extension the Greeks from the islands that are surrounded by water. Finally, in ancient custom, the tomb was surrounded by a field of mystic reeds, the place from which all life emerges. Such life included fish, which were already symbolic and a necessary prey for rebirth.

ha	**behind**	*ḥ3*

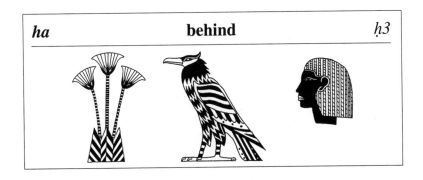

ha-oo	**the entourage**	*ḥ3w*

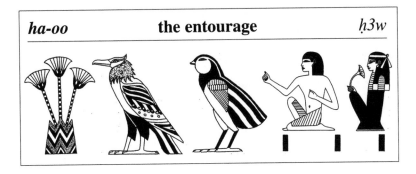

hot	**tomb**	*ḥ3t*

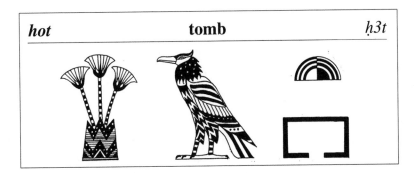

hom	**to fish, catch**	*ḥ3m*

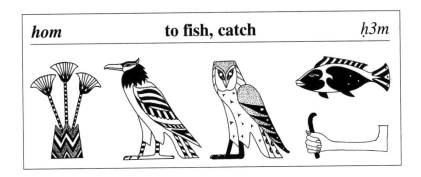

hedj

ḥḏ

Biliteral: A cluster of arms or club. Ideogram for "club."

PHONETICS AND WRITING

Pronunciation: lamp wick and quail.

1. hedjet — White crown, also shown as the determinative.

2. hedj — White (adjective), **luminous.** Determinative: the sun.

3. hedj — The break of day, to start out on a journey at sunrise. Determinative: sun and legs.

4. hedj — White club. Ideogram.

SEMANTICS

All that is white, luminous, even brilliant, is *hedj*, especially the white club, although we don't know what material was used to make it.

The four examples shown here are only the most well-known. White material and clothes are *hedj*, as are money, the treasury house, some chapels, sandals, the cornea, and onions; all of these are written as *hedj*, the determinative being the only distinction. Up to this point, nothing is negative.

On the other hand, the verb *hedji* has a negative connotation: to wound, destroy, disobey, overturn, cancel, eclipse, etc. — in other words, these are in line with the function of the club. Something white is not always pure: it may be bloodless, weakened, or non-existent. The Egyptians grasped both these elements of the concept "white": the radiance of life and the pallor of death.

hedjet	white crown	*ḥdt*

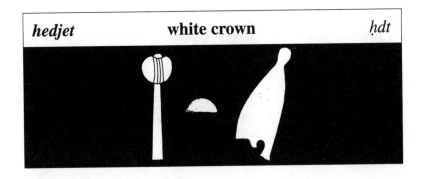

hedj	white	*ḥḏ*

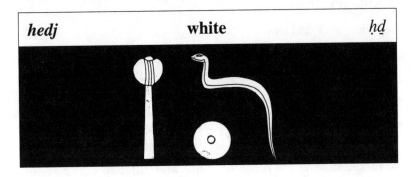

hedj	the break of day	*ḥḏ*

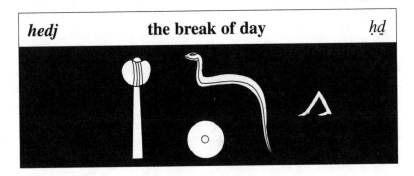

hedj	white club	*ḥḏ*

hem *ḥm*

Biliteral: A well or basin filled with water.

PHONETICS AND WRITING

Pronunciation: lamp wick and owl.

1. hemet nee-soot — Wife of the king, queen. Determinative: a queen. The hieroglyph for "king" is placed first in the written term by respectful inversion.

2. hemet — Wife, woman. Determinative: a woman.

3. hemooset — Counterpart, pendant; feminine form of *Ka*. Determinative: specific emblem, in this case a shield and crossed arrows.

4. hemes — To sit, take one's place by rank and title; to conceive, give birth to. Determinative: here a woman in childbirth.

SEMANTICS

The assimilation of the well with the uterus, and by extension with the reproductive organ of the woman, is a fundamental archetype of the human mind. It was not exclusive to the Egyptians, but they clearly expressed this concept through their writing. The same word is used to express the woman and the organ, with only the determinative that changes. From a biological point of view, they clearly understood that all life comes from water.

hemet nee-soot	**Queen**	*ḥmt n(y) śwt*

hemet	**woman**	*ḥmt*

hemooset	**female counterpart of Ka**	*ḥmwśt*

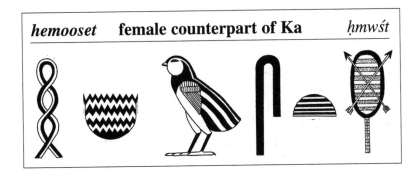

hemes	**conceive, give birth to**	*ḥmś*

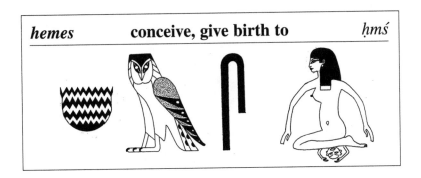

hem

ḥm

Biliteral: A laundry beater. Ideogram for a laundry beater.

PHONETICS AND WRITING

Pronunciation: lamp wick and owl.

1. hem-netcher — Servant of God = priest, divine prophet in general, sometimes with man as determinative.

2. hem-ka — Priest of *Ka* (of a deceased person). Determinative: man, usually without an image of the god.

3. hem — Man servant. Determinative: man.

4. hemet — Woman servant. Determinative: woman.

5. hem — King, Majesty. Determinative: in this instance the divine falcon (often written without a determinative).

SEMANTICS

This ordinary utensil of daily living, used to clean and launder, proceeds by some sort of chain reaction, up to full royal status!

As an instrument, it mainly indicates the function of the person using it, next those who are in the service of the divinity. Lastly, the same word designates the king, the most illustrious servant of the gods, and his parents, just as its feminine form designates the queen. Between the royal Majesties and their most humble slaves, it is only the determinative that makes a difference.

hem-netcher servant of god, prophet *ḥm-nṯr*

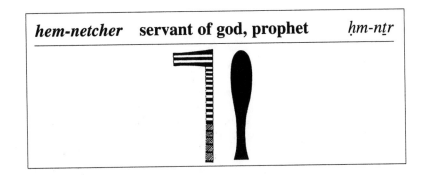

hem-ka Priest of Ka *ḥm-k3*

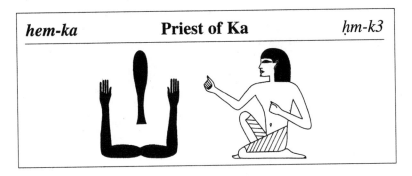

hem man servant | *hemet* woman servant *ḥmt*

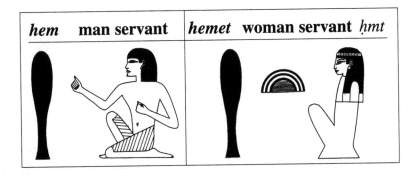

hem king, majesty *ḥm*

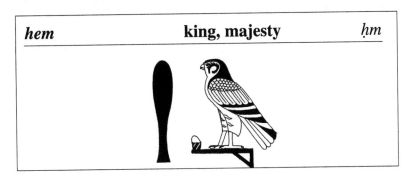

hen

ḥn

Biliteral: Plant with three flowering umbels.
Ideogram for the plant.

PHONETICS AND WRITING

Pronunciation: lamp wick and wavelets.

1. heni — Wetland plant, bulrush. Determinative: the plant.

2. henen — Phallus. Determinative: the phallus.

3. hen — To walk rapidly. Determinative: the legs in motion.

4. henzeket — Braided hair. Determinative: the thing itself.

SEMANTICS

The root *hen,* in general represented by the triple flower, is used in more than 90 words and their derivatives. They reflect a broad cross-section of ancient society, and often have greater phonetic than semantic connections. In the four samples given on the opposite page, there does appear to be a link between a braid of hair and the erotic element, phallus, and movement. The various terms that contain *hen* fall into almost every domain of daily living, of society, and of religion. *Henoo* even represents the sacred bark of the god Sokaris.

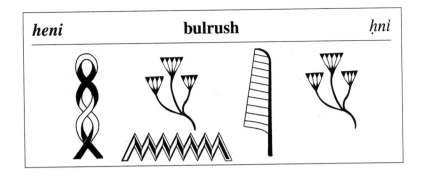

heni **bulrush** *ḥnỉ*

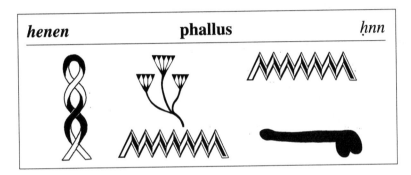

henen **phallus** *ḥnn*

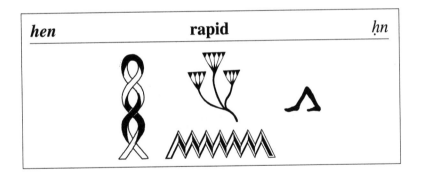

hen **rapid** *ḥn*

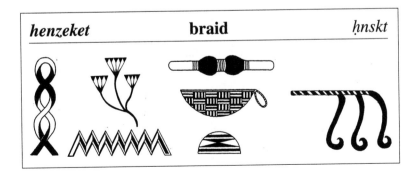

henzeket **braid** *ḥnskt*

her

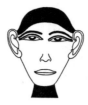

ḥr

Biliteral: The face of man, very rare in Egyptian art.
Ideogram for face.

PHONETICS AND WRITING

Pronunciation: lamp wick and mouth.

1. her — Face. Determinative: the usual way to write this term is with the vertical dash for identification; in this instance the determinative shown is a morsel or scrap of flesh.

2. hereret — Flower. Determinative: flowering plant.

3. heri-tep — Chief, superior, on the subject of, concerning, with regards to. Determinative: the vertical dash of identification.

4. heryoo-renpet — Epagomenal days: no determinative.

SEMANTICS

Anything that is directly facing, often with a connotation of hostility or fear of someone or something, and anything that is above (the sky, clearly, but also figuratively, a chief or superior) is written using this biliteral. The five epagomenal days on the solar calendar (those left over after the ancient calendar of 12 months of 30 days was completed) "over and above" the year, are deemed to be disastrous, even though they are the birthdays of Osiris family members.

her	**face**	*ḥr*

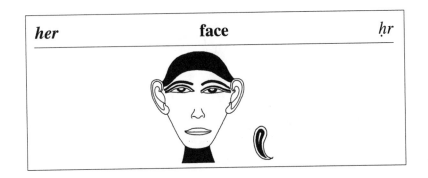

hereret	**flower**	*ḥrrt*

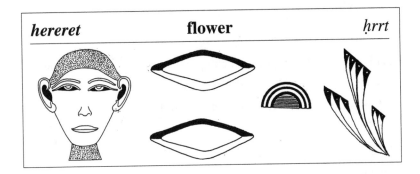

heri-tep	**chief, superior**	*ḥrỉ-tp*

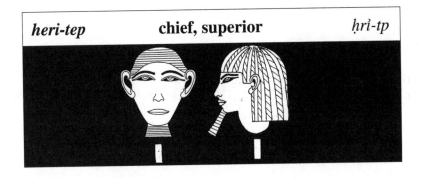

heryoo-renpet	**epagomenal days**	*ḥryw-rnpt*

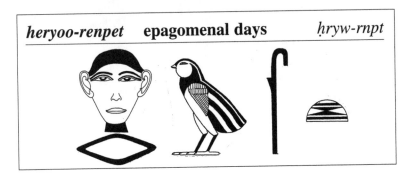

111

hes

ḥś

Biliteral: A vase or a bottle. Ideogram for same object.

PHONETICS AND WRITING

Pronunciation: lamp wick and material-cushion.

1. hes — Joy, rejoicing. Determinative: the papyrus roll (sign of an abstract idea), the man with his hand to his mouth, flower; no room for ambiguity here.

2. hesyoo — The venerable (blessed) departed, the favorites. Determinative: man, woman and three dashes for plural.

3. hesety — Praise; favor. Determinative: the man with hand to his mouth.

4. hesy — Praiseworthy, venerable, the favored one. Two determinatives: the man with hand to his mouth and an important dignitary.

SEMANTICS

All the expressions that contain this root or biliteral express feelings or actions that are positive or even joyful. This rejoicing is extended to the deceased who have been buried according to the rituals.

hes	**joy, rejoicing**	ḥś

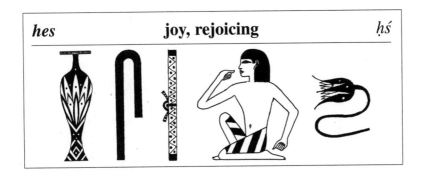

hesyoo	**the favorites**	ḥśyw

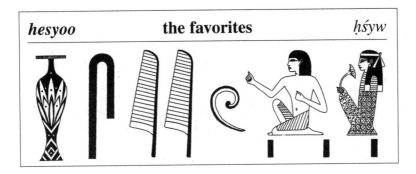

hesety	**favor**	ḥśty

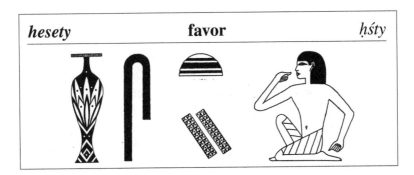

hesy	**the favored one**	ḥśy

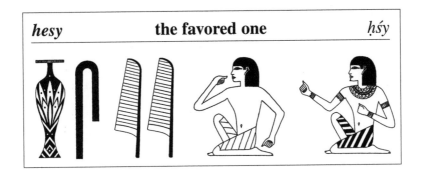

kha

ḫ3

Biliteral: A stylized lotus plant. Ideogram for the number 1,000.

PHONETICS AND WRITING

Pronunciation: placenta and vulture.

1. khabas — Firmament, starry sky. Determinative: three stars = plural.

2. khab — Hippopotamus. Determinative: the same animal.

3. khaset — Mountainous, desert-like, foreign country. Determinative: stylized mountain.

4. khasetyoo — Inhabitants of the desert, Bedouins, foreigners. Determinative: man and woman and plural.

SEMANTICS

It is easy to understand how the lotus, the flower of rebirth, relates to the firmament, and on a completely different level, to the animal that lives in the Nile and its wetlands. But what should we make of the lotus when it is used to graphically depict the mountains and desert, as well as their inhabitants? The link is more phonetic than semantic, as is the case for the multitude of words that are written with this biliteral. On the other hand, the plant — as a symbol for 1,000 — is easy to understand because of the great proliferation of lotuses in the waters of the Delta.

khabas	**firmament**	ḫ3b3ś

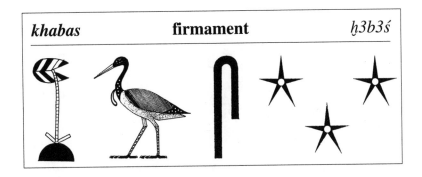

khab	**hippopotamus**	ḫ3b

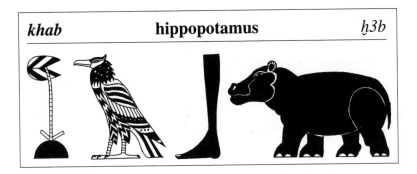

khaset	**mountainous, desert-like**	ḫ3śt

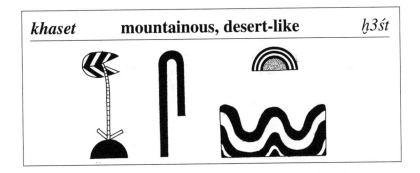

khasetyoo	**Bedouin**	ḫ3śtyw

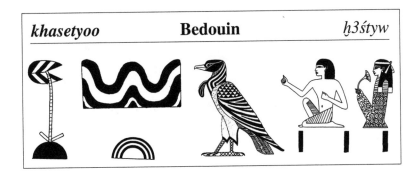

khah h^c

Biliteral: Stylized image of a hill illuminated by the first rays of dawn.
Ideogram for hill at sunrise.

PHONETICS AND WRITING

Pronunciation: placenta and forearm-hand.

1. khah-oo — Crown. Determinative: here the blue crown, but other crowns may also appear as determinatives.

2. khah-ee — Rise, shine, appear (stars, the king on his throne). Determinative: papyrus roll (sign of an abstract idea).

3. khah-oo — Weapons, utensils in general; funeral accoutrements. Determinative: wood and plural.

4. khah-moo — Throat, neck. Determinative: head or neck of a long-necked horned animal, strip of flesh.

SEMANTICS

This hieroglyph refers to the primordial hillock that emerged from the abyss at the invocation of the creative force, which was as radiant as a new sun.

All the words associated with this biliteral have the same connotation. To rise or appear, depending on the determinative used, may be related to a cosmic phenomenon or to the appearance of the king in full regalia, or even the birth of a child. Arms and accoutrements, whether made from wood, leather, or metal, shine as they are raised; the same word is used to designate certain goddesses. Lastly, to see or be seen, you sometimes have to stretch your neck.

khah-oo	crown	$\underline{h}^c w$

khah-ee	rise, shine	$\underline{h}^c i$

khah-oo	weapons	$\underline{h}^c w$

khah-moo	throat	$\underline{h}^c mw$

khet

ḫt

Biliteral: A branch without leaves.
Ideogram: Wood, tree, and linear measure = 100 cubits.

PHONETICS AND WRITING

Pronunciation: placenta and bread.

1. khetyoo — Platform, podium, terrace (whether natural or built into a mountain). Determinative: terrace, stairway.

2. khet — Through (a barrier, a country, time, etc.). Determinative: legs in motion. The same writing is used for the verb "to withdraw."

3. khet — Tree, wood. Determinative: identity dash.

4. kheti — To engrave, snip; the engraver, seal, to seal. Determinative: chisel and arm with weapon (for the noun).

SEMANTICS

This biliteral provides the root for more than 80 different words that are directly derived from the basic concept: wood, branch, tree. Wood, a construction material, is used to make canes, which are attributes of authority and administration. When you think the meaning through, you'll see how this root could as easily refer to a military campaign as to the rejoicing of an entire people. The engraver's chisel, plunged into wood, is another example. Lastly, the various species of trees used medically are indicated by an appropriate determinative.

khetyoo	terrace	ẖtyw

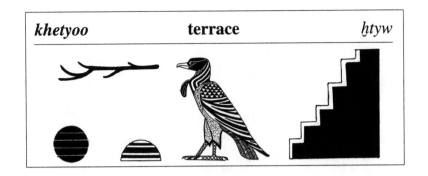

khet	through	ẖt

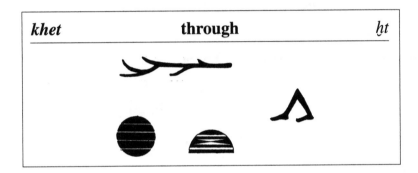

khet	wood	ẖt

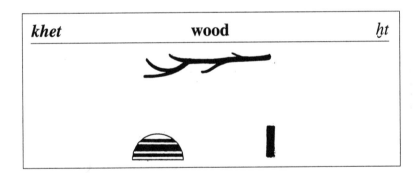

kheti	to engrave	ẖtỉ

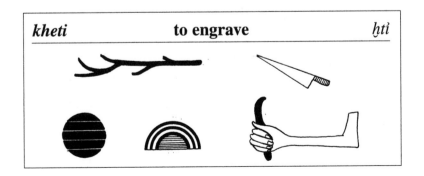

khoo

ḥw

Biliteral: Arm and hand carrying the flagellum.
Ideogram meaning "to protect."

PHONETICS AND WRITING

Pronunciation: placenta and quail.

1. Khoofoo — Cheops. No determinative, but in this instance, surrounded by the royal cartouche.

2. khoo — Protection, to protect. Determinative: papyrus roll (sign of an abstract idea).

3. khoo — Fan. Determinative: the object.

4. khoo-see — To pack for brick making, build with bricks. Determinative: Man packing alluvium into a brick mould.

SEMANTICS

The arm bearing the flagellum is a divine and royal insignia, representing power, used more for protection than subjugation, as indicated by the name Cheops. Vigorous action is expressed through the verbs "to pack," "ram," "flatten" — always used in a constructive sense. The same idea is contained in the word "to govern." The root *khoo* appears in priestly titles and royal and divine epithets (such as Hathor).

Khoofoo	**Cheops**	*Ḥwfw*

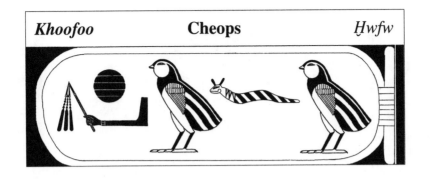

khoo	**protection**	*ḫw*

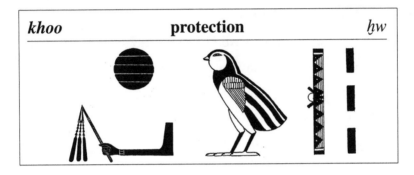

khoo	**fan**	*ḫw*

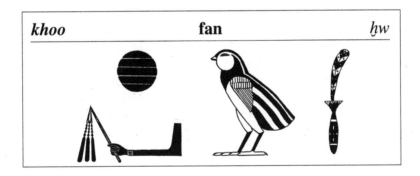

khoo-see	**to build**	*ḫwśỉ*

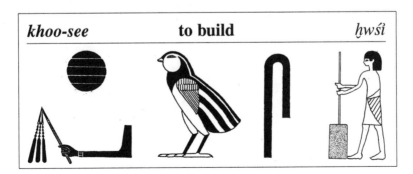

B 25

kha ḫ3

Biliteral: The mako shark (mormyrid fish).
Ideogram (with final t) for mormyrid fish.

PHONETICS AND WRITING

Pronunciation: belly of mammal and vulture.

1. khakhati — Storm and tempest. Determinative: rainy sky and lightning.

2. khat — Cadaver. Determinative: blister.

3. khar — Bag. Determinative: the object itself.

4. kharet — Widow. Determinative: woman.

5. khat — Mako shark. Determinative: the fish.

SEMANTICS

The mako shark was hardly a source of happy thoughts for the ancient Egyptians. The odor must have been the basis for the parallel between the fish and the cadaver. The idea of death is also intrinsic to "widow," with its connotation of abandonment and loss of protection. It is interesting to note that the term "widower" does not exist. Everything that is deformed, deviant, reprehensible, and physically and morally ugly can be linked to this root. The hostile forces of nature are expressed in the expression for "storm" — which also means extreme royal anger.

khakhati **storm** *ẖ3ẖ3tî*

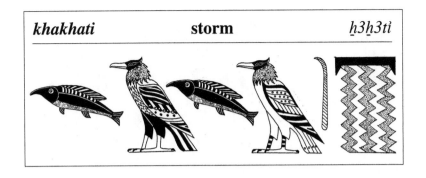

khat **cadaver** *ẖ3t* **khar** **bag** *ẖ3r*

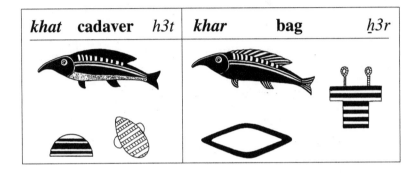

kharet **widow** *ẖ3rt*

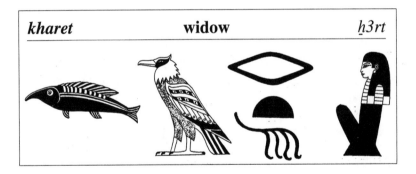

khat **Mako shark, mormyrid fish** *ẖ3t*

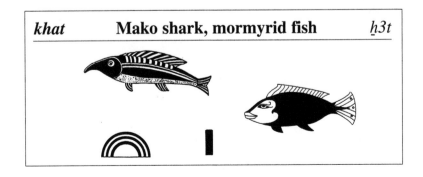

khen

ẖn

Biliteral: Animal carcass (without head).

PHONETICS AND WRITING

Pronunciation: mammal hide and wavelets.

1. khenoo — Interior (of a house, or medically), dwelling residence. Determinative: house plan.

2. khen — To approach. Determinative: legs in motion.

3. khenoo — Stream, stretch of water, canal, desert well. Determinative: water.

4. khenootyoo — Foreign people (dressed in animal skins?), primitive people. Two determinatives: animal skin, man, plural; written with the triliteral *tyoo*.

SEMANTICS

The interior is the fundamental idea underlying this sign: house, body, recipient, and anything else that can be filled. There is a kind of relationship between a carcass and foreign peoples, thought to be primitive and dressed in animal skins. There is also a similarity between the idea of moving water and approach. The skin of an animal can be sewn into a bag, a wineskin, or protective clothing, which is also suggestive of the dwelling, but the similarities are often more phonetic than semantic.

khenoo	**interior**	*ḫnw*

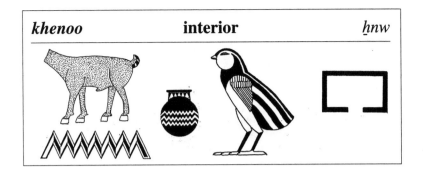

khen	**approach**	*ḫn*

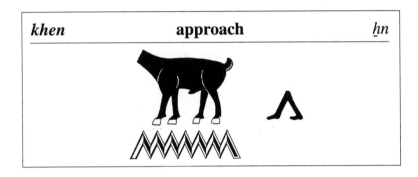

khenoo	**stream**	*ḫnw*

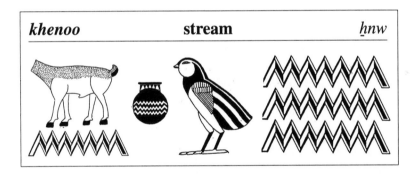

khenootyoo	**primitive people**	*ḫnwtyw*

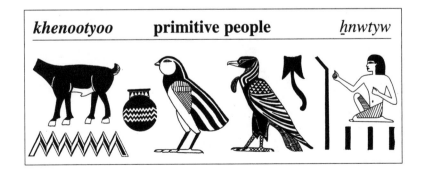

125

khen

ḫn

Biliteral: Nicely stylized drawing of the shoulder and two arms handling an oar.

PHONETICS AND WRITING

Pronunciation: mammal belly and wavelets.

1. khenet — Procession on river, travel by water. Determinative: ritual bark.

2. kheni — To row (often in opposition to traveling by sail). Determinative: ritual bark.

3. khenen — To disturb, intervene, unsettle, provoke disorder, confound, irritate (also medically speaking). Determinative: animal associated with Set.

4. khenty — Statue, image (originally: divine statue used in the procession on water). Determinative: statue.

SEMANTICS

The rhythmic movement of the oarsmen, who proceed toward their goal, plowing through the fluid element of water, suggests a variety of ideas. First of all, the rowing action as opposed to wind and sail propelled the movement, and the *khentyu* are mariners. Processions on the river occurred mainly during major religious festivals, when the statue of the divinity being honored was taken from its temple with great pomp and placed in the ceremonial bark. The idea of turbulence is linked to the unpredictability of water currents as well as the action of the oars, the regular and relentless motion of which is suggestive of the idea of harassment, as indicated in the determinative, the image of the spoil-sport god, Set, the *khenenoo.*

khenet	**procession on river**	*ẖnt*

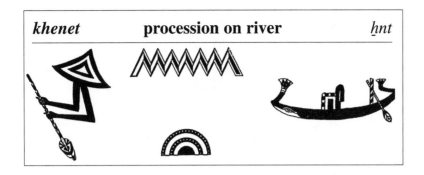

kheni	**to row**	*ẖnỉ*

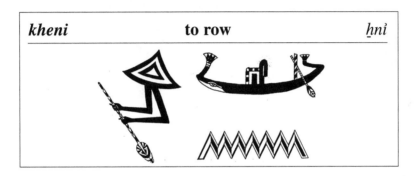

khenen	**to disturb, unsettle**	*ẖnn*

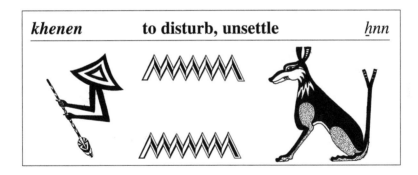

khenty	**statue, image**	*ẖnty*

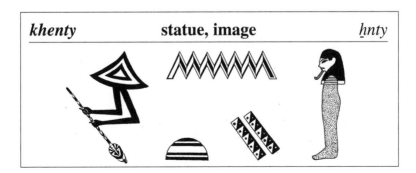

kher

ḥr

Biliteral: The butcher's block.

PHONETICS AND WRITING

Pronunciation: mammal belly and mouth.

1. kheret — Property, possession, portion, lot, due. Determinative: papyrus roll (sign of an abstract idea) and plural.

2. kheroo — Under, base, lower part. Determinative: irrigation canal, irrigated land.

3. kherooy — Male genitals. Determinative: testicles (stylized image).

4. kher — Base (preposition): under, supporting, bearing, holding. Determinative: none.

SEMANTICS

This frightful sign generates only harsh and utilitarian ideas. The main idea is that of holding, possessing, or dominating the things or creatures that are below; by extension things that are held become property. The thought of quartering an animal on the butcher's block leads to the idea of part or portion, as well as to the idea of a parcel of land or an irrigated portion. The oldest word in the language of the pharaohs for testicles is perfectly connected to these concepts. Finally, the idea of cadavers on the butcher block is reflected in the term *kheret-Netcher,* the necropolis (city of the dead).

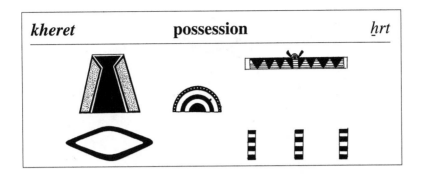

kheret **possession** *ẖrt*

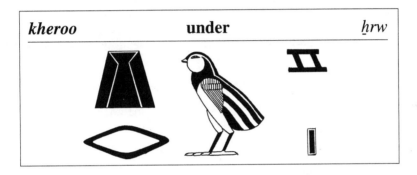

kheroo **under** *ẖrw*

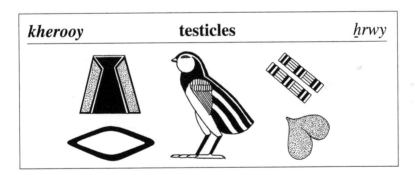

kherooy **testicles** *ẖrwy*

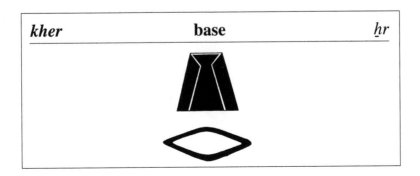

kher **base** *ẖr*

129

een *in*

Biliteral: In the form of a fish; *tilapia nilotica* is its scientific name.

PHONETICS AND WRITING

Pronunciation: reed and wavelets.

1. eenet — a. Valley; b. tilapia fish. Determinative: a. symbol of countryside valleys; b. the fish (not shown here).

2. eenem — Human or animal skin (the latter, in this instance). See the determinative.

3. eeneb — Wall, to wall in. Determinative: a wall for the noun, a wall and the arm with weapon for the verb.

4. eeneh — a. To surround, close in, develop, to set in gold (the rim of a container). Determinative: rope and arm bearing weapon; **b. eyebrows.** Determinative: stylized eyebrows (not drawn here).

SEMANTICS

This biliteral commands a broad semantic palette. The valley gets deeper, and is suggestive of the waves in which the fish thrives. The skin is emptied of its contents. Vital water surrounds the fish, like a protective wall, but also keeps it prisoner.

The metallic edge reinforces the rim of the container, like the eyebrows above the eyes.

eenet	valley	int

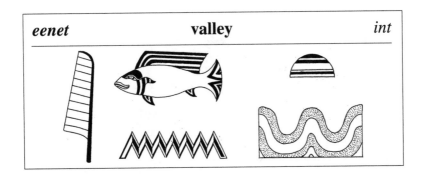

eenem	animal skin	inm

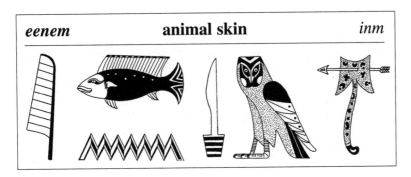

eeneb	wall	inb

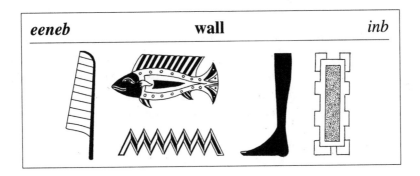

eeneh	to surround, develop	inḥ

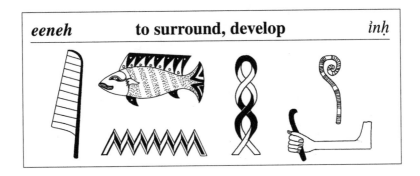

131

eer *ir*

Biliteral: Representing the human eye. Ideogram for "eye."

PHONETICS AND WRITING

Pronunciation: reed and mouth.

1. eeret — Eye. Determinative: the identification dash.

2. eeree — To do, make, create, engender, construct, etc. without determinative.

3. eertyoo — Blue (adjective) color. Determinative: grain of sand or colored mineral and plural.

4. eeret — Milk. Determinative: pitcher of milk.

5. eeret em eeret — Eye for eye. Determinative: identification dashes.

SEMANTICS

The eye is both the supreme organ of perception and a powerful energy emitter. It is indispensable in normal life. It is not surprising that it is used to write one of the fundamental verbs for all activity — "to do" and its various derivatives, including to engender and give birth to. Birth then triggers lactation by the mother, hence *eeret*, milk.

Linen was dyed blue for certain occasions. Linen, cloth, and shroud give rise to the verb "grieve."

Eye for eye needs no comment.

eeret eye *irt*	*eeree* to do *iri*

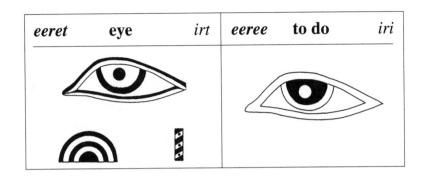

eertyoo	blue	*irtyw*

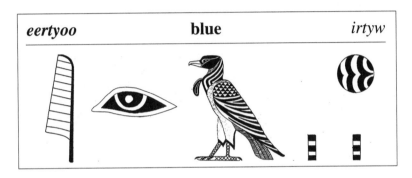

eeret	milk	*irt*

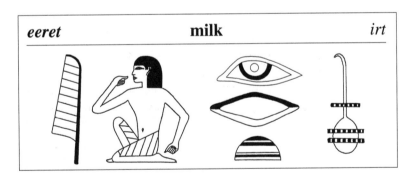

eeret em eeret	eye for eye	*irt m irt*

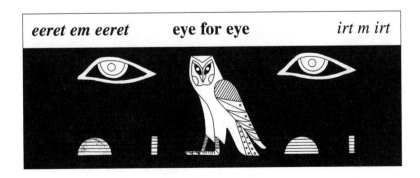

ees

is

Biliteral: A bundle of reeds.

PHONETICS AND WRITING

Pronunciation: reed and cushion-cover (or bolt).

1. eesoot — Crew (boat, workers), company (military). Determinative: man.

2. eesoo — Reeds. Determinative: plant and plural.

3. ees — Tomb; council room. Determinative: construction, house.

4. eesoot — Olden times. Determinative (surprisingly): plant.

SEMANTICS

The basic concept: that which is bound, gathered together, closed, body; crews, stand of rushes, administrative body, councilors.

That which is bound, assembled is also a construction: the tomb, and in the feminine with a different determinative, the royal palace.

In connection with its customs and mores, society has always cast its gaze over time to that which is remote, ancient. This brings up thoughts of things that are old, that may be materially worn out, old age, decrepitude, slowness (figuratively) and so on.

eesoot	crew	*iśwt*

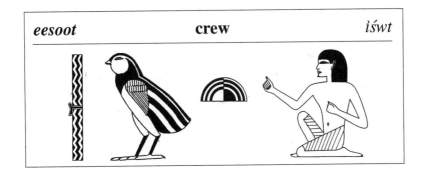

eesoo	reeds	*iśw*

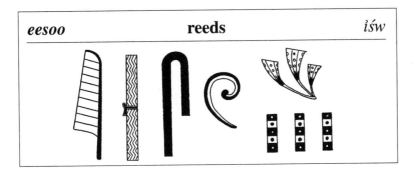

ees	tomb	*is*

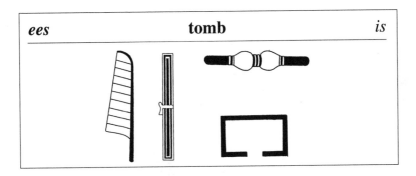

eesoot	olden times	*iśwt*

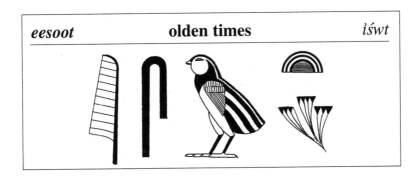

yoo *iw*

Biliteral: A newborn antelope that still has its umbilical chord. Ideogram for cattle.

PHONETICS AND WRITING

Pronunciation: reed and quail.

1. yoonen — Sanctuary. Determinative: house.

2. yooaht — Heritage, inheritance. The determinative is very expressive: hind of beef, papyrus roll (sign of an abstract idea), and plural. The hind of beef is pronounced *iouâ*.

3. yoosoo — Balance. Determinative: branch; the image of a balance may also serve as determinative.

4. yoohoo — Flooding. Determinative: water.

SEMANTICS

The words shown on the facing page all have positive semantic links. Heritage, *youaht*, is the most savory of all, meaning also heir or "heiress," without the determinative or the idea of the abstract. An inheritance is a collection of goods that have to be assessed and weighed, and flooding is the source of the country's wealth. As for the sanctuary, the connection seems to be more phonetic, even though temples were the depositories of various sorts of riches.

Here is a short list of other words that contain the same sign: to cry (derived from flooding), the wailer, to moisten, to irrigate, to impregnate. Other semantic branches contain such verbs as "to harm," "to burden someone with a load," etc. Lastly, the plate of meat; to reward four-legged animals.

| *yoonen* | **sanctuary** | *iwnn* |

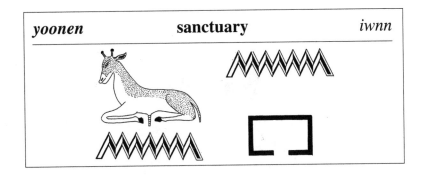

| *yooaht* | **heritage, inheritance** | *iwct* |

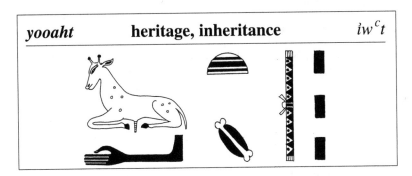

| *yoosoo* | **balance** | *iwśw* |

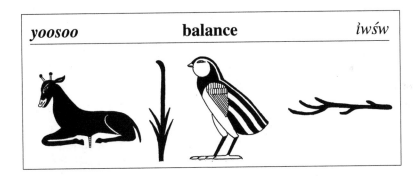

| *yoohoo* | **flooding** | *iwḥw* |

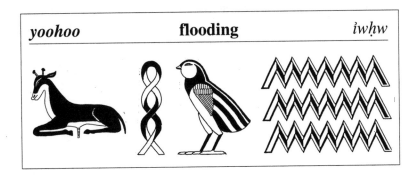

137

ka *k3*

Biliteral: Two stylized arms and hands. Ideogram for *Ka*.

PHONETICS AND WRITING

Pronunciation: basket and vulture.

1. ka — Metaphysical double for the person and his reproductive energy, his essence, the vital force of life. Determinative: identification dash.

2. kar(i) — Temple (naos), chapel. Determinative: chapel.

3. ka — Bull. Determinative: bull and phallus.

4. ka-oo — Fruits, figs. Determinative: phallus, fruit, and plural.

5. kat — Female genitals. Determinative: uterus of cow.

6. kat — To work, construct. Determinative: man bearing load on his head.

7. kahm(oo) — Garden. Determinative: canal and identification dash.

SEMANTICS

There is an obvious semantic link between these seven words. The energy double of a person, which is revealed after his death as a result of the rituals, is part of the same register as *naos*. The bull is another facet of the human *Ka*. Its fecundity, the fruits of the garden, and the irrigated plot of land all have a sexual connotation, which is expressed clearly in the word *kat*, the female genitals. Change the determinative and the word becomes a verb: to work, to build, and other related ideas.

ka the vital force of life *k3*	**kar(i)** chapel *k3r(i)*

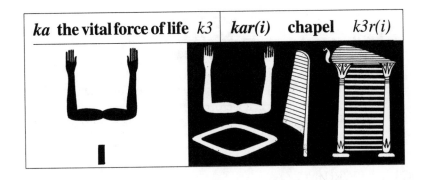

ka bull *k3*	**ka-oo** the figs of the sycamore *k3w*

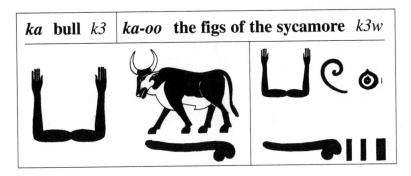

kat female genitals *k3t*	**kat** to work (construct) *k3t*

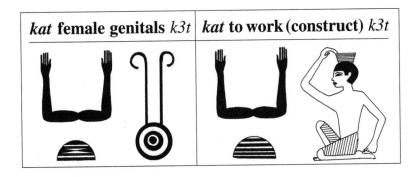

kahm(oo) garden *k3m(w)*

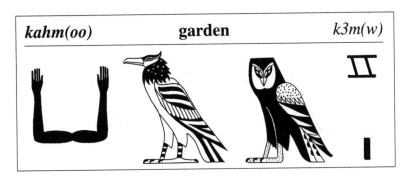

kem

Biliteral: A very stylized fragment of crocodile hide
(or is it a crocodile claw?)

PHONETICS AND WRITING

Pronunciation: basket and owl.

1. kemet — Black earth = Egypt. Determinative: city plan.

2. kemet — Egyptians. Determinative: man, woman, plural.

3. kemeet — Conclusion (of writing, book). Determinative: papyrus clasp.

4. kemi — To complete, finish, achieve. Determinative: papyrus roll (sign of an abstract idea).

SEMANTICS

This word initially appeared in the word *ikem,* "shield," hence it is easy to understand the association with the crocodile. But how it became a synonym for black is a mystery. But this being said, *kem* is used for everything that even remotely resembles black. From the fertile black soil of Egypt (almost black), rich in micro-organisms, the alchemy of life unfolds. This term belongs to Ancient Egyptian. The black country, the *Kemet,* is opposed to the reddish-yellow country: *Desheret,* the desert. The inhabitants of cultivated lands are the *Kemet* or *Kemetyoo.*

The conclusion of a document, written in black ink, ending the work, has the same semantic connotation.

kemet — Egypt — *ḳmt*

kemet — Egyptians — *ḳmt*

kemeet — conclusion — *ḳmyt*

kemi — to total, complete — *ḳmi*

ked *ḳd*

Biliteral: An unidentified tool, probably made from wood and used in construction (to make bricks?). It has also been suggested that it might represent a grain measure or (our suggestion) a potter's blade. The sign also serves as an ideogram.

PHONETICS AND WRITING

Pronunciation: the sand dune and the hand.

1. ked — To sleep, sleep. Determinative: eye.

2. ked — To build, construct, mold, make. Determinative: a mason at work.

3. kedoot — Sketches, paintings. Determinative: papyrus roll (sign of an abstract idea) and plural.

4. ked — Builder, potter, mason, with no determinative in its oldest form. Determin-ative in this instance: man.

SEMANTICS

This vaguely defined hieroglyph is in all likelihood a typical tool, which in our opinion was used to smooth clay, to shape bricks in the brick mould and to shape pottery on the potter's wheel. Potters use the same methods today. This hieroglyph appears in *ked*, potter. It is such an important word that in the Pyramid texts it appears alone with no determinative.

The sketch artist is none other than the "scribe who shapes the forms drawn out," the *sech kedoot.*

There are many related terms: to create beings (divine action), to create a function, a title (royal action), a custom (social action).

Finally, after so much activity, it is time to sleep — unless sleep, the father of dreams, was also a creator — however virtual — for the ancient Egyptians.

ked	**to sleep**	*ḳd*

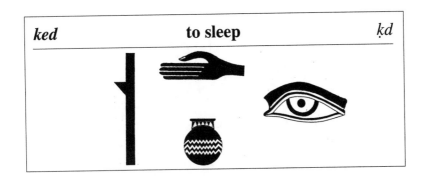

ked	**to build, construct**	*ḳd*

kedoot	**sketches**	*ḳdwt*

ked	**builder**	*ḳd*

kes

ḳś

Biliteral: A harpoon made out of bone.
Determinative for anything made of bone and its derivatives. Ideogram for "bone."

PHONETICS AND WRITING

Pronunciation: sand dune and cushion cover.

For reasons unknown, this sign may read as *gen* in a few rare words. We suggest that this is a misinterpretation, which came about from hieratic writing, of the determinative of the tree branch, *genoo.*

1. kes — Bone. No determinative, only the identification dash.

2. kesenet — Ill, pain, woe, trouble, difficulty. Determinative: bird of ill omen (sparrow).

3. kesen — Painful, troubling, difficult, dangerous, outrageous, evil. Determinative: bird of ill omen.

4. kezen — Painful condition, suffering, trouble, danger. Determinative: harpoon.

SEMANTICS

All words related to bone contain this biliteral. The harpoon, whose role is to attack, wound, and to cause pain, and ultimately death, is also used as a determinative for sarcophagi, bury, burial, and funeral accoutrements.

That the sign is also read as *gen* is seen in *genoot,* archives or annals, and in *genooty,* sculptor.

kes	**bone**	*ḳś*

kesenet	**pain, suffering**	*ḳśnt*

kesen	**painful**	*ḳśn*

kezen	**painful condition, situation**	*ḳsn*

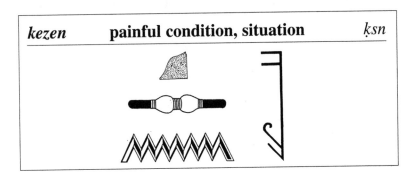

ma *m3*

Biliteral: The sickle. Ideogram: poop deck
(sometimes the prow of a ship) shaped like a sickle.

PHONETICS AND WRITING

Pronunciation: owl and vulture.

1. ma-a — To see, look at, notice, discover; vision. Determinative: eye (unusual position).

2. ma-aht — Truth, justice, balance. Determinative: feather, *maat,* and papyrus roll (sign of an abstract idea).

3. ma-ah-kheroo — Of just voice = one who speaks the truth, justified, victorious. Determinative: the man with hand to his mouth.

4. ma-ee — Lion. Determinative: lion.

SEMANTICS

The particular form of the bow and stern of processional barks is indeed suggestive of the sickle. It subsequently became, for phonetic reasons, the biliteral-root for all words referring to vision and truth, both figuratively and literally. Maat is the name of the goddess of cosmic balance. The deceased, judged as "of just voice" by the Tribunal of Osiris, placed his heart in the balance, against the feather of Maat: if it balanced, he was justified. Other derivatives: to guide, direct, sun rays, etc.

The lion *ma-ee* and the lioness *ma-eet* are included for phonetic reasons.

ma-a	**to see, look**	*m33*

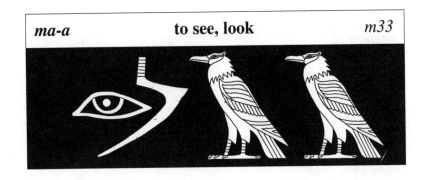

ma-aht	**truth, justice**	*m3ct*

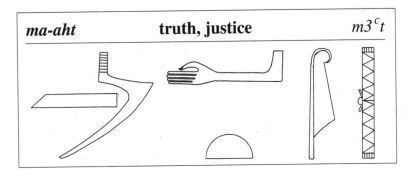

ma-ah-kheroo	**justified**	*m3c-ḫrw*

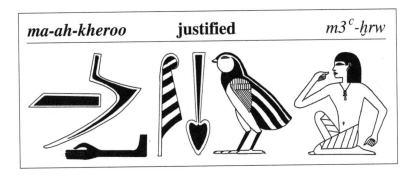

ma-ee	**lion**	*m3ỉ*

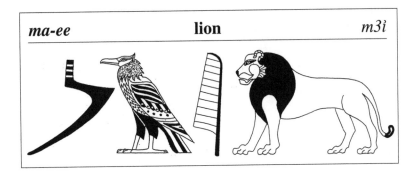

meh *mḥ*

Biliteral: A whip; ideogram for "arm."

PHONETICS AND WRITING

Pronunciation: owl and lamp wick.

1. mehoo — Wetlands of Lower Egypt, the black lands of the North; Determinative: papyrus plant.

2. mehy — Guardian. Determinative: armed man.

3. meh — To hold, seize. Determinative: arm bearing weapon.

4. meh-eeb — Confident, literally, he who fills the heart. Determinative: papyrus roll (sign of an abstract idea).

5. Meheneet — The coil; serpent-goddess Mehenyt, especially borne by the gods around the forehead, the uraeus of the king. Determinative: serpent.

SEMANTICS

The pronunciation of this biliteral gave rise to several semantic families. The first is based on the ideogram for the arm, which was used as a measurement; the cubit. The arm, the grasping or holding hand, and a guardian must have an arm with a weapon. The term "to fill" belongs to the same family as flow, flood, the *meheet,* and figuratively means "to fill the heart" with ideas and feelings, as well as "to fill" the lunar eye of Horus. The movement of water probably inspired words such as "to coil" and the coil, the epithet of the uraeus.

Lastly, the wet swamplands and the fields surrounding the Delta designate the North. The plants that thrive there? Papyrus.

mehoo	**Lower Egypt**	*mḥw*

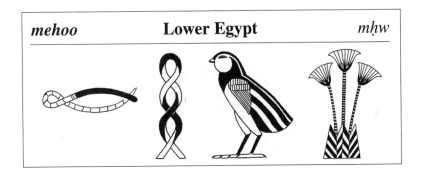

mehy	**guardian**	*mḥy*

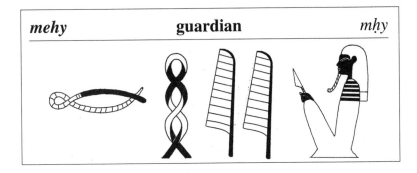

meh **to hold** *mḥ*	*meh-eeb* **confident** *mḥ-ib*

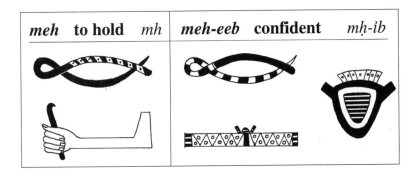

Meheneet	**Mehenyt (goddess)**	*Mḥnyt*

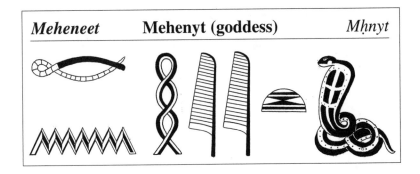

mee *mi*

Biliteral: A jar of milk and the rope by which it is suspended.

PHONETICS AND WRITING

Pronunciation: owl and reed.

1. meen — Today, currently. Determinative: sun.

2. meow — Cat, tomcat. Determinative: cat or skin of a mammal.

3. mee — Metal ring. Determinative: identification dash and plural, crucible (or potter's kiln), and ring.

4. semee — Report, make a report, complain, announce, proclaim, accuse; reception. Determinative: the man with hand to his mouth.

SEMANTICS

The root *mee* means "like" or "equal to" and expresses an entire range of derivative meanings. Hence, "today" means to be equal to the sun of the day, or "current." The words "cat" corresponds to the cry made by the animal (clearly a bit of onomatopoeia); a report is the faithful account of the events that took place at the time of the report.

Mee, meaning metal ring, is a bit of a maverick in this semantic group. Another series of ideas is linked to liquid and contains the words "fruit juice" and "beverage."

meen	**today**	*min*

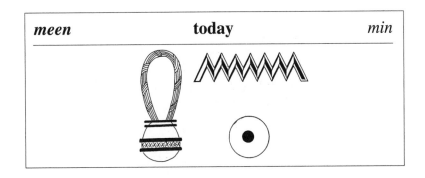

meow	**cat**	*miw*

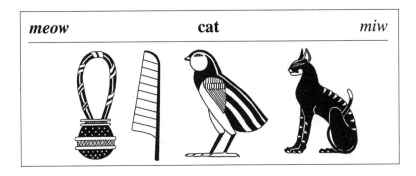

mee	**metal ring**	*mi*

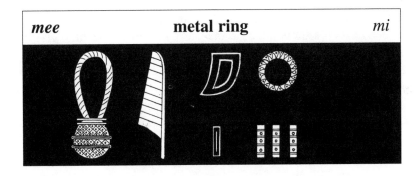

semee	**report, to bring back**	*śmỉ*

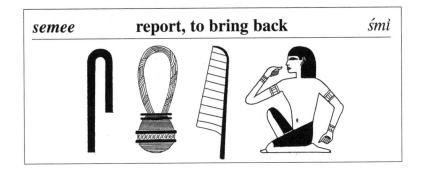

men *mn*

Biliteral: In plain view and elevated view, a chess board and the pawns.
Ideogram for *mene*t = game (board).

PHONETICS AND WRITING

Pronunciation: owl and wavelets.

1. Men-nefer — Memphis. Determinative: pyramid and city plan.

2. Men-kaow-Ra — Mycerinus. Determinative: the cartouche.

3. menoo — Monument(s). Determinative: none, only the triple plural.

4. men-hedj — The scribe's palette. Determinative: the palette and accessories.

SEMANTICS

The biliteral that means, first and foremost, to be strong, stable, enduring, etc., is used to write a variety of words that are not necessarily linked semantically. The city of Memphis is enduring because of its monuments (note the pyramid!), like the departed shades of Mycerinus and monuments in general. The scribe's palette takes us along a different line of meaning. What should we make of the name of the god *Menthu*, of Hathor's pendant (*meneet*), of the wet nurse's breast (*menaht* — there is a clear semantic link between the latter two words), of the fan, and even of disease — to cite just a few examples that are written with this biliteral and that differ only by the phonemes and determinatives that are added?

Men-nefer	Memphis	Mn-nfr

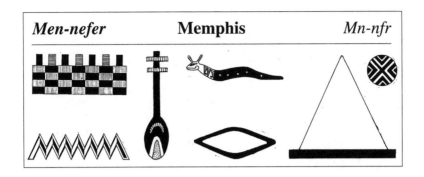

Men-kaow-Ra	Mycerinus	Mn-k3w-R^c

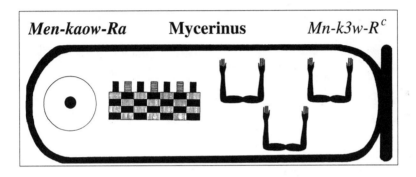

menoo	monuments	mnw

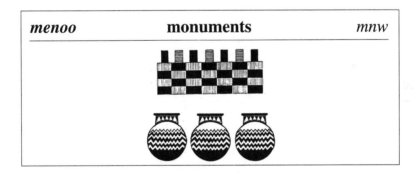

men-hedj	the scribe's palette	mn-ḥḏ

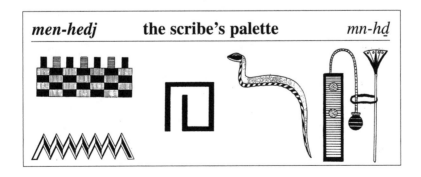

mer *mr*

Biliteral: A burin, an engraving tool.

PHONETICS AND WRITING

Pronunciation: owl and mouth.

1. mer — Pyramid. Determinative: pyramid.

2. semeroo — Friends, court title, courtiers. Determinative: nobleman and plural.

3. mer — Epithet of Set. Determinative: image of Set.

4. meret — Disease, pain. Determinative: bird of ill omen (sparrow).

SEMANTICS

The stone engraver uses a burin, which is appropriate for the pyramid. On the other hand, we would expect to see the following sign (hoe – *mer*), for courtiers.

If the burin is very useful for working in stone, it is certainly very painful when used to carve living flesh! We then understand why this range includes such words as sick, disease, pain, suffering, etc. As the pyramid was used as a tomb, the concept of grief can also be found in these expressions: Nephthys — "she who grieves for Osiris" — and the serpent-goddesses, who spit fire and burned all in their path, literally and figuratively. It is only logical to include the god Set.

meroot	**love**	*mr*

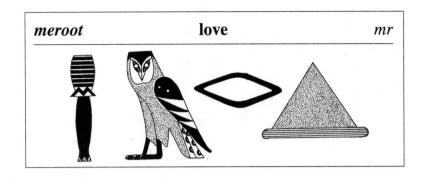

ta mery	**cherished earth, Egypt**	*t3 mry*

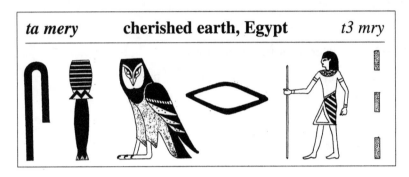

meri	**to love**	*mri*

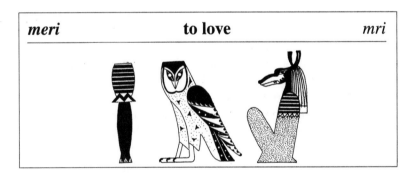

mer	**jar**	*mr*

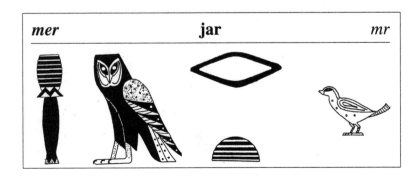

mer

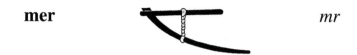

mr

Biliteral: A wooden plough (backward) for "hoe."

PHONETICS AND WRITING

Pronunciation: owl and mouth.

1. meroot — Love. Determinative: the man with hand to his mouth.

2. ta mery — The cherished earth = Egypt. Determinative: city plan and a naked palm branch placed on mouth (as well as the phonetic complement *ri*).

3. meri — To love, desire, wish. The determinative: the man with his hand to his mouth.

4. mer — Milk jar. Determinative: vase.

SEMANTICS

The biliteral, *mer,* representing a hoe (compare preceding biliteral, burin) depicts a long list of concepts that, on the whole, are positive. "To love," "the beloved," "the cherished one," are the most well-known, along with the "cherished earth," Egypt.

The milk jar falls into the category of words representing cosmetics and food: pastry, dishes, oils, balms, fats, etc. From this series, there is a transfer, via balms, to terms related to death, mummification, putrefaction, as well as funeral shrouds. There is also a link to rituals: temple singers and their divine patrons are also *meret.*

mer	**pyramid**	*mr*

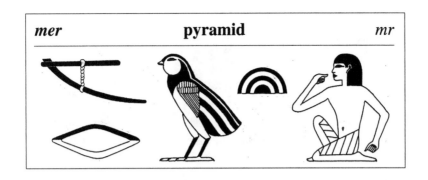

semeroo	**courtiers**	*śmrw*

mer	**Epithet of Set**	*mr*

meret	**disease, pain**	*mrt*

mes

mś

Biliteral: Stylized image depicting three fox (or jackal) skins attached together; the front portion of a loincloth? G-string? Ideogram of the object meset.

PHONETICS AND WRITING

Pronunciation: owl and cloth cushion.

1. mesoot — Birth. Determinative: woman in childbirth.

2. meses — Clothing, tunic. Determinative: a tie (link).

3. mesdjer — Ear. Determinative: the ear of a bovine.

4. mestepet — Catafalque, portable sanctuary (*naos*). Determinative: branch or *naos* on a sleigh.

SEMANTICS

This biliteral is contained in most terms related to birth, descendants, childhood, and produce. Certain ties, events, as well as anything used as a cover are written with this unusual sign.

Neither the divine nor the celestial escape the semantic poetry inherent in becoming: *Meskhenet* is the goddess of childbirth. At the opposite extreme of life is found the catafalque. The same term is also related to the naos used in the procession of divinities. *Mesekhtyoo* is the Big Dipper; *meseket* is the Milky Way.

What about the ear? The term is found mostly in medical or magic texts for mothers and children.

mesoot	**birth**	*mśwt*

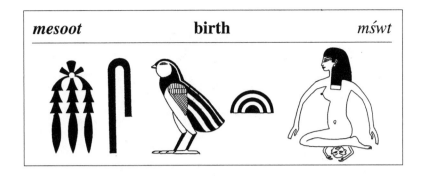

meses	**tunic**	*mśś*

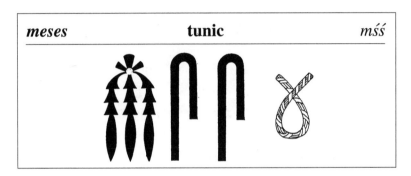

mesdjer	**ear**	*mśḏr*

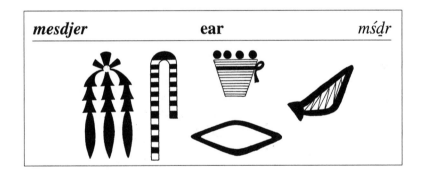

mestepet	**portable sanctuary**	*mśtpt*

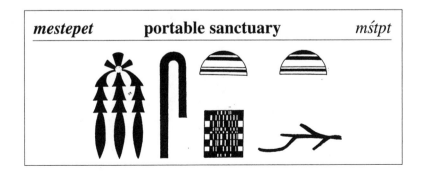

met 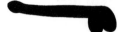 *mt*

Biliteral: Male genitals.

PHONETICS AND WRITING

Pronunciation: owl and bread.

1. metmet — To discuss, discussion. Determinative: ear and the man with hand to his mouth.

2. metet — The exact, precise moment (= noon). Determinative: sun and identification dash.

3. meteroo — Witness, attestation, document. Determinative: fingers and the man with hand to his mouth.

4. mety-haty-eeb — To be courageous, brave (to "have a stalwart heart"). Determinative: plural.

SEMANTICS

The organs depicted by this glyph lend themselves to several semantic applications:

◈ that which is in front, close to
◈ virility, phallus, man, courage, and figuratively, son
◈ flow of liquids (serpent venom; flooding), sounds or voices (witnesses)
◈ tube-shaped organs used to transport air or liquids
◈ precision, exactness, straightforwardness
◈ renown, reward.

metmet	**to discuss**	*mtmt*

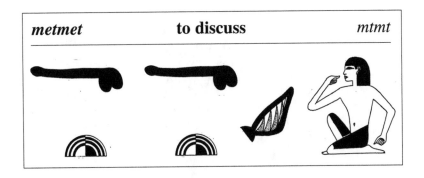

metet	**exact moment**	*mtt*

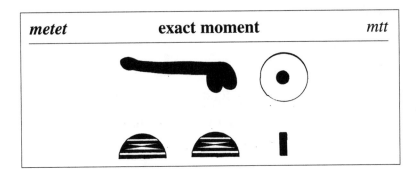

meteroo	**witnesses**	*mtrw*

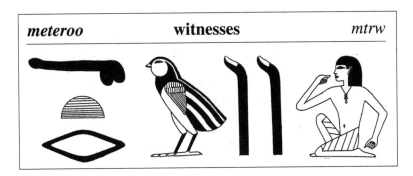

mety-haty-eeb	**courageous, brave**	*mty-ḫ3ty-ib*

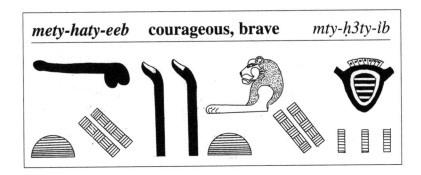

161

moo

mw

Biliteral: Troubled waters with successive waves.
Ideogram for water.

PHONETICS AND WRITING

Pronunciation: owl and quail.

1. moo-oo — Ritual dancers. Determinative: the dancers.

2. moo — Water, seed, and any bodily fluid. Determinative: none. Ideogram.

3. moo-n(oo)-pet — Rain: literally, water from heaven. Determinative: sky.

4. moo-(n)-Ooseer — Divine essence of Osiris. Determinative: mummy.

SEMANTICS

Water, the divine miracle of creation, suggests numerous comparisons. Pure water is the water at the beginning of the year that coincides with the return of the "fathers and mothers" from the country (the gods, especially Osiris).

Water can fall from heaven: rain is rare in Egypt, but can be violent.

The annual flooding is a symbol of renewal. During funerals, the *moo-oo,* (the dancers), imitate a rite that is based on the Osiris cycle.

moo-oo **ritual dancers** *mww*

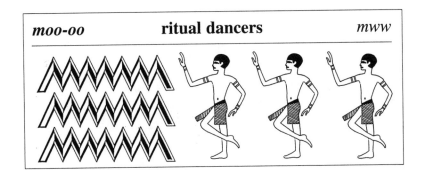

moo **water** *mw*

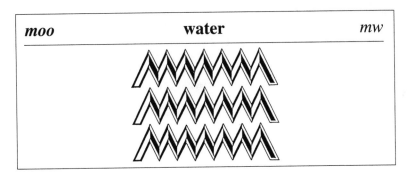

Moo-n(oo)-pet **water from heaven, rain** *mw-n(w)-pt*

moo-(n)-Ooseer **essence, seed of Osiris** *mw-(n)-Wśir*

163

neb *nb*

Biliteral: Outline of a wicker basket.
Ideogram for basket: master, lord.

PHONETICS AND WRITING

Pronunciation: wavelets and legs.

1. nebty — The two ladies, patron goddesses of Upper and Lower Egypt. No determinative.

2. neb-er-djer — The Master of All (the universe). Determinative: a god.

3. neb ahnkh — The Master of Life = euphemism for sarcophagus.

4. neb — Master, lord. Determinative: identification dash.

SEMANTICS

You might wonder why the lowly symbol of a basket represents such lofty terms. In our opinion, it is for phonetic reasons. Nonetheless, the concept of "container' can be seen in the sarcophagus, as well as in the "whole," such as a god, a goddess, or even a king.

The two ladies are perched, each on a basket: they dominate everything. Nekhbet, the vulture-goddess of Upper Egypt, and Uto, the serpent-goddess of Lower Egypt, introduce the third name of the royal protocol and represent the red and white crowns, the twin powers, or *pa-sekhemty,* which in Greek transcription, becomes *pschent.*

nebty	**the two ladies**	*nbty*

neb-er-djer	**Master of the Universe**	*nb-r-ḏr*

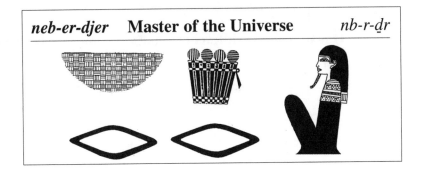

neb ahnkh	**sarcophagus**	*nb ᶜnḫ*

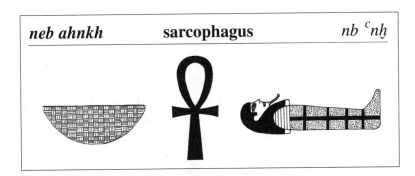

neb	**master, lord**	*nb*

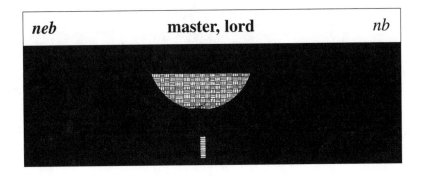

neb *nb*

Biliteral: A large gold and pearl necklace.
Ideogram for "necklace" and "gold"; determinant for gold, silver.

PHONETICS AND WRITING

Pronunciation: wavelets and legs.

1. Nebeet — City of Ombos, now called Kom-Ombo. Determinative: city plan.

2. neboo — Gold. Determinative: melted nugget and plural.

3. neboo — The Golden: Hathor. Determinative: divine serpent.

4. nebeet — Gold necklace. Determinative: none.

5. nebi — To forge metal and to cast in moulds. Determinative: metallurgist at work.

SEMANTICS

Due to its nature, this sign is not used extensively. In daily life, it is used to designate anything made from precious metal (gold, silver, amber, natural white gold, etc.), the techniques for casting metal, and the products into which precious metals are transformed. The King's treasure is stored in the "House of Gold" and the "House of Silver."

The flesh of the gods is gold and their bones are silver; the sun radiates golden rays; sunlight is the gold of heaven.

Nebty, the Ombite is an epithet of the god, Set, whose sanctuary is located in the city of Ombos.

The second name of the royal protocol is introduced with the epithet, the "Golden Horus."

Nebeet	the city of Ombos	*Nbyt*

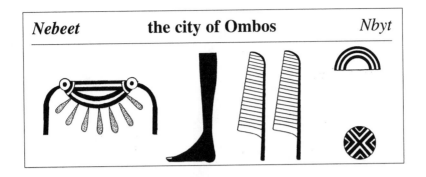

neboo gold *nbw*	*neboo* The Golden: Hathor *nbw*

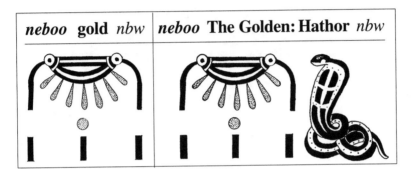

nebeet	gold necklace	*nbyt*

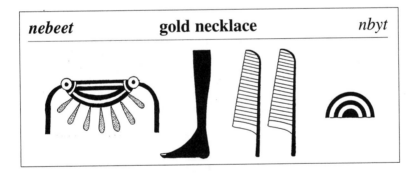

nebi	to cast metal	*nbi*

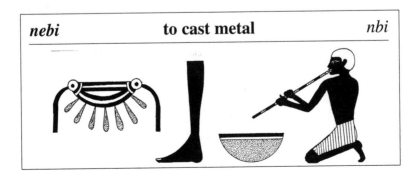

nedj

nḏ

Biliteral: Uncertain identification: mill? tool?

PHONETICS AND WRITING

Pronunciation: wavelets and cobra.

1. nedjnedj — To seek counsel, to ask, inquire. Determinative: the man with hand to his mouth.

2. nedj — To consult, seek information, inquire about news. Determinative: the man with hand to his mouth.

3. nedj — a. Grind grain, rub, grate, stir; b. protect, save someone. Determinative: arm with weapon, for both expressions.

4. nedj-r — To ask advice of someone. Determinative: identification dash.

5. nedj-her — Greet a person; to pay homage or tribute (to); to pay one's respects; make a gift or donation. Determinative: Papyrus roll (sign of an abstract idea).

.

SEMANTICS

The first meaning of this hieroglyph is to grind grain: the "mill" and the "miller" are the same terms. Flour is food and is brought to the mouth. Inquire and seek information, nourish the mind; these are semantically and figuratively linked.

The arm with weapon suggests protection. To be advised, nourished, and protected creates obligations of mutual respect and courtesy, as expressed in the final example.

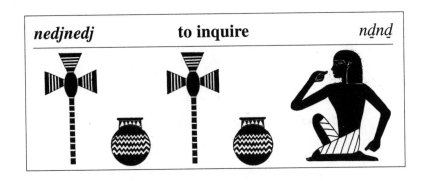

nedjnedj to inquire *nḏnḏ*

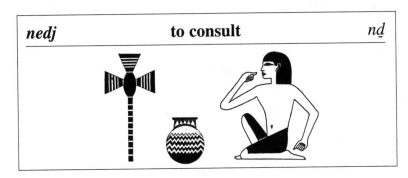

nedj to consult *nḏ*

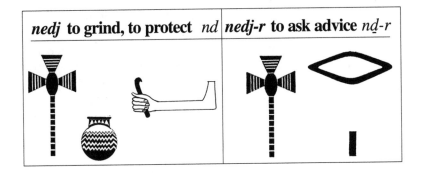

nedj to grind, to protect *nd* | *nedj-r* to ask advice *nḏ-r*

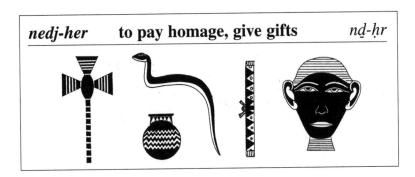

nedj-her to pay homage, give gifts *nḏ-ḥr*

169

neh *nḥ*

Biliteral: A guinea fowl *(numida m. meleagris).*

PHONETICS AND WRITING

Pronunciation: wavelet and lamp wick.

1. neheh — Eternity; forever (adverb). Determinative: the sun.

2. nehebet — Lotus bud. Determinative: the lotus.

3. nehebet — Neck, yoke (for man or beast). Determinative: morsel of flesh.

4. nehet — Prayer, vow. Determinative: the man with hand to his mouth.

SEMANTICS

It may be possible to establish a link between eternity and the lotus of rebirth.

The pliant stem of the lotus may be compared to the neck of humans and animals (especially animals for the slaughterhouse). The idea of the yoke has the same semantic root.

An different semantic aspect is evidenced in the term "prayer" or "vow," which suggests a link with certain deities, notably the protective serpents, whose names share the same root. Lastly, the Egyptians neighbors to the south are the *Nehesy* or the Nubians.

neheh	**eternity**	*nḥḥ*

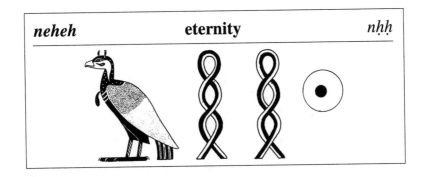

nehebet	**lotus bud**	*nḥbt*

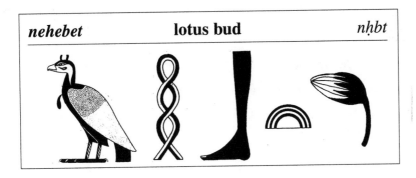

nehebet	**neck**	*nḥbt*

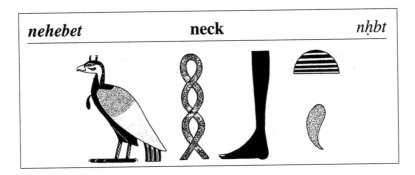

nehet	**prayer, vow**	*nḥt*

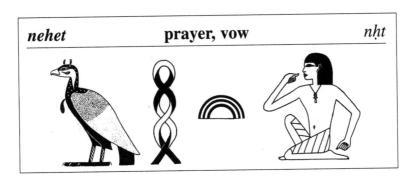

nem

nm

Biliteral: A butcher's knife. Ideogram for knife.

PHONETICS AND WRITING

Pronunciation: wavelets and owl.

1. nem — Dwarf. Determinative: dwarf.

2. nemes — Wig, royal or divine headdress. Determinative: same.

3. nemnem — To be moved, tremble, shiver. Determinative: legs in motion.

4. nemah — To lie down, fall asleep (also figuratively). Determinative: funeral bed.

SEMANTICS

The samples shown here do not reveal any clear semantic links. The knife might be linked to one who trembles from fear, and figuratively with the idea of falling asleep, especially as the determinative is a funeral bed. The famous nemès, the royal headdress for the king, being transformed, might also be appropriate in this place.

The closest word to knife is *nemet* meaning slaughter (not shown here).

As for "dwarf," the only link we can see is the phonetic link.

nem	dwarf	*nm*

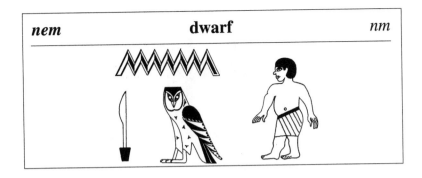

nemes	**royal or divine headdress**	*nmś*

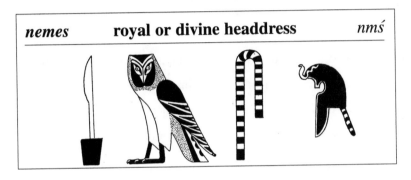

nemnem	**to be moved, tremble, shiver**	*nmnm*

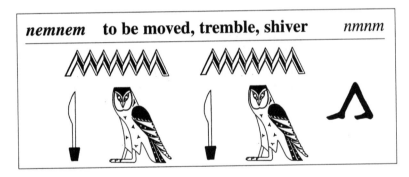

nemah	**to fall asleep**	*nmc*

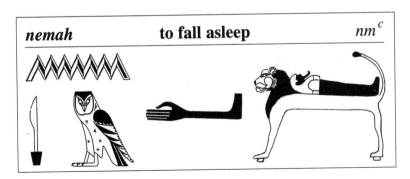

173

nen

nn

Biliteral: Two stylized rushes with foliage.

PHONETICS AND WRITING

Pronunciation: wavelets twice.

1. neny — To be tired, fatigued, inert. Determinative: man slumped down.

2. nenet — Low sky. Determinative: reversed image of sky.

3. nen — This, that, these, those. Determinative: none.

4. nenyoo — Inert people = the deceased. Determinative: man slumped over, "death" sign and plural.

SEMANTICS

Except for expressing demonstrative adjectives and in the old name of Hierakonpolis (*Nenynesut*), most terms containing this sign are related to the idea of death. The phase preceding death, characterized by fatigue, exhaustion, and lassitude, is described in terms like "to drag one's feet," "to lose one's balance," etc. For liquids, you find the same word, meaning "to taste," which comes from a slower paced life.

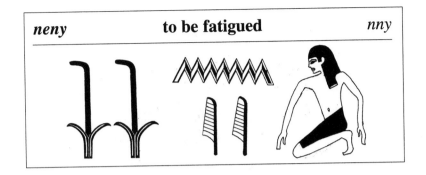

| *neny* | **to be fatigued** | *nny* |

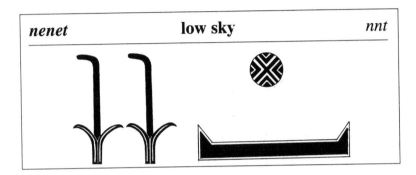

| *nenet* | **low sky** | *nnt* |

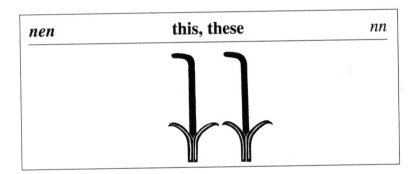

| *nen* | **this, these** | *nn* |

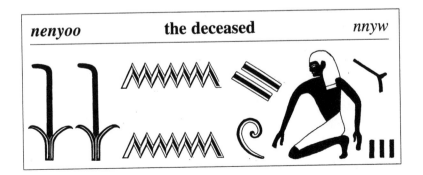

| *nenyoo* | **the deceased** | *nnyw* |

nes *nś*

Biliteral: The outline of a tongue.

PHONETICS AND WRITING

Pronunciation: wavelets and cushion cover.

1. neser — Flame. Determinative: lighted lamp.

2. neset — Seat, throne. Determinative: base of jar.

3. nes — Tongue. Determinative: morsel of flesh and identification dash.

4. neseb — To lick. Determinative: the man with hand toward mouth.

5. nesyoot — Arm, javelin, lance. Determinative: metal crucible and dash.

SEMANTICS

Neset, the seat, seems to be distinct from other words related to tongue. The organ is also compared to a knife — words can injure. This is likely the base for the word javelin, the arm hurls an object at a distant target.

The serpent's tongue is said to spit fire; figuratively a flame.

As for lick, the link with tongue is clear.

neser	**flame**	*nśr*

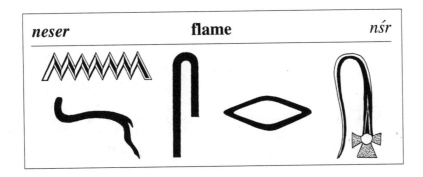

neset	**throne**	*nśt*	nes	**tongue**	*nś*

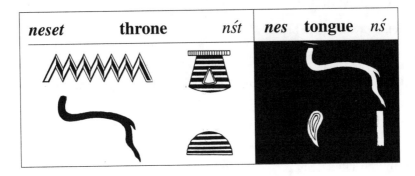

neseb	**to lick**	*nśb*

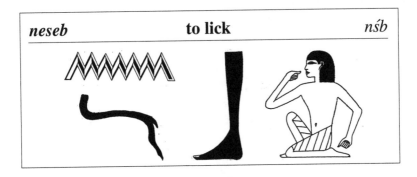

nesyoot	**javelin**	*nśywt*

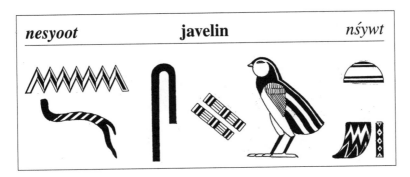

net *nt*

Biliteral: Two bows joined in a sheath. Ideogram for the goddess Neith.

PHONETICS AND WRITING

Pronunciation: wavelets and bread.

1. Neith — The goddess Neith. (the vowel *i* comes from the Greek).

2. Netikrety — Nitocris, divine Adorer. Determinative: the adorer.

SEMANTICS

This biliteral is used only to describe the name of the goddess. She is the warrior goddess and virgin; by the latter feature she resembles Nitocris: the mystic wife of Amun, who could not unite with any mortal.

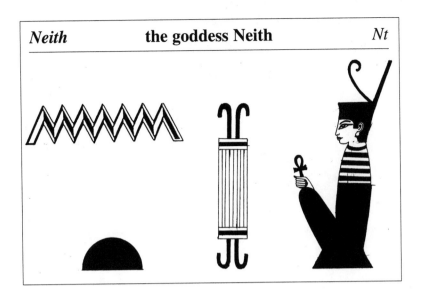

Neith the goddess Neith *Nt*

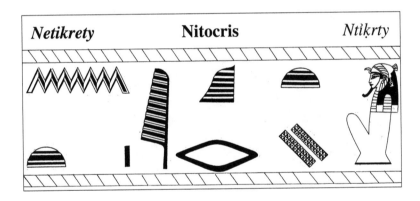

Netikrety Nitocris *Ntiḳrty*

noo *nw*

Biliteral: A globe-shaped vase.
Ideogram: the same vase or bowl, which is sometimes made from metal.

PHONETICS AND WRITING

Pronunciation: wavelets and quail (or spiral).

1. noot — Nut, goddess of the sky. Determinative: Nut, integrated into the glyph.

2. noo-oon / nenoo — Primordial waters. Determinative: water.

3. noo — Time, duration. Determinative: the sun.

4. manoo — The Western Mountain. Determinative: the mountain.

SEMANTICS

This biliteral is found in a variety of words, many of them clearly related to daily living: son, cloth, ropes; prejudice, hunting grounds, ointment, perfume, etc. Among these, we can distinguish those that have a religious or cosmic meaning, as in the four examples shown here.

The goddess of the sky, Nut, the primordial waters personified by the god Nun, the mountain of the setting sun that is swallowed by Nut in the evening and from him reborn in the morning. Finally, concepts of time are determined by the alternation between day and night.

Noot	**Nut, the sky goddess**	*Nwt*

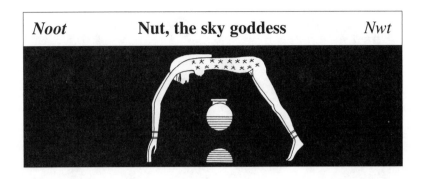

noo-oon / nenoo	**primordial waters**	*nww(n) / nnw*

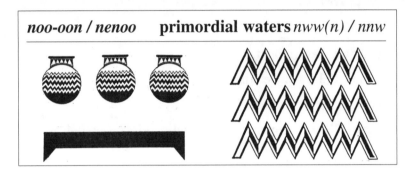

noo	**time**	*nw*

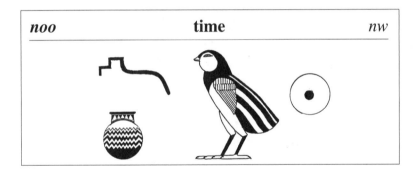

manoo	**the Western Mountain**	*m3nw*

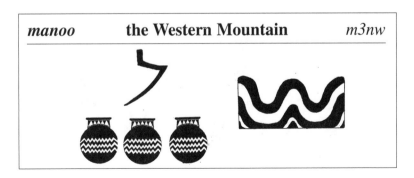

pa *p3*

Biliteral: A pintail duck *(dafila acuta)* in flight.

PHONETICS AND WRITING

Pronunciation: footstool and vulture.

1. pa — To fly, fly off. Determinative: wing.

2. pa-oot — Primordial time. Determinative: wing.

3. pakh — To claw, rip. Determinative: none.

4. Pakhet — Clawed beast, ripper: Pakhet, lion-goddess. Determinative: lion.

SEMANTICS

The semantic connection between time and flight is well established, but here we are dealing with "primordial time," which came before creation, when time did not exist. Hence, gods from this mysterious era were known as *pa-ooty*.

Pakh and the goddess *Pakhet* are derived from the same root. There is no doubt that she defended herself with her claws — and her teeth! She is a local manifestation (*Speos Artemidos*) of the goddess Sekhmet, also linked with time.

| pa | to fly | p3 |

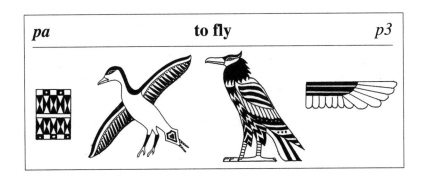

| pa-oot | primordial time | p3wt |

| pakh | to claw, rip | p3h |

| Pakhet | Pakhet, lion-goddess | P3ḫt |

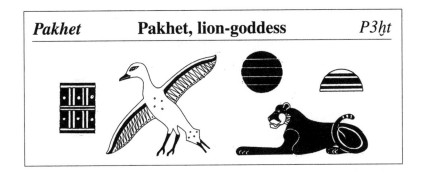

peh *ph*

Biliteral: The hind quarters of a feline (lion, leopard, cheetah).

PHONETICS AND WRITING

Pronunciation: footstool and lamp wick.

1. pehoo — Wetlands; swamps, flood prone land, cultivated lands. Determinative: canal.

2. pehty — Physical force, power. Determinative: arm with weapon.

3. peharooey — Missionary, envoy, ambassador. Determinative: man walking.

4. peh-eeb — To reach, to attain your heart's desire. Determinative: papyrus roll (a sign of abstraction).

SEMANTICS

All vocabulary containing this sign is related to physical force. The image is eloquent: the prodigious ability of felines to pounce comes from the strength of their hind quarters, legs, claws, and tail (as a rudder). The verbs to attain, reach, finish off, conquer, strike, etc., express these fundamental concepts. Strength of character is required from envoys on a mission, which may be perilous — and also if you are to be successful in attaining your heart's desire.

On a more banal level, *peh* is used in words meaning rear, anus, buttocks, and figuratively, the end, rear guard, the decans, or the last ten days of a constellation.

pehoo	**swamps**	*pḥw*

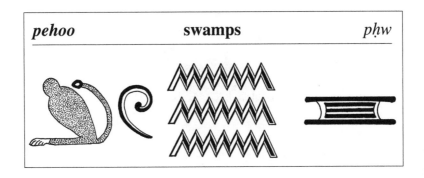

pehty	**force, power**	*pḥty*

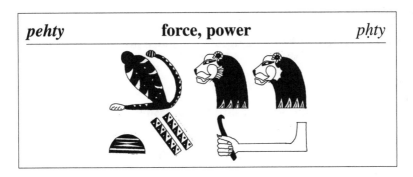

peharooey	**missionary**	*pḥ3rwy*

peh-eeb	**reach your heart's desire**	*pḥ ỉb*

per

pr

Biliteral: A basic "house plan."

PHONETICS AND WRITING

Pronunciation: stool and mouth.

1. per-ahnkh — "House of Life," scriptorium, place of teaching in temple. Determinative: house.

2. per — To go out. Determinative: legs walking.

3. peret — Egyptian winter season; ritual procession (same graphic). Determinative: the sun.

4. peret sepedet — Heliacal rising of Sirius. Determinative: star.

5. pery — a. Hero, champion. Determinative: man; **b. Wild bull.** Determinative: the bull.

SEMANTICS The house is the basis of words constructed with this biliteral. The "House of Life" is a section of the temple. The (Double) Great House (*Pa-per-ah* from which Pharaoh is derived) is the royal palace. The House of Gold, House of Silver, the king's treasury, etc., follow the same pattern.

On a more modest level, *per* also refers to a private home, from which are derived words meaning heritage, administration, house of the king, and family, in the widest sense of the term. A house is not just a dwelling place, but also a location where there is coming and going. The Egyptian peasant would see the first shoots of his new crop in winter.

At a cosmic level, the heliacal rising of Sirius, after 70 days, during which it was invisible, was equated with the return of the goddess Sothis (Sepdet). The same idea is expressed in the procession of the goddess.

Last of all is the hero, who has to gather up all his courage to prepare his sortie as a combatant or contestant, like the bull rushing into the arena.

per-ahnkh **House of Life** *pr c nḥ*

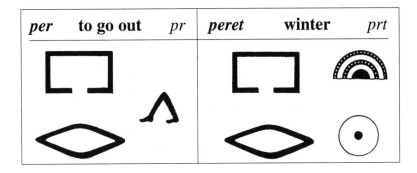

per **to go out** *pr* **peret** **winter** *prt*

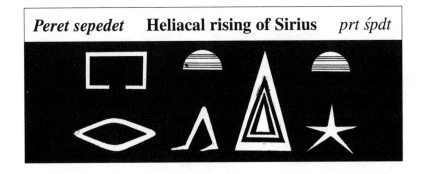

Peret sepedet **Heliacal rising of Sirius** *prt śpdt*

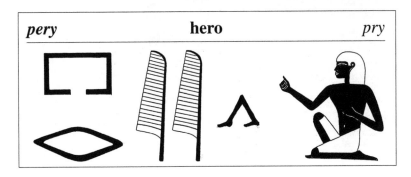

pery **hero** *pry*

roo *rw*

Biliteral: A crouching lion.
Ideogram for "lion" (*maï* = standing lion).

PHONETICS AND WRITING

Pronunciation: mouth and quail.

1. Rooty — The two lions (Shoo and Tefnoot). No determinative needed as it is understood from the glyph.

2. roo-eet — Court of Justice, seat of administration. Determinative: house.

3. roo — Calumny, injury, malice. Determinative: papyrus and man wounding himself.

4. rooah-ee — Iron(?), instrument made from metal. Determinative: knife.

SEMANTICS

The Two Lions are Shoo and Tefnoot, but if the house appears as the determinative, the meaning shifts to the "lions' den."

The court of justice, calumny, and metal (in this case, the knife) all fall within the same semantic range, all are various forms of constraint.

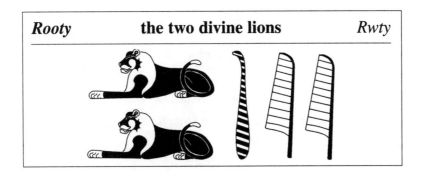

Rooty — the two divine lions — *Rwty*

roo-eet — court of justice — *rwyt*

roo — calumny, insult — *rw*

rooah-ee — metal — *rw3y*

189

sa / za

s3

Biliteral: A pintail duck *(dafila acuta)*.

PHONETICS AND WRITING

Pronunciation: latch (originally) or cloth cushion and vulture.

1. sah — Son. Determinative: man.

2. saht — Daughter. Determinative: woman.

3. sah Rah — Son of the Sun (name from the royal titulary). Determinative: none; the sun is sufficient.

4. Hesaht — Hezat, the celestial cow. Determinative: the image of the same cow.

SEMANTICS

The particular reason, other than phonetic, why the meaning "son" was associated with this biliteral is unknown.

The son of the god Re is clearly the king. This name is the last of the "five great names" of the king; it was introduced into the royal titles during the 5th Dynasty.

The phonetic occurrence of *za / sa* in the hieroglyph is used for the celestial cow, Hezat.

sah	**son**	*s3*

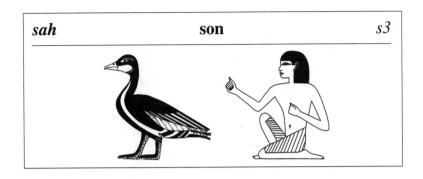

saht	**daughter**	*s3t*

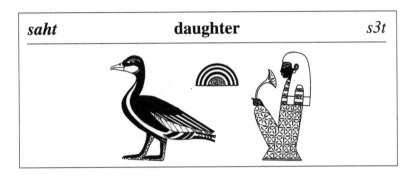

sah Râh	**son of the Sun**	*s3-Rc*

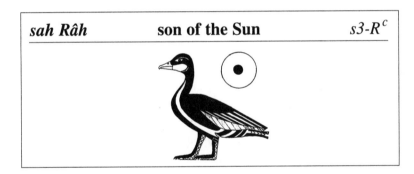

Hesaht	**the celestial cow**	*Ḥs3t*

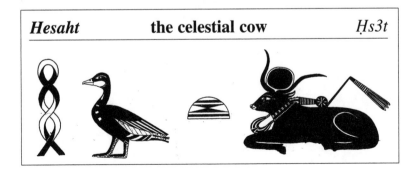

za / sa *s3 / s3*

In addition to B 59, two other biliterals are required to reproduce the sound *za* or *sa*.
The first represents a woven mat or the tent of a shepherd that has been rolled up and tied; the
second is an enclosure for cattle. One is the ideogram for the "herdsman's tent," and the other for
the cattle pen. The two signs are often interchangeable.

PHONETICS AND WRITING

Pronunciation: bolt (or cloth cushion) and vulture.

1. sa-oo — Magician. Determinative: man.

2. sa — Protection, surveillance, guarding. Determinative: papyrus and plural.

3. Sa-oot — Egyptian name for the city of Lycopolis. Determinative: city.

4. sa-oo — Priestly order. Determinative: man.

SEMANTICS

The tent is protection; the bolt is a restraint or immobilization.

From the idea of protection, we get: guard, surveillance, an amulet made by a magician,
a walled city that provides protection but which also shuts you in. The concept of protec-
tion is also reflected in *za-oo:* which on the one hand is physical implying armed guards
(the verb *sa-oo*) with, as determinative, a man carrying a stick; and on the other hand, the
protection is magical, as evidenced by the priestly order.

sa-oo	magician	s3w

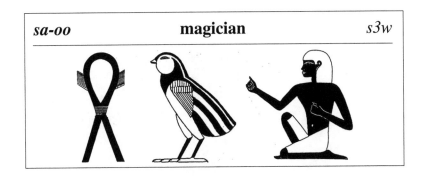

sa	protection	s3

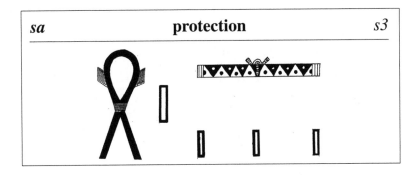

Sa-oot	Lycopolis	S3wt

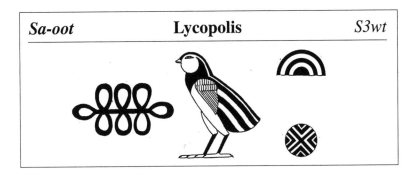

sa-oo	phyle of priests	s3w

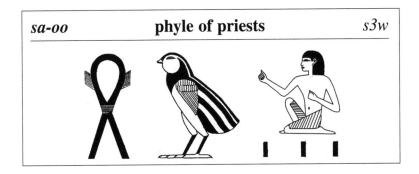

sah *š3*

Biliteral: A box and its cover, and probably the back of something. Ideogram for "back."

PHONETICS AND WRITING

Pronunciation: cushion cover and vulture.

1. em-sa — Following, after. Determinative: none.

2. saa — Wisdom, the wise man, prudence. Determinative: a man or two men.

3. sah — Stable, store. Determinative: house.

4. sa-oo — Satisfaction, satiety. Determinative: the man with hand toward mouth.

SEMANTICS

There are very few significant links here. *Sah*, the stable, and *saht*, the wall (determinative: the wall), both refer to construction.

Wisdom, the wise man, prudence all fall into the same dimension.

On the other hand, we can find no semantic link between satiety and the back of something.

Relatively few words are written with this sign. Although not shown here, we can cite *sah*, "weak"; *sah(r)y,* "a needy person"; *sah-ee*, " to recognize," among others.

em-sa	**next, after**	*m-ś3*

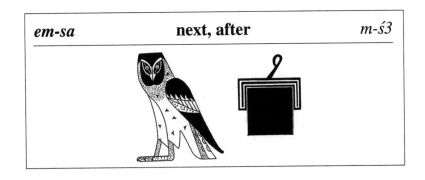

saa	**a wise man**	*ś33*

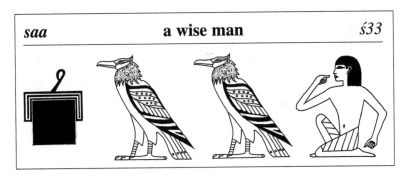

sah	**stable, store**	*ś3*

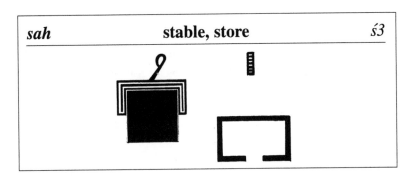

sa-oo	**satiety**	*ś3w*

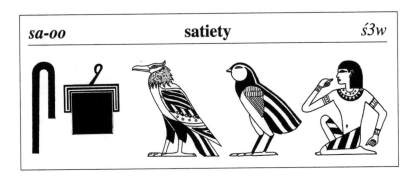

sek

śk

Biliteral: A straw broom (compare this sign also with triliteral *wah* (T 27).

PHONETICS AND WRITING

Pronunciation: cushion cover and basket.

1. seki — To perish, flounder (especially as used in the negative to not…). Determinative: bird of ill omen (sparrow).

2. sekoo — Battle, combat. Determinative: arm carrying weapon and plural.

3. sekoo — Troops, soldiers, companies. Determinative: armed man, man and three dashes for plural.

4. sek — Lance (for the young troops). Determinative: an array of arms with rope.

SEMANTICS

The broom is a tool for cleaning, either actually or figuratively. To dust, wash, wipe, rub out, etc. Figuratively, it is to sweep aside obstacles, vanquish or destroy enemies, etc. The four words chosen here fall within the latter category; they all have a military connotation and refer to troops, arms, and combat in which many perish.

seki	to perish	śkỉ

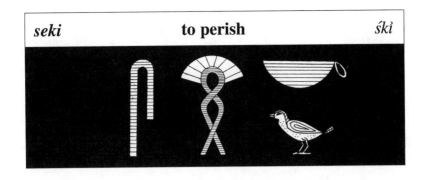

sekoo	battle	śkw

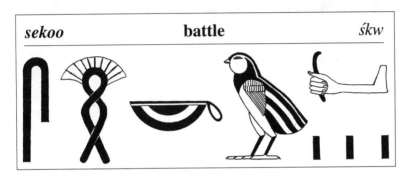

sekoo	troops	śkw

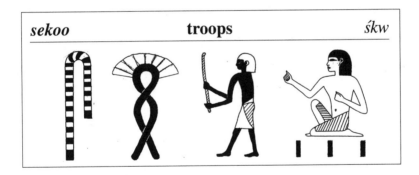

sek	lance	śk

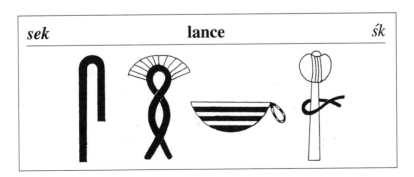

sen *śn*

Biliteral: An arrow head. Ideogram for "arrow."

PHONETICS AND WRITING

Pronunciation: cushion cover and wavelets.

1. senet — Sister. Determinative: woman.

2. sen — Brother. Determinative: man.

3. senetcher — Incense. Determinative: ball (here they are of resin, but they can be metal, stone, or seeds).

4. senoo — Companion, friend. Determinative: man and the two dashes.

SEMANTICS

Terms written with this sign deal with life in society.

The first words here refer to the family — not only immediate family, such as brothers, but also cousins. "His beloved sister" does not automatically refer to a man's sister, but more often to his wife. The same transfer occurs with "brother," which often designates the husband.

In society, everyone has his friends, companions, and associates. In the divine sphere, Isis and Nephthys are the two companions, the *senooty*.

Sen also means to "smell" and what the gods smell is incense. The same verb means to embrace (a woman, the hand of the king) and to "touch" or "grasp."

Lastly, *sen* is the Figure 2, with its many related words (second, the same, etc.).

senet	sister	śnt

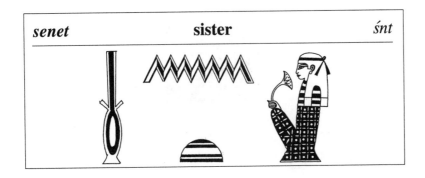

sen	brother	śn

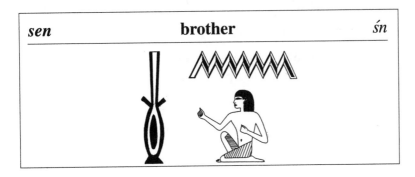

senetcher	incense	śnṯr

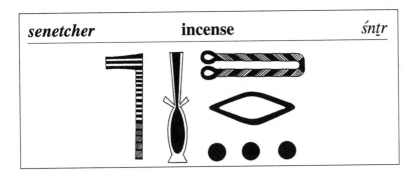

senoo	friend, companion	śnw

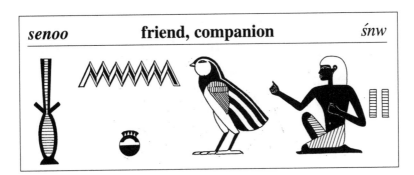

199

set *śt*

Biliteral: The stylized image of an animal hide, with its tail, pierced by an arrow.

PHONETICS AND WRITING

Pronunciation: cushion cover and bread.

1. setoot — Rays (of the sun). Determinative: sun.
2. seti — To shoot, throw, stimulate, pour, radiate, launch (a flood). Determinative: armed man.
3. Setet — The goddess Satet (or Sati). Determinative: woman.
4. seteet — Seed, posterity, descendants. Determinative: phallus and plural.

SEMANTICS

The aggression reflected in this image is seen in the words created from the biliteral. Anything that provokes pain, pierces, burns — but also that radiates and creates — falls within the meaning of this sign. The rays of the sun and the seed reflect the same idea on both cosmic and terrestrial planes.

To shoot an arrow, or cast a stone, are the basic meanings. They can also be understood figuratively as "to launch the flooding of the Nile," an activity that falls under the control of the goddess Satet, along with the other divinities of the first cataract.

setoot	rays	śtwt

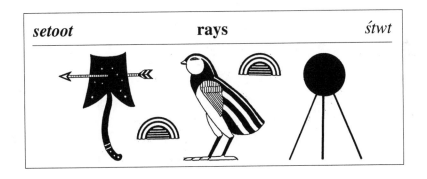

seti	to shoot	śtỉ

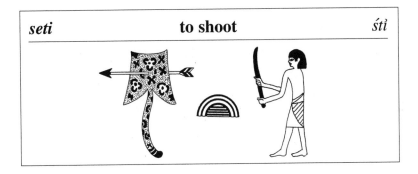

Setet	the goddess, Satet (Sati)	śtt

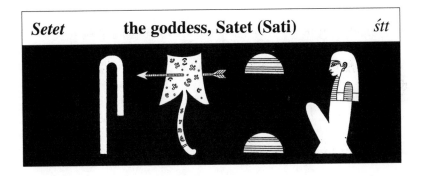

seteet	seed, posterity	śtyt

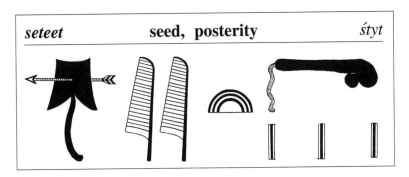

SOO *św*

Biliteral: A rush with two sets of double leaves or some other plant of the *juncaciae* family.

PHONETICS AND WRITING

Pronunciation: cushion cover and quail.

1. n(ee)-soot — The King of Upper Egypt ("he of the reed" who grows in the Delta!). Determinative: king.

2. Sootekh — The god Set. Determinative: Set's animal.

3. nesoo-eet — Royalty. Determinative: papyrus roll (a sign of abstraction).

4. soot — Rush or reed. Determinative: a plant.

SEMANTICS

This sign is rarely used aside from its function as a personal pronoun.

Why does the term "king," and especially the "king of Upper Egypt," contain an image of a plant that grows in the northern marshlands in Lower Egypt? The answer remains a mystery.

Royalty expresses the abstract, the royal function. Set is the god of natural disturbances and of the desert, so the image of this aquatic plant likely appears in his name only for phonetic reasons.

The same writing is used to designate the reed or the rush — the plant itself.

n(ee)-soot	the King of Upper Egypt	*n(y)-śwt*

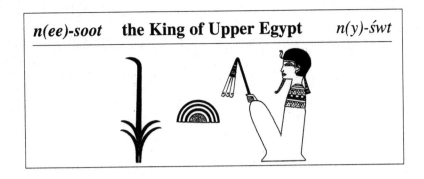

Sootekh	the god Set	*Śwtḫ*

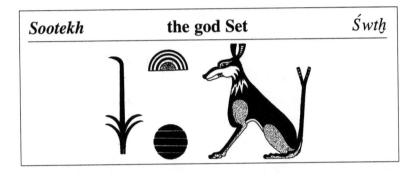

nesoo-eet	royalty	*nśwyt*

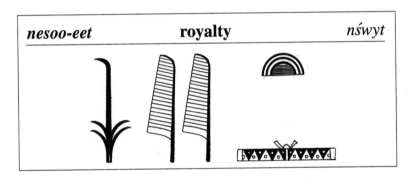

soot	reed	*śwt*

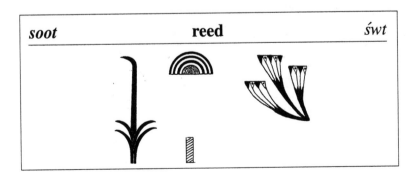

sha

š3

Biliteral: Lotus flowers in a basin.
Ideogram for "lotus flower basin" is a plant bed and the determinative is "marshlands."

PHONETICS AND WRITING

Pronunciation: basin and vulture.

1. shaee — To travel, flee, escape. Determinative: legs walking.

2. shasha(ee)t — Necklace of pearls, gold or precious stones. Determinative: necklace or bond.

3. sha-ee — The pig in general, the black boar of Set. Determinative: pig.

4. Shashank — The king Shoshenq. Determinative: a cartouche (an oval or oblong figure enclosing a sovereign's name).

SEMANTICS

The basic concept: ponds and flowers on one hand, movement on the other. The phonetic applications are very numerous, as are the semantic dimensions. The words chosen on this page may indicate a certain connection between the boar and the Shoshenq Libyan kings. These foreign kings were assimilated with the Bedouin "sand merchants"; in other words, with desert dwellers, those who lived in Set's domain. The *sha-ee* is opposed to the *sha-eet*, the white sow, the epithet of Isis.

The necklace may evoke the beauty of the lotus flowers, which inspired the form of the pearls in the large *oosekh* necklaces.

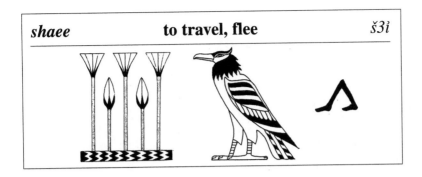

shaee **to travel, flee** *š3ỉ*

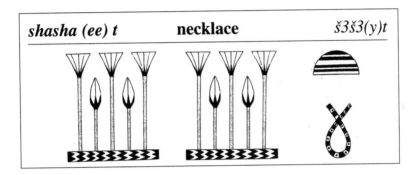

shasha (ee) t **necklace** *š3š3(y)t*

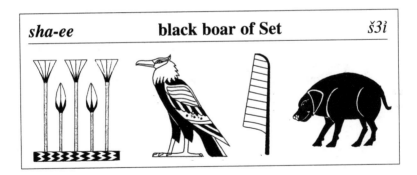

sha-ee **black boar of Set** *š3ỉ*

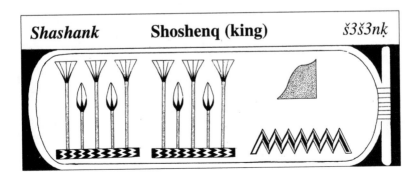

Shashank **Shoshenq (king)** *š3š3nḳ*

shed

šd

Biliteral: Leather wineskin.

PHONETICS AND WRITING

Pronunciation: basin and hand.

1. shedi — To read out loud, recite. Determinative: the man with hand toward his mouth.

2. shedi — To feed, suckle, raise. Determinative: female breast.

3. shed — Vulva. Determinative: a strip of flesh.

4. Shedet — Egyptian name of the ancient city of Crocodilopolis. Determinative: a city.

SEMANTICS

The wine skin, filled up, holds liquids, and from it such fluids as water can be drawn, often directly into the mouth. The meaning may be extended to mean feed, suckle, raise, protect, a tutor, or educator.

The voice comes out of the trachea as from a pipe: to read or recite out loud, to proclaim or to agitate are related meanings.

In general, female sexual organs are often compared to containers, especially for water. The crocodile finds its element in water.

shedi	**to read**	*šdỉ*

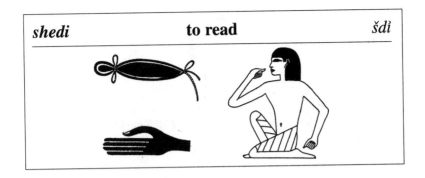

shedi	**to suckle, raise**	*šdỉ*

shed	**vulva**	*šd*

Shedet	**Crocodilopolis**	*Šdt*

shen

šn

Biliteral: A looped rope, the ends of which point downwards. Determinant: for ring, band.

PHONETICS AND WRITING

Pronunciation: basin and wavelets.

1. shenoo — The cartouche that encircles the King's name. Determinative: ring-seal.

2. shenoo — Hair. Determinative: a lock of hair.

3. shen — Tree. Determinative: tree.

4. shen djet — Acacia of the Nile. Determinative: acacia.

SEMANTICS

The basic meaning of this hieroglyph is to encircle, surround, encompass, to be round-shaped. Its related concepts fall into two main categories: terms that connote protection and those that connote limitations.

The first category includes such meanings as to surround, enclose, and protect, especially in a figurative sense. Thus the *shenoo* "everything that is encompassed by the sun" denotes a protection of the royal name, in the form of an amulet. The hair with its locks frames the face. In architecture, the function of the walls is to protect — and this introduces us to the second category: the walls of a prison, or to surround someone in order to arrest him. The dead are buried and surrounded by the earth, but they may be liberated by magic rites…

The roots of trees enjoy a similar relationship with the earth.

shenoo	**cartouche**	*šnw*

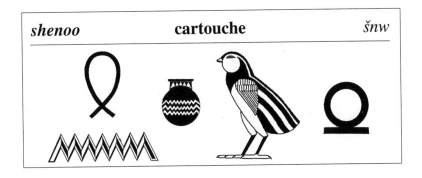

shenoo	**hair**	*šnw*

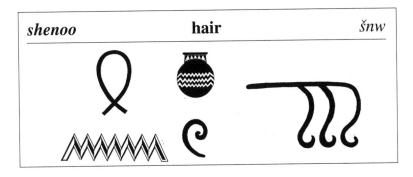

shen	**tree**	*šn*

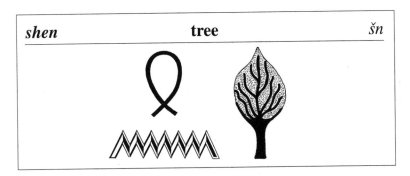

shen djet	**acacia**	*šn ḏt*

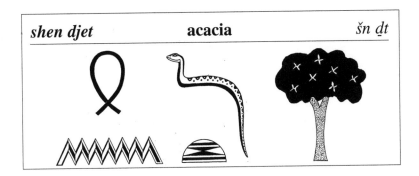

shes *šś*

Biliteral: resembling a looped rope or thread, the ends of which point upwards.

PHONETICS AND WRITING

Pronunciation: basin and cushion cover.

1. shes — Alabaster. Determinative: rock.

2. sheser — Arrow. Determinative: arrow.

3. shes — Rope, strip (of leather). Determinative: a cord forming a loop.

4. shes — Funeral bed, coffin. Determinative: funeral bed.

SEMANTICS

Contrary to what appears at first glance, the words here are semantically related. The basic idea is reflected in meanings such as "precious," "fine," "select."

Alabaster, especially the blue stone of Hatnub, is a precious material that is used for eternity, although the King may have made use of it during his lifetime. The sign does not refer to rough ropes, but to the fine cords and linen threads destined for the royal linen. Linen shrouds and bindings were costly, as were all the other funerary accoutrements.

The tongue (*sheser*) is like a cords or string; string is used to shoot arrows (*sheser*), or cords may be stretched out between two posts to mark the foundations of a building.

shes	**alabaster**	*šś*

sheser	**arrow**	*šśr*

shes	**cord**	*šś*

shes	**coffin, funeral bed**	*šś*

shoo

šw

Biliteral: An ostrich plume seen in profile.
Ideogram for "feather."

PHONETICS AND WRITING

Pronunciation: basin and quail.

1. shoot — Feather. Determinative: none, identification dash.

2. shoo — Light (sun and the moon). Determinative: sun.

3. Shoo — The god Shoo. Determinative: the god.

4. shoo-oo — Edible vegetable. Determinative: a flowering plant.

5. shoo-eet — Shadow (as opposed to light); the spirit of a god. Determinative: the sun.

SEMANTICS

The concepts of levity, lightness, and air are expressed by this biliteral, which is, after all, a feather of the bird. Shu was the god of the air. The same word is used to express the light of the sun and of the moon, as opposed to shadow. This shadow is also the spirit of a god that interferes with the viewing of his creatures. The name of small temples, erected for the royal ladies and called *shoo-(eet)-Re*, "the shadow of Re," is quite significant.

shoot **feather** *šwt*	*shoo* **light** *šw*

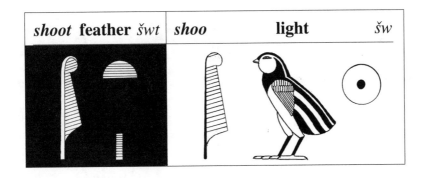

Shoo	**the god Shu**	*Šw*

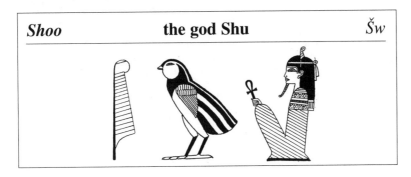

shoo-ou	**vegetable / legume**	*šww*

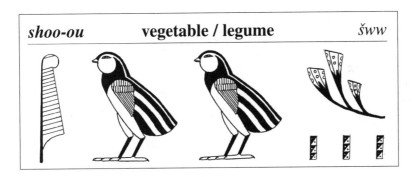

shoo-eet	**shadow**	*šwyt*

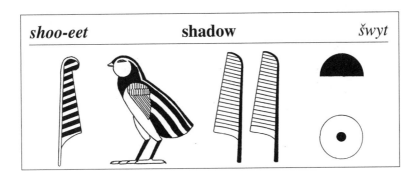

ta t3

Biliteral: Stylized drawing of a strip of land, with stones and grains of sand.
Ideogram for "land," "country."

PHONETICS AND WRITING

Pronunciation: bread and vulture.

1. Tatenen — Tatenen, god of the earth. Determinative: a god.

2. Ta-meri — "Beloved land" = Egypt. Determinative: basin or stone and city plan.

3. ta-djeser — The sacred country, the necropolis. Determinative: mountain.

4. Sa-ta — Name of a serpent spirit. Determinative: serpent.

SEMANTICS

All words containing this biliteral refer to the idea of land, country, locality, etc.

Tatenen, god of the earth worshipped in Memphis, as well as the serpent spirit "Son of the Earth," are incarnations of the subterranean forces that act on all beings. Modern science has confirmed as a reality what people of antiquity personified. The impact of such forces is also illustrated by the name of the necropolis, the "sacred land," which echoes other meanings of *djeser*: secret, guarded, inaccessible, magnificent, etc., written with the armed hand.

The "beloved land" can only be Egypt!

Tatenen the god Tatenen *T3-ṯnn*

Ta-meri beloved land: Egypt *T3-mri*

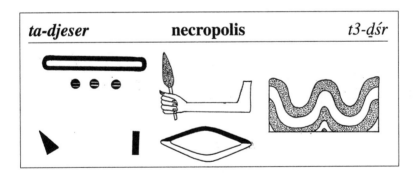

ta-djeser necropolis *t3-ḏśr*

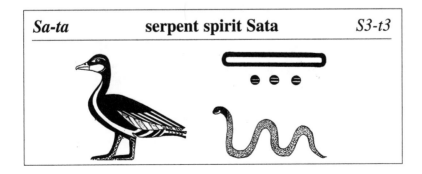

Sa-ta serpent spirit Sata *S3-t3*

ta

t3

Biliteral: A potter's kiln. Ideogram for "potter's kiln."

PHONETICS AND WRITING

Pronunciation: bread and vulture.

1. ta — Hot, hot-headed (character). Determinative: a lighted lamp.

2. tash — Frontier, border. Determinative: district and identification dash.

3. ta — Kiln, oven. Determinative: house, construction.

4. tahet — Liquid deposit, residue, medicine. Determinative: vase and plural.

SEMANTICS

Heat and kiln connote the same idea, and maybe also a liquid deposit, which has condensed from evaporation during cooking. The term is also mentioned as being an ingredient of a medication, often of a rather doubtful concoction.

The idea of a frontier, boundary, or border is probably derived phonetically from *ta*, the earth. Another surprising application of *ta,* the oven, is the name of the goddess of weaving, Ta-eet, which is the equivalent of *ta-eet*, the shroud: when written, the only distinction is the determinative.

ta	hot	*t3*

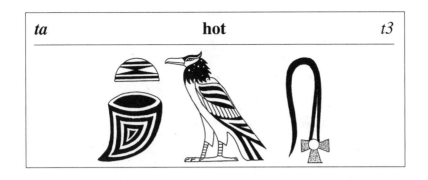

tash	border	*t3š*

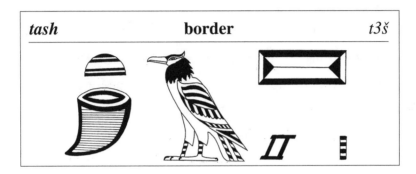

ta	oven	*t3*

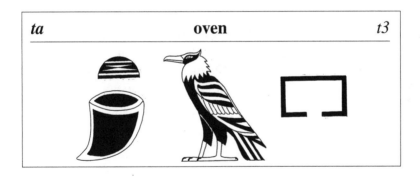

tahet	liquid deposit, medication	*t3ḥt*

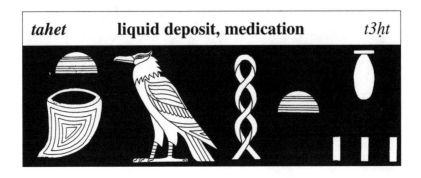

217

tee *ti*

Biliteral: A pestle. Ideogram for the verb "to stomp on."

PHONETICS AND WRITING

Pronunciation: bread and reed.

1. tee-oo — Yes! Determinative: the man with hand toward mouth.

2. ee-tee — Sovereign. Determinative: king.

3. teet — The knot of Isis. Determinative: the same knot.

4. Tee-yee — Queen Tiyi. Determinative: queen.

SEMANTICS

Aside from the exclamation of the affirmative, the words on this page are all semantically connected: the general designation for a king, the related name of the queen and the emblem of the goddess Isis. We do not know exactly what the latter means: probably the knot in some cloth that often hung from the belt of a god or goddess.

Teet also means image or form; *tyew (tiw)* refers to the gnashing of teeth! The latter terms are linked phonetically.

tee-oo	yes!	*tiw*

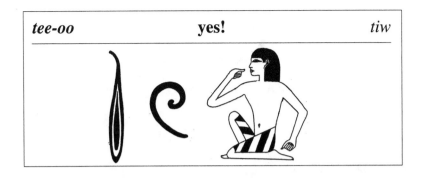

ee-tee	sovereign	*ity*

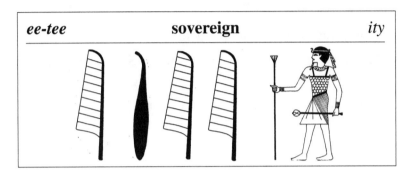

teet	the knot of Isis	*tit*

Tee-yee	the Queen Tiyi	*Tyy*

tem *tm*

Biliteral: A sleigh. Ideogram for a "sleigh."

PHONETICS AND WRITING

Pronunciation: bread and owl.

1. Tem — The god Atum. Determinative: a god.

2. temoo — Humanity, all people. Determinative: man and woman and three dashes for the plural.

3. tem — Complete; incomplete. Determinative: none.

4. temet — Sleigh. Determinative: none (the sleigh is integrated into the glyph).

SEMANTICS

A sleigh in Egypt? Not to slide on the snow but to cross the sands. Heavy loads had to be transported, particularly during funerals, when the coffin and the funeral ornaments for eternity had to be brought from the Nile to the desert necropolis.

The adjective *tem* means both "complete and incomplete," "existent and nonexistent." The contradiction derives from the nature associated with the demiurge, Atum, who unites in himself the limits of existence, the cosmic cycle. Humanity, like all other creatures, proceeds from him.

Tem	the god Atum	Tm

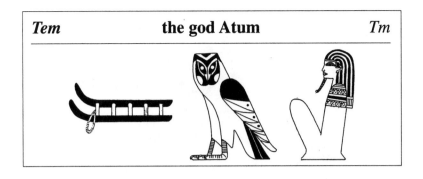

temoo	humanity	tmw

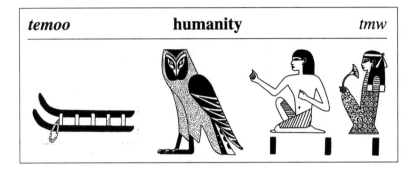

tem	complete, incomplete	tm

temet	sleigh	tmt

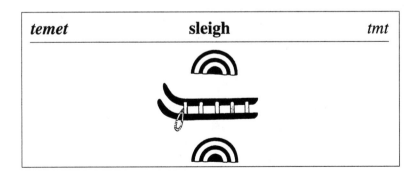

tsha

t3

Biliteral: A baby bird, a young duckling.
Ideogram for "young bird."

PHONETICS AND WRITING

Pronunciation: shackle and vulture.

1. tshat(y) — Vizier. Determinative: man.

2. tsha — Young bird, animal. Determinative: identification dash or bird.

3. tsha-ee — Male, man. Determinative: phallus and man.

4. tshabet — Loan granted to someone. Determinative: grain measure.

SEMANTICS

The range of meaning attributable to *tsha* is quite broad as well as diverse. The biliteral connotes high functions, such as those of a vizier, the king's fan bearer, and the standard bearer of His Majesty.

On the other hand, beginning with "young duckling," "young animal," and moving on to "child," we find the root "male" in such expressions as: "to take a man," "to get a man" (such as with Isis and Osiris), which is the flip side of to take a woman — to marry in both cases. These expressions are a good reflection of the freedom of action that existed between the sexes.

The loan you grant to someone comes from the same root as "gift," as does "theft" and its derivatives. The phonetic links lead to other possibilities, such as cloth, grains, small quantities, recipients, book, wind, etc.

tshat(y) **vizier** _t̲3t(y)_

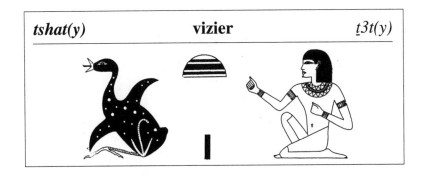

tsha **young bird** _t̲3_

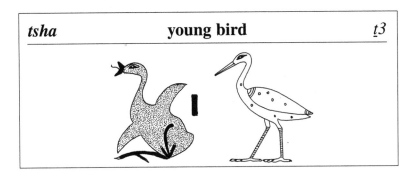

tsha-ee **male** _t̲3y_

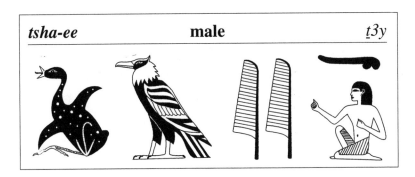

tshabet **a loan** _t̲3bt_

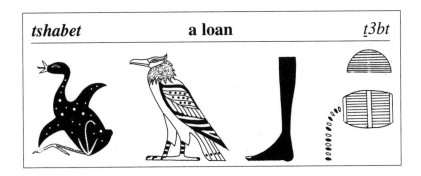

tshez *t̲s*

Biliteral: A belt tied with a knot. Ideogram for "vertebrae."

PHONETICS AND WRITING

Pronunciation: shackle and bolt.

1. tshezoo — Vertebrae, spinal column. Determinative: vertebrae.

2. tshezet — Knot (for clothing cords). Determinative: cord.

3. tshezoo — General, chief, protector. Determinative: armed man and man.

4. tshez — Word, exclamation. Determinative: the man with hand to his mouth.

SEMANTICS

The basic concept is that of tying, and the result is a knot. Vertebrae are "tied" with ligaments; together they form the spinal column, which is both firm and supple at the same time.

The idea of tying was extended to include the following meanings: to join, weave, model, form, bring together, guide, etc., all in the figurative sense as well.

The chief who commands belongs to the same semantic register as the following expressions: word, exclamation, phrase, maxim.

tshezoo	**vertebrae**	*ṯsw*

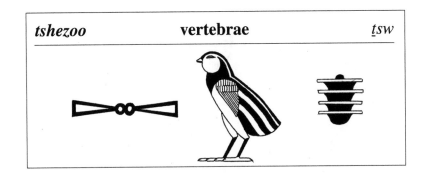

tshezet	**knot**	*ṯst*

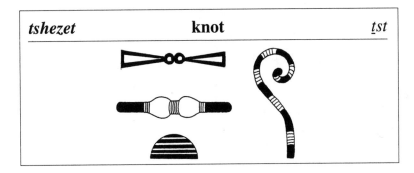

tshezoo	**chief, general**	*ṯsw*

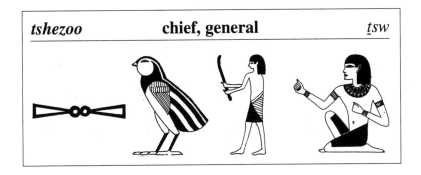

tshez	**word**	*ṯs*

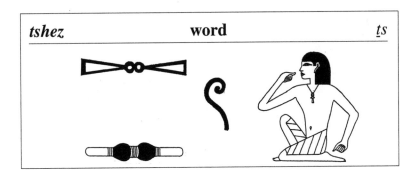

wa

w3

Biliteral: Lasso, slip knot, cord.

PHONETICS AND WRITING

Pronunciation: quail and vulture.

1. wat — Road, route. Determinative: road or route, traced out and lined with trees.

2. wah-oo — Waves (on sea or lake). Determinative: water.

3. Wahwaht — Nubia, northern part of Egypt at border. Determinative: mountain.

4. Wah — Distant (in space and time). Determinative: road or route.

SEMANTICS

Any pathway, whether in time, in space, or in the mind, may be expressed by this sign.

The shaded route through the agricultural countryside presents a stark contrast to the mountainous country and the desert, where the population lives a more precarious existence, suffering periodic incursions and raids. This observation leads to a new line of thought. The spirit can advance and conceive plans, whether for good or evil, fruitful or barren. Its ideas may be arid, like the *wah-ee,* dates that are left to dry in the sun, but whose rays can enflame the spirits: it is a rebellion — in this far-off desert country, whose name means "burning."

wat	road	w3t

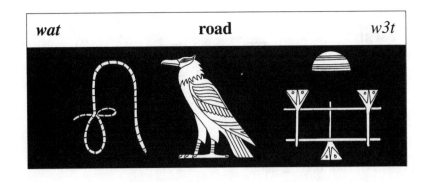

wah-oo	waves	w3w

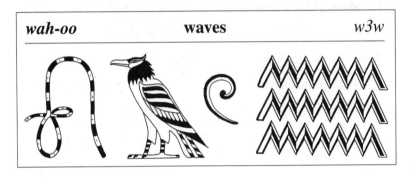

Wahwaht	Nubia	W3tw3t

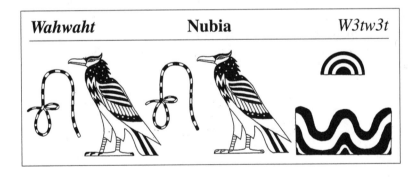

wah	remote, distant	w3

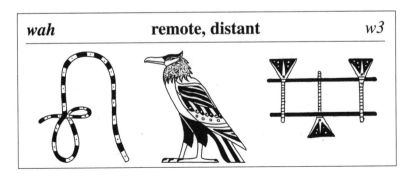

wah

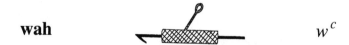

w^{c}

Biliteral: A harpoon with its rope. Ideogram for "harpoon."

PHONETICS AND WRITING

Pronunciation: quail and forearm-hand.

1. wahtet — Goddess, royal uraeus. Determinative: cobra

2. wah — One (the number), unique. Determinative: identification dash.

3. wah-oo — Solitude; private domain. Determinative: none.

4. wat — Prisoner. Determinative: a prisoner of war (Asian in this example).

SEMANTICS

A single harpoon is cast — hence the number one and the concept of uniqueness. The title "the king's unique friend" was a coveted distinction granted to privileged courtiers. Thus the king ended up with an entourage of "unique" friends who were not really unique!

A single bite from a venomous serpent is enough to kill. A single arrow can strike and fell the warrior, in the same way that a harpoon can strike a fish.

Loneliness allows a man to come face-to-face with himself; he is "unique" in his own domain.

wahtet	the royal uraeus	w^ctt

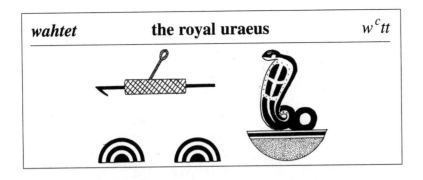

wah	one, unique	w^c

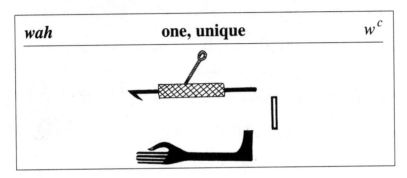

wah-oo	solitude	$w^{cc}w$

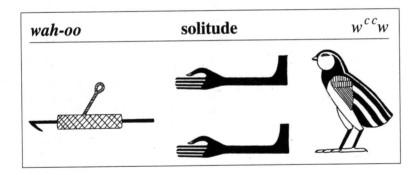

wat	captive, prisoner	w^ct

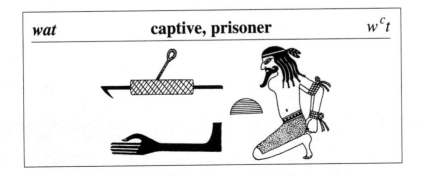

oodj

wḏ

Biliteral: A wad of rope, wound around a stick.

PHONETICS AND WRITING

Pronunciation: quail and cobra.

1. oodj — To order; pilot, direct. Determinative: forearm with weapon.

2. oodjeet — Trip, expedition. Determinative: walking legs.

3. oodj — To issue a command, order, decree. Determinative: abstract papyrus roll.

4. oodj — Stela, boundary stone, boundary marker. Determinative: a stela or stone.

SEMANTICS

This hieroglyph is used in terms that express direction and movement in general — including vigorous action, as is shown by the armed hand that "directs."

With the third word shown in the samples, we go from the concrete to the figurative: to command, permit, trust, or recommend someone, and also to issue an order, establish a decree, state a precept.

The boundary stone shows that there is a limit to everything. The stela records the memory of all these activities, thus becoming the history of the events.

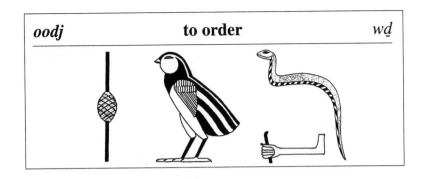

oodj — to order — *wḏ*

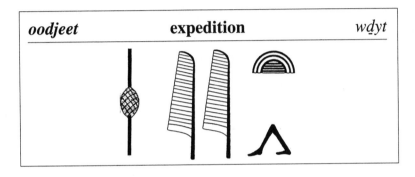

oodjeet — expedition — *wḏyt*

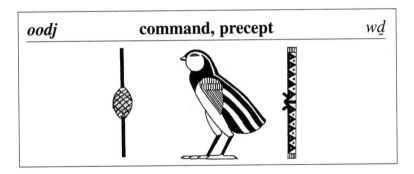

oodj — command, precept — *wḏ*

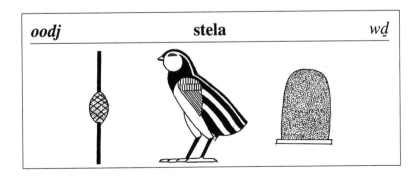

oodj — stela — *wḏ*

231

oon *wn*

Biliteral: The desert hare is known to the ancients as sekhât.
However, this biliteral expresses the sounds "*oon (oonen)*" and at the same time is the ideogram for the verb "to be" or "to exist."

PHONETICS AND WRITING

Pronunciation: quail and wavelets.

1. oon-oot — Time, punctual service. Determinative: star and sun.

2. Oonen-nefer — Osiris–Onnophris. Determinative: a god.

3. oonem — To eat, slice, exhaust. Determinative: the man with hand toward his mouth.

4. oonesch — Jackal, wolf. Determinative: canine carnivore (*canidea*).

SEMANTICS

The functions necessary to life — to being — are evoked by this biliteral, whether they are on or under the earth, or even in the cosmos.

The sun and the stars, which regulate the day, become synonymous with time or hours. The god "bearing stars in his hands," the priest of the hours, the tasks that have to be carried out at a fixed time, all belong to the same semantic register.

In order to live, it is essential to eat. "He who exists," Osiris, King of the "Living," (this actually refers to the dead and is known as *Oonen-nefer*), "the victor who has survived," is rejuvenated.

Dogs and jackals, dark like the god of embalmers, Anubis, roam through the cemeteries: that is the end of the cycle.

oon-oot	time, hour	*wnwt*

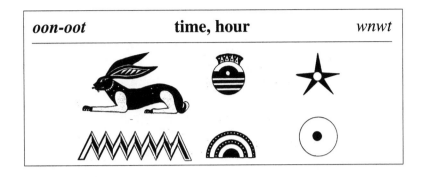

Oonen-nefer	**Osiris-Onnophris**	*Wnn-nfr*

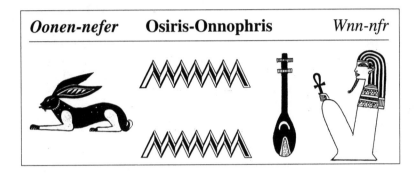

oonem	to eat	*wnm*

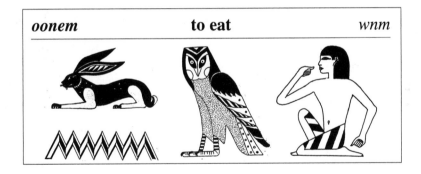

oonesh	jackal, wolf	*wnš*

233

oon

wn

Biliteral: Probably represents a star.

PHONETICS AND WRITING

Pronunciation: quail and wavelets. The same sound as for the hare (B 80); to a certain extent these signs are also interchangeable.

1. oonemet — Food. Determinative: the man with hand toward mouth, bread and bowl, three dashes to show plural (abbreviated writing).

2. ooneb — Flower, bouquet. Determinative: bouquet.

3. oondjoot — Associates. Determinative: man and woman, and the plural (three dashes).

4. oondjoo — Goats, billy goats, cattle. Determinative: goat.

SEMANTICS

The sound that is the same for the hare and the flower places this biliteral in the same register as the previous one, but it has a greater range.

Food, whether for humans or animals, naturally appears here. The range opens up to the environment, plants, flowers, animals, and also to society.

oonemet	**food**	*wnmt*

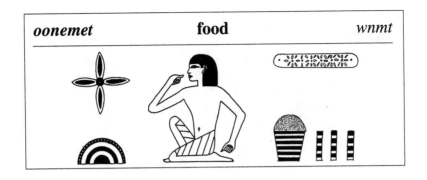

ooneb	**flower, bouquet**	*wnb*

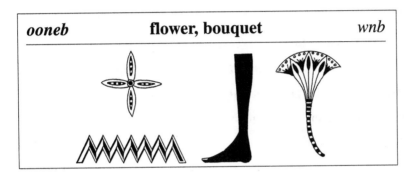

oondjoot	**associates**	*wnḏwt*

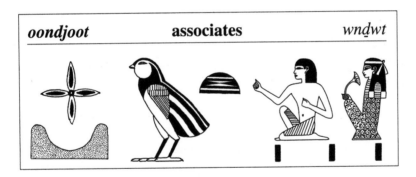

oondjoo	**goat, cattle**	*wnḏw*

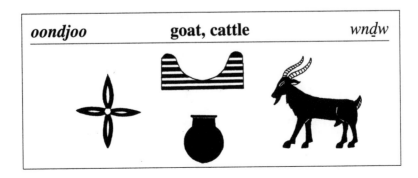

oop *wp*

Biliteral: An elegant set of cattle horns.
Ideogram for "horns" and "crown of the head."

PHONETICS AND WRITING

Pronunciation: quail and stool.

1. oopet-rah — First day of the month. Determinative: none.

2. Oo-pooh-ow-oot — The god Upuaut. Determinative: the god.

3. oopootee — Messenger. Determinative: man.

4. oop — To open. Determinative: mathematical sign.

SEMANTICS

The horns shown above, which open up from the top of head and are able to open horrible wounds, influence all these themes.

The first "opener" is without a doubt the sun: it opens the day and the month, and especially the new year.

The dog-god, Upuaut (or Wepwawet), opens the way to afterlife for the dead. The messengers, agents and commissioners must often be trail blazers and travel difficult routes.

Many related words are evoked by the verb *oopi* — not just to open, but also to separate, shave, divide, judge, distinguish, etc.

oopet-rah	**first day of the month**	*wpt rc*

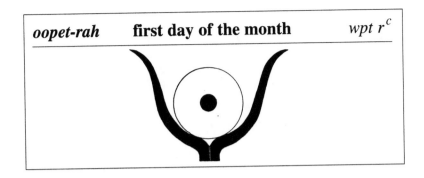

Oo-pooh-ow-oot / Upuaut, opener of roads *Wpw 3wt*

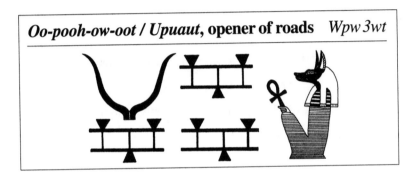

oopootee	messenger	*wpwty*

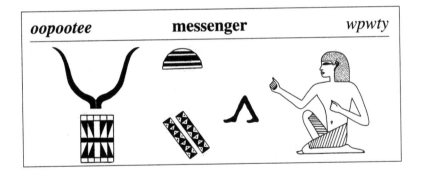

oop	**to open**	*wp*

oor

wr

Biliteral: The graceful form of a swallow.
Ideogram for "swallow."

PHONETICS AND WRITING

Pronunciation: quail and mouth.

1. oo-resh — To pass the time, spend a day; to be awake. Determinative: sun.

2. oo-reh — Ointment. Determinative: sealed jar.

3. oor-maw — High Priest of Heliopolis. Determinative: man and plural.

4. ou-rereet — War chariot. Determinative: chariot.

SEMANTICS

How did such a charming little bird become the graphic symbol of something high and mighty? It is a mystery.

The High Priest of the City of the Sun is literally "the greatest of the seers."

To pass the time belongs to the same root as to be awake and alert — and by extension, to observe and watch: these are states of high attention.

The war chariot is endowed with great resistance and speed.

An ointment must have a major effect…and in addition, we see all the other facets of "great": the chief, magnanimity, physical stature, social importance, quantity, quality, magic, knowledge, wisdom, etc., practically without end.

oo-resh — to pass the time — *wrš*

oo-reh — ointment — *wrḥ*

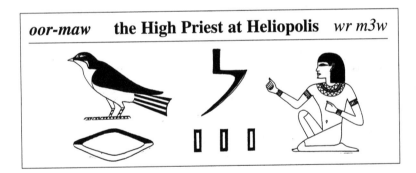

oor-maw — the High Priest at Heliopolis — *wr m3w*

oo-rereet — war chariot — *wrryt*

TRILITERALS

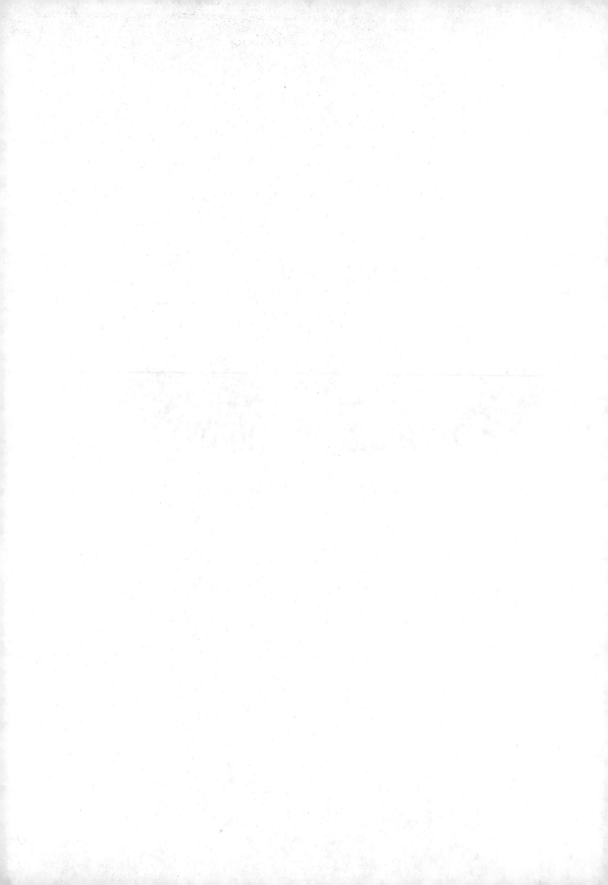

The triliteral group of hieroglyphs consist of groupings of three roots that correspond to three sounds, even if we are required to use more than three letters for purposes of transliteration. There are far fewer of these signs than there are biliterals. We have chosen thirty of those that are most frequently encountered. They are presented, defined, and commented upon following the same pattern that was used for the biliterals, and they follow the same order. We draw the reader's attention to the last group in the series, where phonemes corresponding to the semantic sign *waf* can appear either under the sound *oo* or *w*.

Lastly the sign T 27 can also be a biliteral; in fact, there is a cross-reference under B 62; a good example of a phonetic chameleon!

aha

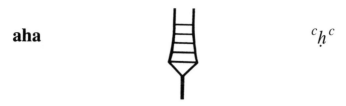

$^c h^c$

Triliteral: A mast or ladder. Ideogram for "mast."

PHONETICS AND WRITING

Pronunciation: arms and lamp wick.

1. ahh-ah-oo — Life expectancy, period. Determinative: none.

2. ahh-ah — To stand up, maintain oneself, rise, succeed. Determinative: legs.

3. ahh-ah-oo — Rank, social position. Determinative: legs and three dashes for plural.

4. ahh-ah — Stela. Determinative: stone.

SEMANTICS

The basic ideas behind this sign are based on stability, right, order, duration, and limits, expressed in time (life) and space (the stela). The main mast of a boat is an ideal symbol for depicting anything that is upright, erect, imposing, indispensable, resistant, and durable.

When you stop after a movement, you stand up; you stand before the court; you stand to be present, to ensure your service — these fall within the same range of meaning. To stand up also expresses resistance, which can culminate in success and the guarantee of a defined social rank, especially if you are beyond reproach.

To be standing also means to be in good condition, in good health. But even this enviable state is subject to time.

Inscriptions on erect boundary stones, even today, keep the memory of humans alive.

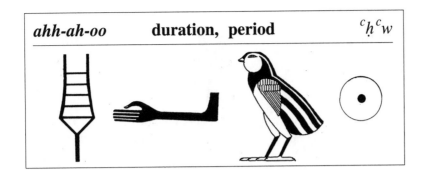

ahh-ah-oo **duration, period** $^c\underline{h}^cw$

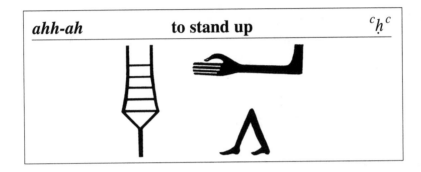

ahh-ah **to stand up** $^c\underline{h}^c$

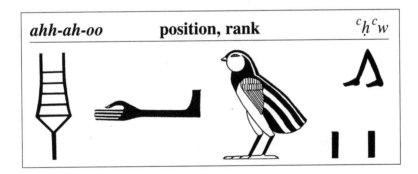

ahh-ah-oo **position, rank** $^c\underline{h}^cw$

ahh-ah **stela** $^c\underline{h}^c$

245

ahnkh

$^c n\underline{h}$

Triliteral: Known as the "cross of life." But what does it really represent? The laces of a sandal? A belt or apron? The question remains. Ideogram for "life."

PHONETICS AND WRITING

Pronunciation: arm, wavelets, and placenta.

1. ahnkh — Life, without determinative; word-sign: to live.

2. ahnkh — Mirror. Determinative: the object itself (or a metal kiln).

3. ahnkh-oo — The living (euphemism for the dead, who live in the afterlife). No determinative, three dashes for the plural.

4. ahnkh-oo — Stars. Determinative: star and plural.

5. ahnkh-oo-ee — The two ears. Determinative: two ears.

SEMANTICS

This sign covers a range of concepts that are impossible to separate from the life of the person, physical or figurative, and his or her perceptions.

The mirror, as a reflection of the person and of life, is a lunar symbol that has always intrigued human beings. What's happening on the other side? What would you find there? The question has not been answered, even though we have made great strides in that direction in modern times, and even planted a flag on our satellite!

The universe has grown, but our life unfolds between the earth (and also under the earth) and the stars, which are thought to be the souls of the blessed departed.

ahnkh	life	$^c n\underline{h}$

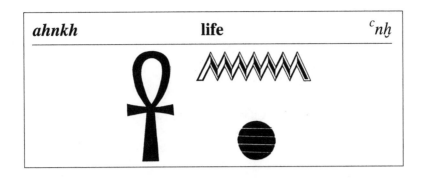

ahnkh mirror $cn\underline{h}$	*ahnkh-oo* the living $^c n\underline{h}w$

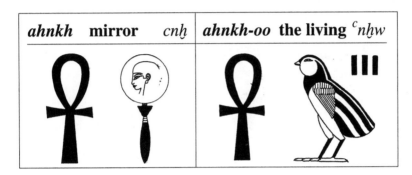

ahnkh-oo	stars	$^c n\underline{h}w$

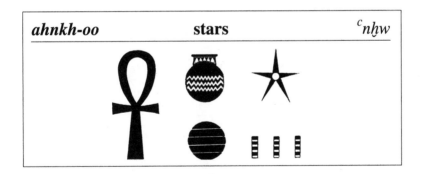

ahnkh-oo-ee	the two ears	$^c n\underline{h}wy$

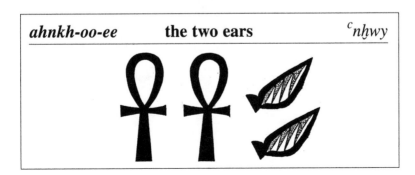

asha

$^c\check{s}3$

Triliteral: A lizard. Ideogram for "lizard."

PHONETICS AND WRITING

Pronunciation: arm, basin, and vulture.

1. asha — Numerous, many. Without determinative, but uses the three signs of the plural for this collective adjective.

2. asha — Lizard. Word-sign without determinative, only the identification dash.

3. asha-r(o) — To chatter. Determinative: the man with hand to his mouth.

4. asha-kheroo — Noisy. Determinative: the man with hand to his mouth.

SEMANTICS

This sign refers to all that is numerous, abundant, teeming, lively, and even to a certain extent obstructive. The observation of nature and its parallels to humanity often occur with a certain sense of humor: the "swarming mouth" for "a chatter box," for example, and "many voices" for "noisy" are mischievous word plays.

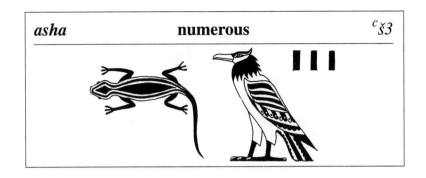

asha **numerous** $^{c}\check{s}3$

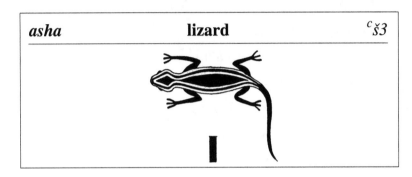

asha **lizard** $^{c}\check{s}3$

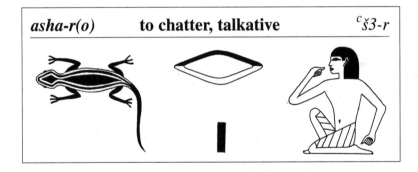

asha-r(o) **to chatter, talkative** $^{c}\check{s}3\text{-}r$

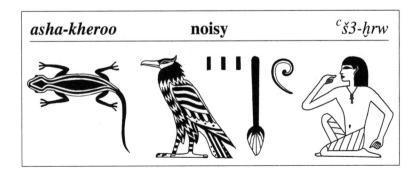

asha-kheroo **noisy** $^{c}\check{s}3\text{-}\underline{h}rw$

249

hot *ḥ3t*

Triliteral: The head and shoulders of a lion.

PHONETICS AND WRITING

Pronunciation: lamp wick, vulture, and bread.

1. hotee — Heart. Determinative: image of heart.

2. er-hot — Facing, frontward. No determinative.

3. hotee-ah — Prince, noble. Determinative: a noble.

4. hotet — Mooring rope, bow rope. Determinative: rope.

SEMANTICS

The concept of anything that excels, stands out, is foremost, forward, essential, and noble are evoked in this sign. What else should we expect? The lion is the king of the animals.

A word on "heart." For the ancients, the heart was the seat of intelligence, courage, and thought. Many modern expressions evoke the same idea: "put your heart into it," "a half-hearted effort," etc. Should we really be surprised that the plural of heart, *hotyoo*, means "thoughts"? The Egyptians thought with their heart, their innermost being.

hotee	**heart**	*ḥ3ty*

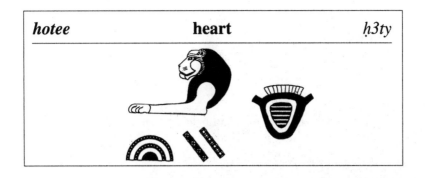

er-hot	**facing, frontward**	*r-ḥ3t*

hotee-ah	**prince, noble**	*ḥ3ty-ᶜ*

hotet	**mooring rope**	*ḥ3tt*

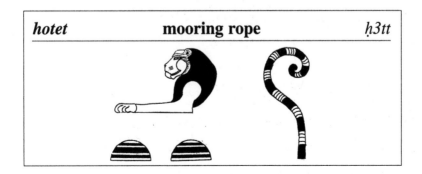

heka

ḥk3

Triliteral: One of the royal attributes. Ideogram for "scepter."

PHONETICS AND WRITING

Pronunciation: lamp wick, sand dune, and vulture.

1. heka — Prince, regent, governor. Determinative: the person.

2. hekat — Sovereignty. Determinative: papyrus roll (sign of abstraction).

3. hekat — The *hekat* or scepter. Determinative: none, identification dash only.

4. hekat — Calibrated object used to measure grain, unit of measurement. Determinative: the object.

5. Hekat — Hekat, the frog-goddess, goddess of birth. Determinative: divine serpent.

SEMANTICS

Originally, the *hekat* was the shepherd's staff, which was very useful because its curved hook could be used to bring back wandering sheep by the neck. For the ancients, the king was the "good shepherd," who assembled, guided, and protected his flock. The *hekat* was passed on to the West, where it is used to represent the bishop's staff, one of the customary attributes of power.

The measure of grain belongs to the same register. The harvest was assessed, measured, and stored, partially in the temple granaries, which were supply posts in case of scarcity. This was basic good management and Pharaoh did not need anyone to interpret his dreams!

"The mistress of childbirth," Hekat, the frog-goddess, was entitled to the same title as those reserved for princesses and queens.

| *heka* | **prince, regent** | *ḥḳ3* |

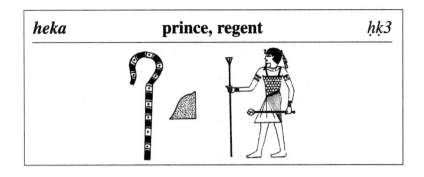

| *hekat* | **sovereignty** | *ḥḳ3t* |

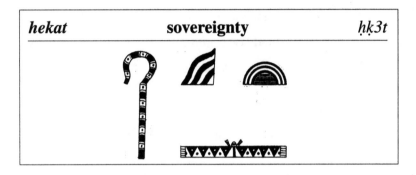

| *hekat* scepter *hḳ3t* | *hekat* | **measurement** | *ḥḳ3t* |

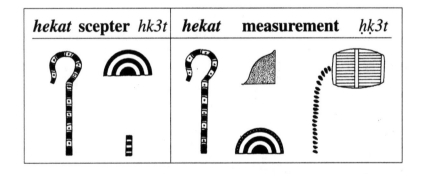

| *Hekat* | **Hekat, the goddess** | *Ḥḳ3t* |

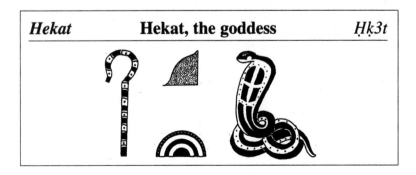

hetep *ḥtp*

Triliteral: A table for offerings or an altar, which in ancient times consisted of a woven mat and a loaf of bread in a mould. Ideogram for "table of offerings."

PHONETICS AND WRITING

Pronunciation: lamp wick, bread, and mat / stool.

1. hetep — To be satisfied, fulfilled (verb and adjective). No determinative.

2. heteptyoo — The fulfilled, i.e., the blessed departed, the ancestors. Determinative: a personage.

3. hetep(et) — Offerings, which are also shown in the determinative.

4. ee-em-hetep — Come in peace, welcome! Determinative: the triliteral and phonetic complements.

SEMANTICS

Anything that expresses contentment, happiness, calm, peace, food, and rest are expressed by this hieroglyph.

Hetep is the key word for positive relations between men and women, among men themselves, and with the Pharaoh, who is the pivotal figure between the two worlds. *Hetep* can also mean "to sit on the throne," to occupy a function, to receive an inheritance — the king first of all, and then his subjects.

hetep	**to be satisfied, at peace**	*ḥtp*

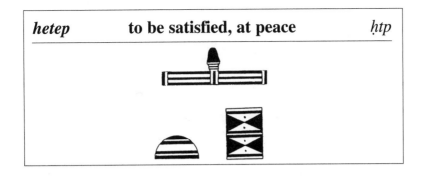

heteptyoo	**ancestors**	*ḥtptyw*

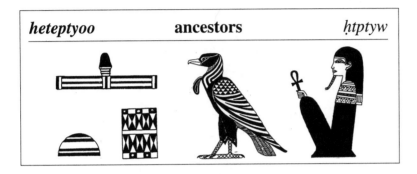

hetep(et)	**offerings**	*ḥtp(t)*

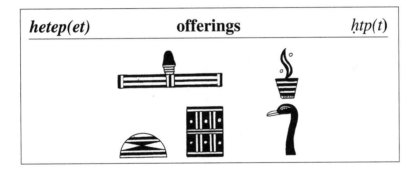

ee-em-hetep	**come in peace!**	*i(y)-m-ḥtp*

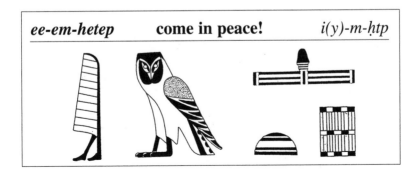

kheper

ḫpr

Triliteral: A scarab. Ideogram for the same insect.

PHONETICS AND WRITING

Pronunciation: placenta, mat / stool, and mouth.

1. Khepri — The god Khepri. Determinative: a god.

2. kheper — To become, to transform. Determinative: papyrus roll (sign of abstraction).

3. kheperoo — Form (materialized). Determinative: statue, papyrus roll (sign of abstraction) and three dashes for plural.

4. kheper djesef — Issuing from itself (the epithet for demiurges). Determinative: none.

SEMANTICS

All words related to the sign *kheper* fall into the category of "becoming," whether this means into existence, to take shape, or to be transformed or changed: the basic idea is constant.

In the religious dimension, to come into existence by your own agency is characteristic of a demiurge, who alone is able to emerge from the void, take shape, and act.

The ancients saw in the scarab, with its unusual reproductive techniques, a symbol of divine force — just as the hot ball, in which its eggs were contained, was seen as a symbol of the sun.

Kheper	**the god Khepri**	*Ḫprỉ*

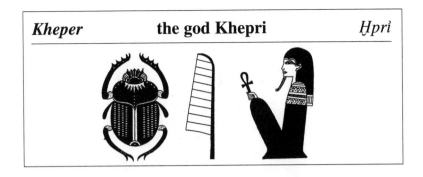

kheper	**to become, transform**	*ḫpr*

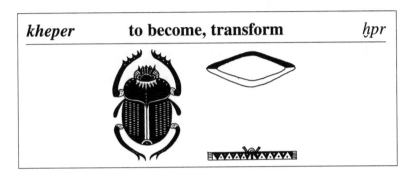

kheperoo	**form**	*ḫprw*

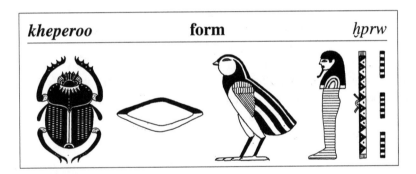

kheper djesef	**issuing from itself**	*ḫpr ḏś.f*

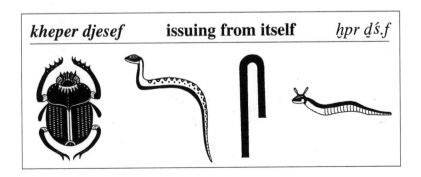

kheroo

ḥrw

Triliteral: An oar.

PHONETICS AND WRITING

Pronunciation: placenta, mouth, and quail.

1. kheroo — Voice. Determinative: the man with hand to his mouth.

2. ma-ah-kheroo — Victorious. Determinative: the man with hand to his mouth.

3. kheroo-eet — War. Determinative: an arm with weapon.

4. kheroo-ee — Enemy. Determinative: armed man.

SEMANTICS

The voice and the breath that issue from the mouth, with greater or lesser force, rush out toward the person standing face-to-face with the speaker, to whom the communication is addressed.

This explains the various meanings associated with this word: the voice and obstructive or aggressive noise are comparable to an enemy, therefore to war. The voice is also a defensive weapon, which can be used for self-justification. It can produce a positive advantage for the person who proclaims (or for the person addressed). The same idea is seen in the verb "to make an offering."

kheroo	voice	ḫrw

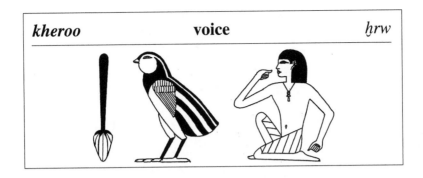

ma-ah-kheroo	justified, victorious	m3ᶜ-ḫrw

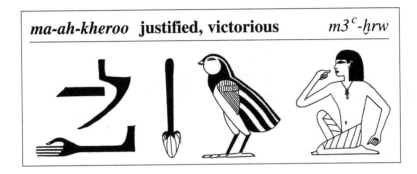

kheroo-eet	**war**	ḫrwyt

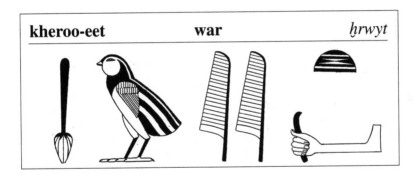

kheroo-ee	enemy	ḫrwy

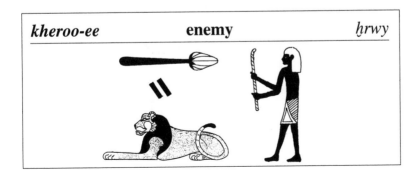

khenem

ḥnm

Triliteral: A large jar. Ideogram for the "jar – khenem."

PHONETICS AND WRITING

Pronunciation: mammal belly, wavelets, and owl.

1. khenemet — Cistern. Determinative: the sign of water or of the basin.

2. Khenemoo — The ram-god Khnemu. Determinative: image of the god.

3. khenem — To join, unite. Determinative: papyrus roll (sign of abstraction).

4. khenem — Flock. Determinative: gazelle or mammal hide, and three dashes, sign of the plural for this collective noun.

SEMANTICS

The semantic associations from the route *khenem* are very interesting.

First, there is the idea of a large container of liquids: the link with the ram-god of the first cataract, reputed for his ardor, is quite evident. One of his epithets, the "handsome copulator," reflects some of the abstract connotations of the verb, *khenem*: to unite with (a god, the deceased), to bud, to encircle, to receive. On the one hand, there is the idea of great quantity, and on the other, the idea of protection and containment (derived from the container). The range of meanings can extend to a whole field of derivative concepts.

Khenem, used with an animal determinative and the sign for the plural, means "flock," but when used with a man or a woman as determinative, it can mean people en masse, citizens, dependents.

khenemet	cistern	*ḥnmt*

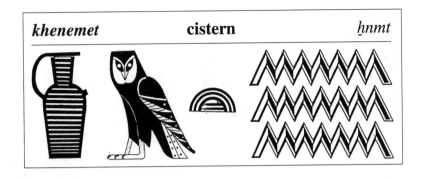

Khenemoo	the god Khnemu	*Ḥnmw*

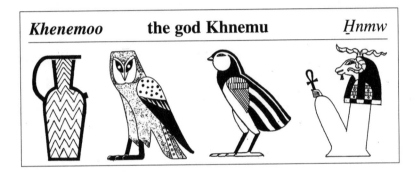

khenem	to join, unite	*ḥnm*

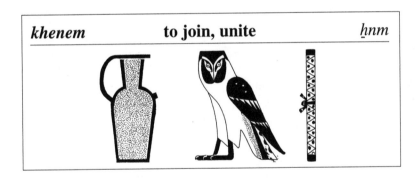

khenem	flock	*ḥnm*

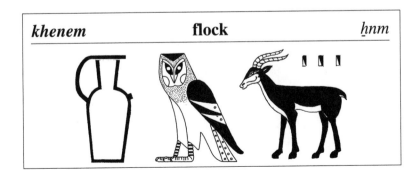

yoon *iwn*

Triliteral: A pillar. Also ideogram for "pillar."

PHONETICS AND WRITING

Pronunciation: reed, quail and wavelets.

1. yoonet — Hypostyle, a room surrounded by columns. Determinative: house or construction.

2. Yooneet — City of Esna (Latopolis). Determinative: city.

3. Yoonet — City of Dendara. Determinative: city.

4. Yoonoo — City of Heliopolis. Determinative: city.

SEMANTICS

The concepts of stability, support, and massive constructions are clearly linked to this root. One of the epithets of Horus, "pillar of his mother," is a good example of how this word is applied.

To this group of sacred cities should be added Hermonthis, the Iuny of the ancients.

yoonet	**a large room with columns**	*iwnt*

Yooneet	**Esna (a city)**	*ʾIwnyt*

Yoonet	**Dendara**	*ʾIwnt*

Yoonoo	**Heliopolis**	*ʾIwnw*

menekh *mnḫ*

Triliteral: Wood chisel. Ideogram for "chisel."

PHONETICS AND WRITING

Pronunciation: owl, wavelets, and placenta.

1. menekh — Wood chisel. Determinative: the triliteral for this object, preceded by phonetic signs, including the biliteral *men* (B 40), is almost always the case.

2. menekh — Efficient, capable, trustworthy. Same as for the previous term, only the determinative changes: in this example, the papyrus roll (a sign of abstraction).

3. menekhoo — Excellence: a person's virtues or qualities. Determinative: the triliteral, the sign of abstraction, and the plural: a general concept.

4. menekhet — Goodwill, open-hearted. Determinative: the triliteral, sometimes (though not in this case) followed by the papyrus roll and the three dashes for the plural.

SEMANTICS

The tool that digs and shapes reflects the qualities of the one handling the tool. These are not limited to his technical skills, but also his mental disposition. All the concepts related to this root — based on construction — are positive: splendid, powerful, esteemed, devoted, etc. In other words, excellence in all things. To be conscientious about your skills, whatever they may be, is a way of shaping character, and of fostering enduring values — which is the intrinsic meaning of the hieroglyphs shown here.

menekh **wood chisel** *mnḫ*

menekh **efficient** *mnḫ*

menekhoo **excellence** *mnḫw*

menekhet **good will, open-hearted** *mnḫt*

moot

mwt

Triliteral: The white vulture *(gyps fulvus).*
Ideogram for "mother."

PHONETICS AND WRITING

Pronunciation: owl, quail, and bread. This sign was originally a biliteral pronounced *ner*; e.g., *neret* = vulture. For unknown reasons, the image of the vulture was used for "mother," *moot* and its derivatives.

1. Moot — Goddess Mut. Determinative: a goddess.

2. moot — Mother. Determinative: woman.

3. moot — Weight (balance). Determinative: stone.

4. mery-en-Moot — Beloved of Mut. Determinative: none.

SEMANTICS

This hieroglyph is devoted mainly to the mother, the source of life, love, and protection. It is interesting to see that in Latin, Germanic, Anglo-Saxon, and even Semitic languages, the mother is always designated by terms containing the sounds *u/oo/ah*, and the labial occlusive consonant *m*. In pronouncing this word, the mouth momentarily becomes like that of the suckling child, being breast fed by his mother.

On the other hand, though, in Western languages, words to indicate the father begin with a *p,* which sounds like a blow, or with an *f,* which whistles like a whip.

Some queens placed themselves under divine protection by adopting the title "beloved of Mut," which was a title chosen by Nefertari, favorite wife of Ramses II.

But what does weight have to do with this? It makes us think of a passage from the *Book of the Dead,* where the heart of the deceased, appearing before the tribunal of Osiris, is placed in Maat's balance, from whence he proclaims: "O heart of my mother, do not testify against me!"

Moot	**the goddess Mut**	*Mwt*

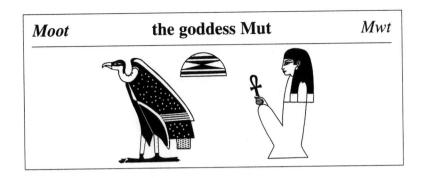

moot	**mother**	*mwt*

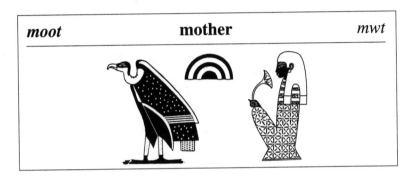

moot	**weight**	*mwt*

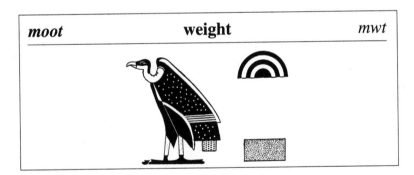

mery-en-Moot	**beloved of Mut**	*mrt-n-Mwt*

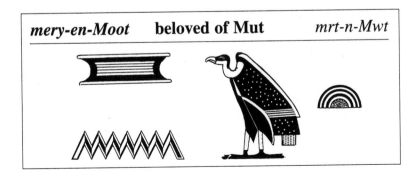

nedjem

nḏm

Triliteral: A cluster of vegetables, probably from the carob tree.

PHONETICS AND WRITING

Pronunciation: wavelets, cobra, and owl.

1. nedjem — Carob tree. Determinative: tree.

2. nedjem — Soft, sweet. Determinative: papyrus roll (sign of abstraction).

3. nedjemmeet — Passion. Determinative: phallus and plural.

4. nedjem — Agreeable, pleasant. Determinative: the man with hand to his mouth.

SEMANTICS

The sweet fruit of the carob tree evokes a variety of pleasant sensations — of taste, smell, and touch.

Figuratively speaking, a person enjoys pleasant, courteous, amiable, and joyful behavior. Sexual pleasures are included, in the context of passion.

nedjem	**carob tree**	*nḏm*

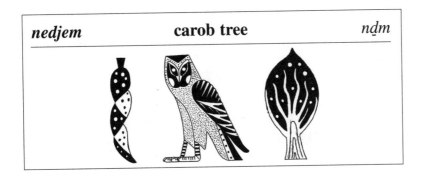

nedjem	**soft, sweet**	*nḏm*

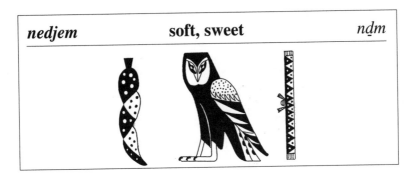

nedjemmeet	**passion**	*nḏmmyt*

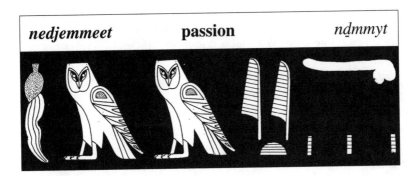

nedjem	**to be agreeable, pleasant**	*nḏm*

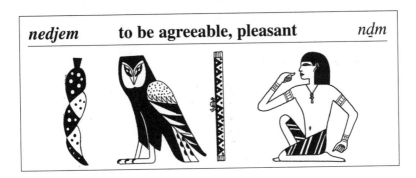

nefer

nfr

Triliteral: A stylized image showing the trachea and the heart.
Ideogram for "good," "perfect," "beautiful," "young," etc.

PHONETICS AND WRITING

Pronunciation: wavelets, viper, and mouth.

1. Nefer-tem — The god Nefertem. Determinative: a god.

2. Nefer-tee-tee — Queen Nefertiti. Determinative: none; name encircled in cartouche.

3. neferoot — Beauties. Determinative: three women and plural.

4. nefer — Beautiful, perfect, good. Determinative: identification dash.

SEMANTICS

Two vital parts of the body, the blood circulation pump and the air (oxygen) supplier, are used to create this strange sign. Without a doubt, the ancient Egyptians knew the importance of both these organs. They are the root of a series of positive ideas — not only the widely used adjectives (good, beautiful, perfect), but also vigorous, young, good quality, capable, kind, gracious, devoted, trustworthy, etc.

These terms are employed as epithets in certain priestly and administrative titles and in current expressions, where they may be used as nouns.

Wine, beer, and grain are *nefer*; several animals (cows, horses), clothing, the foundations of a building, the light from the sun, fire, crowns, etc., are all *nefer*!

Nefer-tem	**the god Nefertem**	*Nfr-tm*

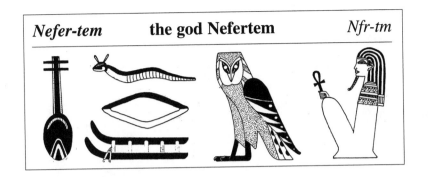

Nefer-tee-tee	**Nefertiti**	*Nfrt(y)-i(i)ty*

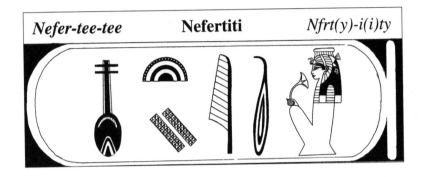

neferoot	**beauties**	*nfrwt*

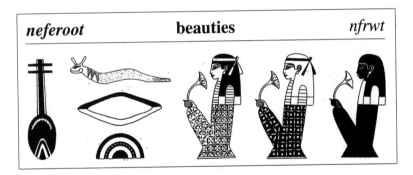

nefer	**beautiful, good, perfect**	*nfr*

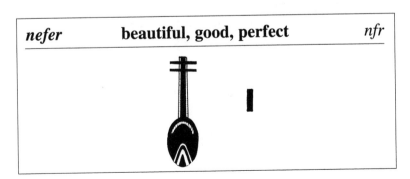

271

netcher

nṯr

Triliteral: Emblem of divinity. It seems to depict a flagpole around which a piece of fabric has been rolled. Ideogram for a "god."

PHONETICS AND WRITING

Pronunciation: wavelets, shackles, and mouth.

1. medoo-netcher — Sacred signs, hieroglyphics. Graphically, the sign *netcher* precedes these triples (plural) for "words": respectful inversion for gods and kings. Determinative: god.

2. netcheret — Goddess. Determinative: the goddess.

3. netcher — God. Determinative: archaic symbol for god.

4. netcher — God. Determinative: a god.

SEMANTICS

This hieroglyph was reserved for any concept related to the divine, therefore, also the king. The latter is *netcher nefer*, the perfect, victorious, beneficent, etc. The queens and the wives of the pharaohs use the same titles, but in the feminine.

Priestly titles, such as "divine father" and "servant of god" fall into the same category.

Everything concerning the divine through the rites is *netcher*: the natron, a substance used in mummifying, the priestly vestments or the divine statues, the paraphernalia for funeral rites (especially the rite for the opening of the mouth), and incense, the *sen-netcher*, a term that has passed down into our expression an "odor of sanctity."

Writing is believed to have been of divine origin and the hieroglyphics the words of god.

medoo-netcher	**hieroglyphics**	*mdw-nt̲r*

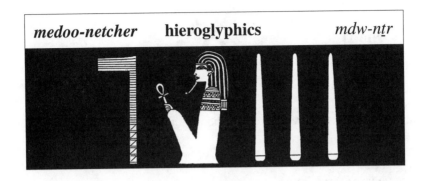

netcheret	**goddess**	*nt̲rt*

netcher	**god (archaic writing)**	*nt̲r*

netcher	**god (later writing)**	*nt̲r*

273

roodj

rwḏ

Triliteral: A bowstring, unfastened from the bow with its hooks. Ideogram for "bowstring."

PHONETICS AND WRITING

Pronunciation: mouth, quail, and cobra.

1. roodj — Sandstone, rock. Determinative: stone.

2. roodj — Solid, strong. Determinative: an arm bearing a weapon.

3. roodj — To administer. Determinative: arm holding weapon.

4. roodjet — Success. Determinative: the bowstring.

SEMANTICS

To "administer" and "success" both belong to the same line of thought: the string is the soul of the bow, which speeds the arrow — the will — straight at the target. *Roodj* is also the epithet for civil servants, even high-ranking ones. Success allows a short rest, which is illustrated by the unhooked bow string.

Strength is a quality of the bowstring, which by extension applies to the threads in fine linens and clothes. Another transposition of ideas lies in the hardness of the construction stone, which correlates with the strength of bones, a solid state of health, good physical resistance. The term also refers to effective medication. Based on that, it is not difficult to see a hint of protection: a *roodj* is also a guardian spirit who watches over Osiris!

roodj	**sandstone, rock**	*rwḏ*

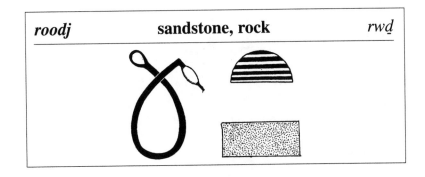

roodj	**solid, strong**	*rwḏ*

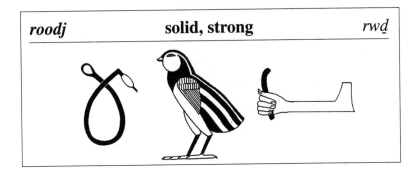

roodj	**to administer**	*rwḏ*

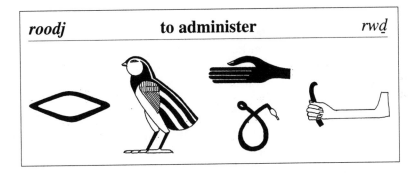

roodjet	**success**	*rwḏt*

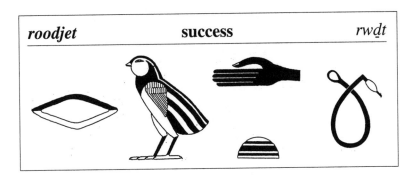

seba

śb3

Triliteral: A five-pointed star. Ideogram for "star."

PHONETICS AND WRITING

Pronunciation: cloth cushion, leg, and vulture.

1. seba — Star. Determinative: a star.

2. seba-eet — Written teaching. Determinative: papyrus roll (sign of an abstract idea).

3. seba — Door, gate. Determinative: house plan.

4. seba — To learn, teach. Determinative: arm with weapon.

SEMANTICS

Astronomy was a well-developed science in ancient Egypt. The movements of stars, recognized as different from planets, were observed and noted down. As knowledge was accumulated, it was written down on long papyrus rolls and used as part of the décor of certain temples (the Ramesseum, for example) and tombs (Seti I). These writings were part of the temple libraries and were used for teaching. The arm with a weapon, which is the determinative of the verb "to teach," says a lot about the types of methods that were used. We should add that *seba-oo* — "education" — is written with the same determinative and can also mean "punishment" — information that is worth thinking about. It is not surprising then that "to tire," and "to exhaust" are linked to the same root.

The stars, the gates of heaven, are also used as earthly gates.

seba	**star**	*śb3*

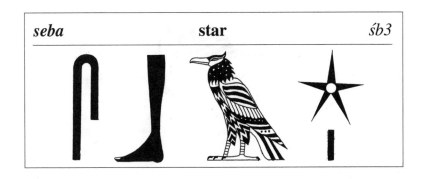

seba-eet	**written teaching, instruction**	*śb3yt*

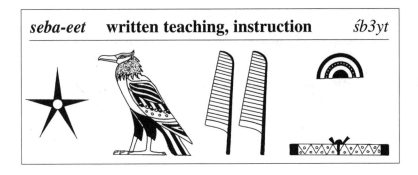

seba	**gate**	*śb3*

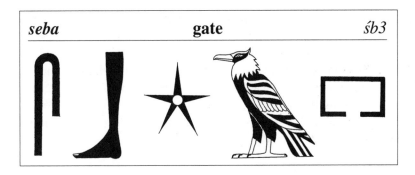

seba	**apprendre**	*śb3*

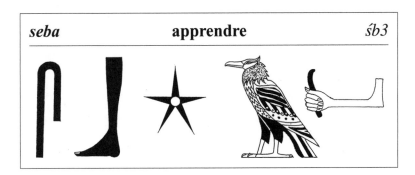

see-ah *śі3*

Triliteral: A folded and fringed piece of cloth.
Ideogram for "cloth."

PHONETICS AND WRITING

Pronunciation: cloth cushion, papyrus, and vulture.

1. See-ah — Sia, the spirit of learning, perception, and innate knowledge.
Determinative: a god.

2. see-ah-eeb — A wise man. Determinative: none.

3. see-ah — Recognize, perceive, know. Determinative: the man with hand to his mouth.

4. see-ah — Cloth. Determinative: cloth.

SEMANTICS

For the ancient Egyptians, the seat of innate knowledge was the heart, hence *sia-ib*, written with the sign for the heart. Wisdom was a quality that was attributed to several gods, especially Thot, of whom Sia is a personified emanation.

To know, understand, perceive — and even to see — all belong to the same semantic register, with a connotation of "watching over" and even of "spying" — thus having knowledge of something that is secret.

But why is a piece of cloth the graphic and semantic support for these terms, while also being a simple ideogram? Mystery. . .

See-ah	Sia, the spirit of innate knowledge	*Śi3*

see-ah-eeb	wise man	*śi3 ib*

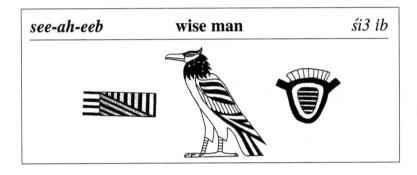

see-ah	to know, perceive	*śi3*

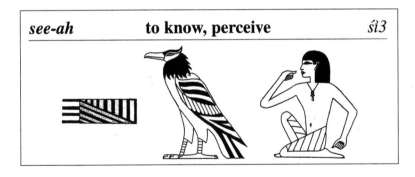

see-ah	cloth	*śi3*

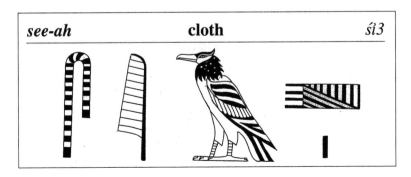

sekhem

śḥm

Triliteral: A scepter or standard.
Ideogram for "scepter" or "emblem."

PHONETICS AND WRITING

Pronunciation: cloth cushion, placenta, and owl.

1. Sekhmet — The goddess Sekhmet. Determinative: Sekhmet.

2. sekhemty — The double crown. Determinative: the *pschent.*

3. sekhemet — Power. Determinative: plural of the collective, abstract.

4. sekhem — Powerful. Determinative: arm with weapon.

SEMANTICS

The lion-goddess, Sekhmet, is the image of power and ferocity. The scepter is also a symbol — of divinity.

The double crown of the Pharaoh was considered the seat of power, somehow mystically filled with the two patron goddesses of Upper and Lower Egypt. The two "Powers" or the *sekhemty* — a word that was transcribed in Greek — became *pschent.*

Sekhmet	**the goddess Sekhmet**	*Śḫmt*

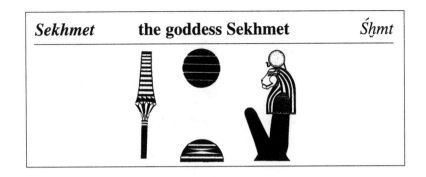

sekhemty	**double crown**	*śḫmty*

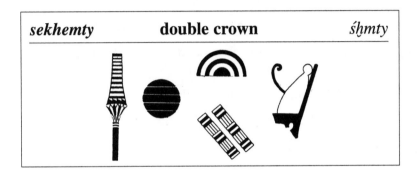

sekhemet	**power**	*śḫmt*

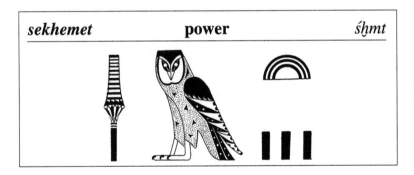

sekhem	**powerful**	*śḫm*

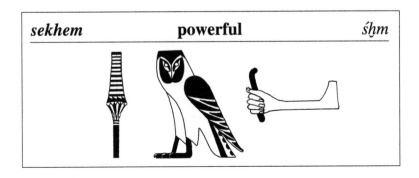

sema

śm3

Triliteral: Lungs and trachea. Ideogram and determinative for "join," "unite."

PHONETICS AND WRITING

Pronunciation: cloth cushion or, originally, bolt, owl, and vulture.

1. Sema-ta-ewy — The Union of the Two Lands — Upper Egypt and Lower Egypt. Determinative: "channel" and identification dash.

2. sema — To unite. Determinative: papyrus roll (sign of an abstract idea).

3. sema-oo — Branches. Determinative: wood and plural.

4. sema — Side, scalp. Determinative: lock of hair.

SEMANTICS

The best known application of this sign is the representation of the royal rite of the Union of the Two Lands — Upper and Lower Egypt. The emblem of the rite, carried by the gods Horus and Set (often replaced by Thot) appears as a vignette on the side panels of the royal throne.

The branches are closely connected to the tree, as the scalp is to the cranium.

Words deriving from the root "to unite" are quite numerous: joint, associate, share, prepare, companion, etc. The great royal spouse is *sema-eet* or the royal consort.

Sema-ta-ewy The Union of the Two Lands *śm3-t3wy*

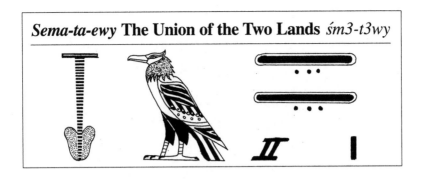

sema to unite, join *śm3*

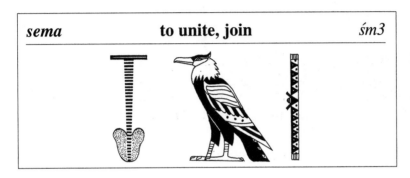

sema-oo branches *śm3w*

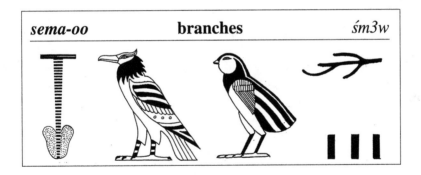

sema side, scalp *śm3*

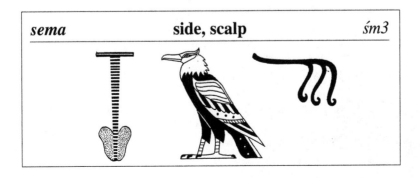

senedj

śnḏ

Triliteral: A trussed goose or duck.

PHONETICS AND WRITING

Pronunciation: cloth cushion, wavelets, and cobra.

1. senedj — To fear, respect. Determinative: the man with hand toward mouth.

2. senedjet — Fear. Determinative: identification dash.

3. senedjoo — Frightened, timid man. Determinative: the man with hand toward mouth, plus a man.

4. senedjet — Terror. Determinative: the triliteral *senedj.*

SEMANTICS

The poor fowl, being prepared for roasting, can only inspire fear among its fellow creatures and incite human beings to healthy reflection. Along the same lines, the verb *ooshen* — "to wring a neck" — also has this solemn triliteral as its determinative.

"To fear," "dread," "to feel terror," and all other derived terms obey the same logic. The fear may be respectful, as with reverence to the gods, the king, and other high personages who enjoy the privileges of social rank and position. Men are happy to turn to them and seek their protection (also *senedj*). Moreover, a conscientious chief will not deny them his support so that they will be spared their worries (*senedj*).

senedj	**to fear, respect**	*śnḏ*

senedjet	**to fear**	*śnḏt*

senedjoo	**frightened man**	*śnḏw*

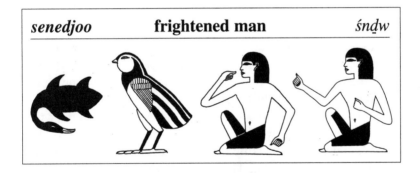

senedjet	**terror**	*śnḏt*

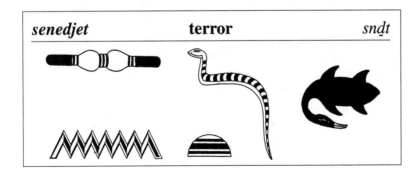

285

shemah

šm ᶜ

Triliteral: A flowering plant, not identified.
Ideogram for Upper Egypt.

PHONETICS AND WRITING

Pronunciation: basin, owl, and arm.

1. Ta-shemah / Ta-shema — Upper Egypt. No determinative.

2. shemah-eet — Female singer (generally for a god — usually Amon). Determinative: a woman.

3. shemaht — Flax from Upper Egypt. Determinative: a bond, thread.

4. eet-shemah-ee — Barley from Upper Egypt. Determinative: a measure of grain.

SEMANTICS

Terms referring to Southern Egypt all belong to the same semantic register. The triliteral plant has never been identified, despite repeated efforts of the specialists. Opinions vary widely, ranging from a wetland to a desert flower, which means that the range of attributes is equally vast. What is certain is that this plant was emblematic of Upper Egypt, often shown in contrast to the emblem for Lower Egypt (whose symbol is the whip, *meh*, see B 38). Products from Upper Egypt were held in high esteem: grain (barley for beer), beef, and flax, which was renowned for its flexibility. Its fibers were used for the finest linen, which fit the body like a second skin. Through a play on words and semantic similarity, flax or linen slipped into the verb *shema*, meaning to press closely against another person.

The link between *shema* and "to sing" appears to be no more than phonetic. But this meaning has several derivatives: to clap hands, applaud, the moaning of the wind or of monkeys, to sing, a singer of Amun (the most famous), and to play a musical instrument.

Ta-shemah / Ta- shema Upper Egypt *T3-šmc / T3-šm3*

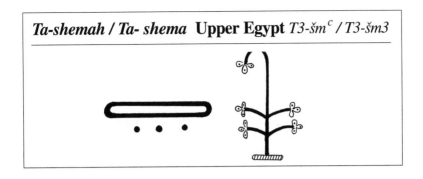

shemah-eet **singer (of a god)** *šmcyt*

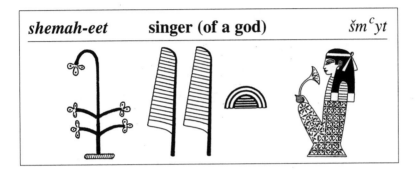

shemaht **flax from Upper Egypt** *šmct*

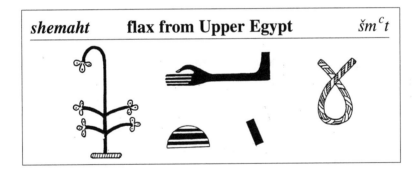

eet-shemah-ee **barley from Upper Egypt** *ỉt-šmc(y)*

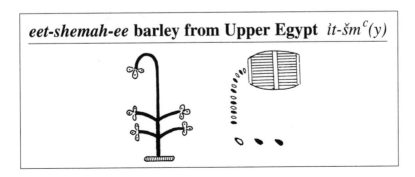

shemes

šmś

Triliteral: The pack of a hunter or warrior.
Ideogram for the verb "to follow" or for "entourage."

PHONETICS AND WRITING

Pronunciation: basin, owl, cloth cushion.

1. shemes — To follow. Determinative: walking legs.

2. shemesoo — Courtiers, followers. Determinative: man (sometimes with the plural).

3. shemesoot — The king's or the god's entourage. Determinative: legs and plural (three dashes).

4. shemes-oodja — Funeral procession. Determinative: legs.

SEMANTICS

What did the pack really contain? What was its original function? The question is still worth asking. It probably contained all the instruments required for a hunting or war expedition and always remained in the possession of its owner — or was carried by one of his aides. All derivative words written with this symbol contain the meaning of following, being of service, being available.

The courtiers were the followers of the king; the priests were the followers of the gods. The heavenly spirits followed the sun and pulled its bark; on earth, the members of the funeral procession pulled the catafalque, followed by family and friends.

The association of this hieroglyph with the cat, *Madfet*, the executor of lofty deeds in the hereafter, opens new and troubling perspectives with respect to this strange sign.

shemes	**to follow**	*šmś*

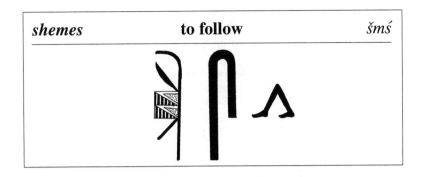

shemesoo	**courtiers, followers**	*šmśw*

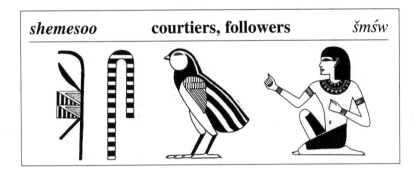

shemesoot	**royal or divine entourage**	*šmśwt*

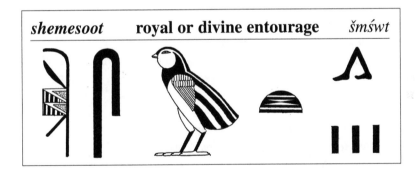

shemes-oodja	**funeral procession**	*šmś-wḏ3*

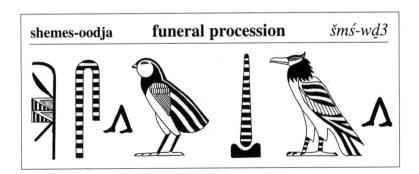

shesep

šsp

Triliteral: A barrier or enclosure.

PHONETICS AND WRITING

Pronunciation: basin, bolt (or cloth cushion), and stool. The inversion from *shesep* to *seshep* often occurs.

1. shesepoo — Sphinx. Determinative: sphinx.

2. shesep — Image, statue. Determinative: statue.

3. shesep — White, shining. Determinative: the shining sun.

4. shesepet — Cucumber. Determinative: fruit, three dashes for plural.

SEMANTICS

The selection here reveals the variety of words written with the help of this hieroglyph, which is intrinsically limited and compartmentalizing, but logical.

The verb *shesep* means to receive, accept, seize. It is used in many different ways and also as a medical term — hence the inclusion of cucumber along with other ingredients. Everyone is happy to receive a gift, a civil servant accepts his position, the king accepts his tribute and seizes the throne, whereas the soldiers seize their arms. A host receives his friends; he gives shelter to the persecuted. Figuratively, we receive both praise and blows (real ones and the blows of fate). Temples, houses, and tombs receive their inhabitants. *Shesep* is also a measure: a handful is a subdivision of the cubit.

All these activities have their derivatives. The artist's hand shapes the images that receive the imprint of magic: they are "charged." The sphinx is a "living image," which was brought to life through ritual. The ceremonial known as the "Opening of the Mouth" used to be called the "Book of the Statue." Once charged, the images shine, as they emit the divine vibrations with which they have been invested.

shesepoo	**sphinx**	*šspw*

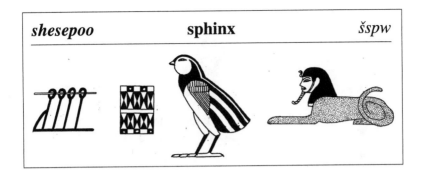

shesep	**statue, image**	*šsp*

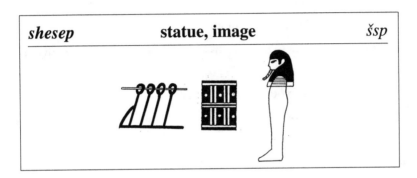

shesep	**white, shining**	*šsp*

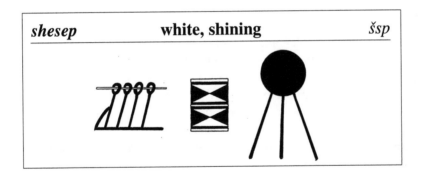

shesepet	**cucumber**	*šspt*

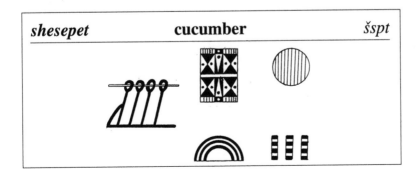

tyoo

tyw

Triliteral: A hawk (buteo ferox).

PHONETICS AND WRITING

Pronunciation: bread, double reed, and quail.

1. khertyoo-netcher — Those belonging to the necropolis. Determinative: man and sign for plural (three dashes).

2. ee-tyoony — Greetings to you! No determinative.

3. eemntyoo — The inhabitants of the West. Determinative: none; sometimes a man and a woman.

4. kheftyoo — Enemies. Determinative: man hitting his head.

SEMANTICS

This triliteral is a purely graphic and phonetic sign and not an ideogram: therefore it does not refer to any specific semantic idea and is used for a number of different words that are not semantically related. Our only possible observation about this term is the identity of the bird depicted, a particularly ferocious bird of prey, as indicated by its Latin name. The greeting it represents is not necessarily friendly; it is used with reference to enemies and their habits, which we might say are similar to the habits of the vulture. It can apply both to the workers in the necropolis and to the deceased who are buried toward the west in the dwelling place of the living.

khertyoo-netcher **those of the necropolis** *ẖrtyw-nṯr*

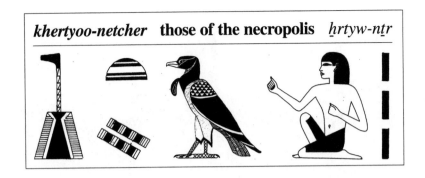

ee-tyoony **Greetings to you!** *ii-tywny*

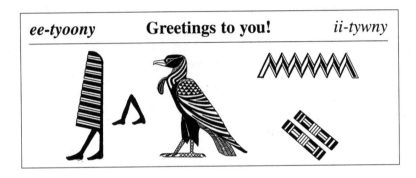

eemntyoo **inhabitants of the West (the dead)** *imntyw*

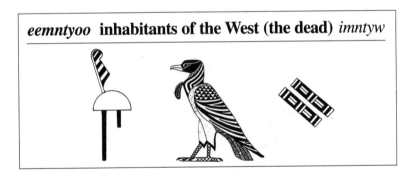

kheftyoo **enemies** *ḫftyw*

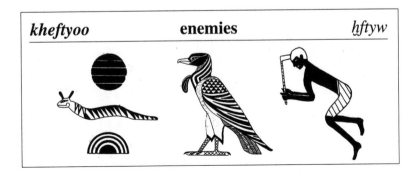

293

wadj

w3ḏ

Triliteral: The image of the stem of a flowering papyrus.
Ideogram for "papyrus-shaped column," "papyrus," the plant.

PHONETICS AND WRITING

Pronunciation: quail, vulture, and cobra.

1. Wadjeet — Wadjyt, cobra-goddess. Determinative: coiled cobra.

2. wadj — Papyrus (plant). Determinative: the sign for plants.

3. wadj — Green. No determinative.

4. wadj-oor — The deep green = the sea. Determinative: water.

5. wadjedjet — Vegetation, greenery, green plants. Determinative: plants and three dashes for plural (collective).

SEMANTICS

What greenery! The most Egyptian of all plants forms the root of many words, all of which are positive. "Papyrus," "green," and "vegetation" are the most evident. The sea lent its name "deep green" to the Mediterranean, which we more often refer to as the "deep blue."

The cobra-goddess is hardly green, but this sacred animal lives in the green swamplands. The goddess was venerated in the Delta, especially in her main temple at Buto, the ancient twin sacred cities of Pe and Dep. *Wadjyt* is the personification of the red crown (complementary color to green!) of Lower Egypt, of which she was the patron.

But other meanings are derived from *wadj*: scepter of the goddesses, "green" sexuality, vigor, son, offspring, youth, good health. One who prospers is happy; the papyrus-shaped column is green, just like the amulet that imitates it. Some perfumes, ointments, and invigorating oils are *wadj*. When applied to food, the word means fresh (milk), unspoiled (figuratively as well), or raw. Offerings are fresh and provide vigor to the dead who are promised rebirth.

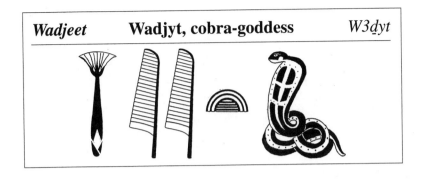

Wadjeet — Wadjyt, cobra-goddess — *W3ḏyt*

wadj papyrus *w3ḏ* | **wadj** green *w3ḏ*

wadj-oor — the deep green sea — *w3ḏ-wr*

wadjedjet — vegetation — *w3ḏḏt*

295

wah

w3ḥ

Triliteral: Straw broom, see also the biliteral *sek* (B 62).

PHONETICS AND WRITING

Pronunciation: quail, vulture, and lamp wick.

1. wah — To put on, lay down. Determinative: papyrus roll (sign of an abstract idea).

2. wah-eeb — Friendly, patient. Determinative: papyrus roll.

3. wahoo — Necklace. Determinative: necklace.

4. waheet — Grain, cereal. Determinative: grain measure.

SEMANTICS

The triliteral pronunciation is completely different from that of the cleaning instrument, even though it is written with the same hieroglyph. We don't know why this mutation took place, but we believe it happened at the end of the Middle Kingdom. Both a phonetic and a semantic change, it is based on the various meanings of the verb: to put on, lay down, give, make offerings, found, consecrate, endure, etc. Thus you put on a dressing, lay down arms or a load, give a garment or a piece of jewelry. On a different semantic register, you consecrate your heart and your time with loving patience. Laying down rich offerings perpetuates the memory of the departed and is also a supplication to a god. Everyone hopes to prolong his days as long as life endures on this earth (*wah-tep-ta*).

When calculating, you put down the remainder to get the right results. This idea is reflected in *waheet,* the measure of grain. The right measure also applies to justice, which is why by extension, *wah* is used in formulas for swearing an oath or in set expressions like "to bow your head" (*wah tep*), which the condemned prisoner must do when "meted out death" (*wah moot*).

wah	put on, lay down	w3ḥ

wah-eeb	friendly, patient	w3ḥ-ib

wahoo	necklace	w3ḫw

waheet	grain	w3ḫyt

was

w3ś

Triliteral: Long, straight-stemmed scepter. Ideogram for the *was* scepter. Often replaces the spirally twisting stem scepter, *djam*.

PHONETICS AND WRITING

Pronunciation: quail, vulture, and cushion cover.

1. wahsty —Theban, the epithet of the god Menthu. Determinative: a god.

2. Wahset — Thebes. Determinative: a city.

3. Wahset — Theban Nome. Determinative: nome.

4. Wahs — Scepter (*was*). Determinative: wood.

SEMANTICS

The origin of this unusual scepter is not easy to ascertain; it appears very early in Egyptian writing and probably represents the animal of Set. Its forked tip is reminiscent of the sticks used by snake hunters, which are still in use in the mountains of Egypt. The interpretation we are proposing is hypothetical. Stories abound in mythology about the relations between the god Set and the snake Apophis. Set is the incarnation of the indomitable forces of nature; he plays a negative, even a shameful role, but one that is necessary for cosmic equilibrium. He helped maintain this equilibrium during the perilous nighttime travel of the sun waiting to be born. Set joined Atum on the trip, and he held off and even killed the fearful snake, Apophis using a long blade! Yet some even treated Set himself as Apophis! The bearer of the scepter *was* has power over the forces of darkness, so it was no surprise that Osiris and Ptah seized it.

The triliteral is applied almost exclusively to Thebes, its nome (territorial district), and its divinities. In addition, *was* means well-being and happiness, but curiously enough, also weak, miserable, and ruined — there is a flip side to every coin.

Wahsty	the Theban god Mentou	*w3śty*

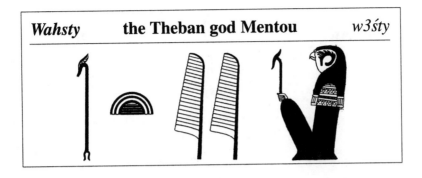

Wahset	Thebes	*W3śt*

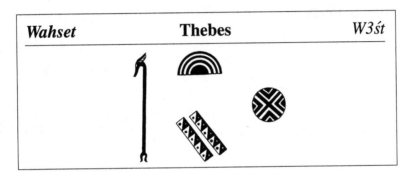

Wahset	the Theban Nome	*w3śt*

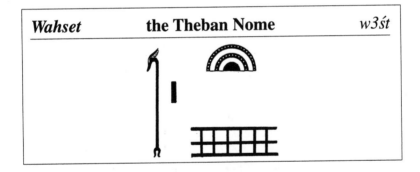

wahs	scepter	*w3ś*

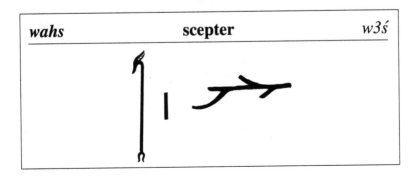

oohem

wḥm

Triliteral: The leg of a hoofed (bovine) animal.
Ideogram for "bovine leg."

PHONETICS AND WRITING

Pronunciation: quail, lamp wick, and owl.

1. em-oohem-ah — Again, once more. Determinative: papyrus roll (sign of an abstract idea).

2. oohemet — Hoof. Determinative: identification dash.

3. oohem — Redo, repeat (action). Determinative: papyrus roll (sign of an abstract idea).

4. oohemoo — Herald, clerk. Determinative: two spokesmen.

5. oohememeet — Repetition (words). Determinative: man and three dashes for collective and plural

SEMANTICS

This hieroglyph is a good example of terms that express the idea of repetition. Observe the behavior of the bull before it attacks, angrily stamping its front leg on the ground again and again, and you will understand why this sign has been chosen as the ideogram.

When words are repeated or reported — benevolently or malevolently — by order of the herald, or by witnesses, and then recorded in writing by the clerk, the expression is "what has been said" (*oohem medet*). When an action is repeated, a gesture, or a ceremony, you may find such expressions as "repeat the feast of *sed*," the jubilee of the king (*oohem hebsed*); or "to reappear" (*oohem khaoo*) also used for the king, referring to his reappearance on the throne, the renewal of his coronation.

The most important repetition of all is that of life itself: renewal, rejuvenation, resurrection (*oohem-ahnkh*), referring to the flood waters and the return of life. *Oohem-ahnkh* is also the name of one of the squares in the famous game *senet*, which is written with the frog as determinative. This also recalls the lamps of a later era that were shaped like frogs, and the batrachia, which in its tadpole form is used as the sign representing one million years.

em-oohem-ah **again, once more** *m-wḥm-ᶜ*

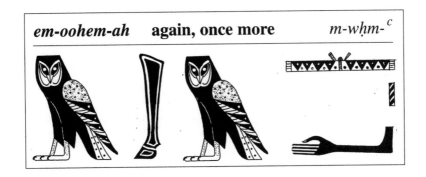

oohemet **hoof** *wḥmt* **oohem** **redo, repeat** *wḥm*

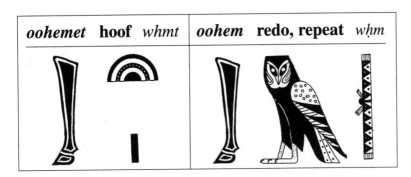

oohemoo **herald** *wḥmw*

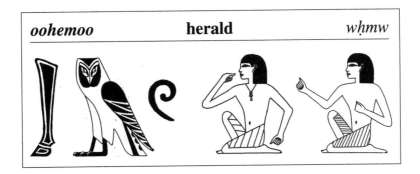

oohememeet **repetition (of words)** *wḥmmyt*

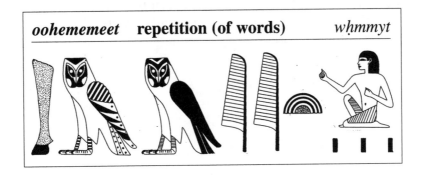

ooser

wśr

Triliteral: Head and neck of a canine carnivore *(canidae).*

PHONETICS AND WRITING

Pronunciation: quail, cloth cushion, and mouth.

1. Ooser-Maaht-Re — Name referring to the crowning of Ramses II. No determinative, replaced by the cartouche.

2. ooser — Powerful, strong. Determinative: the arm with weapon.

3. ooseret — The neck. Determinative: morsel of flesh and identification dash.

4. ooser — Influential man. Determinative: man.

5. ooseret — Powerful woman. Determinative: lady, queen, goddess.

SEMANTICS

The powerful neck of the members of the canine family — snout thrust forward ready to bite — is the model for this hieroglyph and its meaning. *Ooser* means powerful in all its manifestations.

Men and women, and of course gods, kings, and queens are powerful or influential, according to the circumstances. In the plural (a collective) this sign is used to express absolute power, for which it is the emblem. Physical power and strength are also expressed by this term, and figuratively it is used in expressions like "great-hearted" to signify bravery and courage. The sign appears among royal names and epithets. The most famous is known as the "crowning of Ramses II," which can be translated as "Powerful is the balance of Ra," which is cosmic balance or justice: these terms are related to the essence and function of the goddess, Maat.

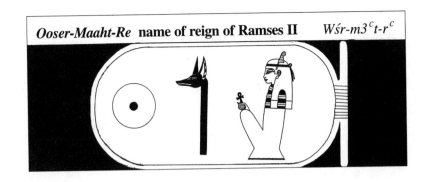

Ooser-Maaht-Re name of reign of Ramses II *Wśr-m3ᶜt-rᶜ*

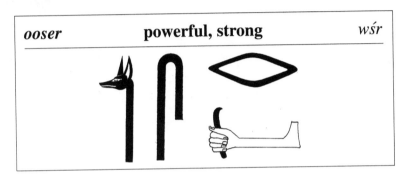

ooser **powerful, strong** *wśr*

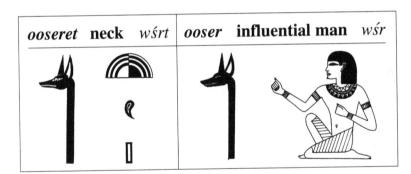

ooseret neck *wśrt* | *ooser* **influential man** *wśr*

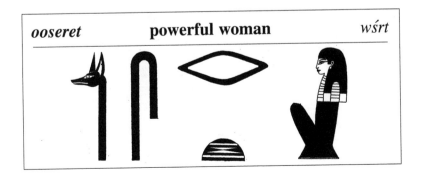

ooseret **powerful woman** *wśrt*

303

THE SUPPLEMENTAL SERIES

The twenty-nine plates that follow contain a variety of expressions that are not necessarily interrelated. Their purpose is to provide you with an attractive support that will allow you to test what you have learned. That is why no commentary has been provided for the approximately one hundred words that are shown here. The words are only translated and transcribed. Our intention is to provide a learning tool based on your ability to interact with the book. We hope that you will be duly impressed by both the artistic merit of the images shown and the originality of thought of the ancient Egyptians. Perhaps you will even be motivated to create your own mini-dictionary, which will spur you on to further more in-depth investigations — and who knows? As a new scribe, you will be able to test your learning on the roughly 700 hieroglyphics that exist from the classical age and the several thousand from the Greco-Roman era.

akhakh	the stars	3ḫ3ḫ

Aker	the god Aker	3kr

ad	to be savage	3d

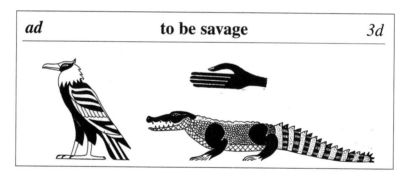

Abdjoo	Abydos	3bḏw

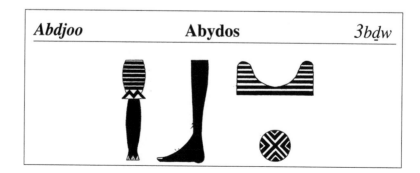

akhet	**horizon**	*3ḫt*

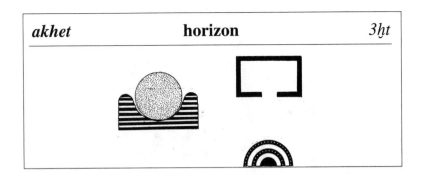

yow	**to adore**	*i3w*

yow	**to be elderly**	*i3w*

yowt	**function, duty**	*i3wt*

309

yabtet	the East	*t3btt*

yahn	baboon	*i͑n*

yoo-m-hetep	come in peace	*iw-m-ḥtp*

oz	to hurry	*3ś*

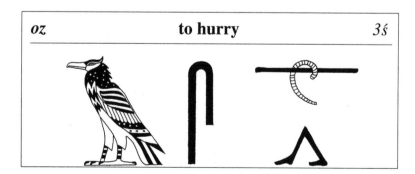

Oosir	**Osiris**	*Wsîr*

yoor	**to conceive a child**	*iwr*

ee-bar	**stallion**	*ib3r*

yam	**gracious**	*i3m*

een	**to bring**	*in*	*een(oo)*	**tributes**	*inw*

eeten	**disk, solar disk**	*itn*

eeker	**excellent**	*iḳr*

eeghep	**cloud**	*igp*

312

eepy-eeb	a regular heart	ipy-ib

eeteroo-renpoot	seasons	itrw-rnpwt

eech	to take, seize	i͏t	aht	member	ͨt

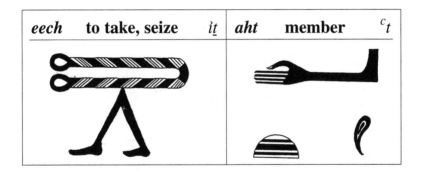

ahfef	fly	ͨff

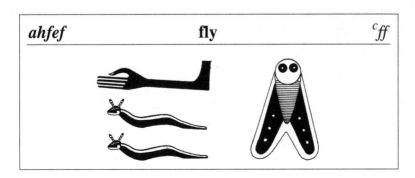

ah-a	door	c3

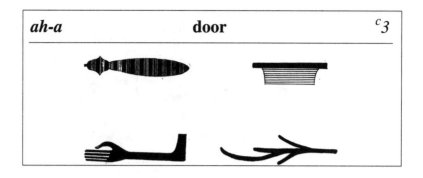

oon	to open	*wn*

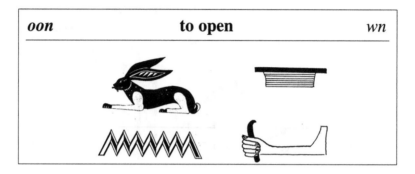

oor-eeb	insolent	*wr-ib*

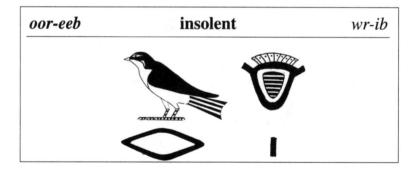

oor-heka-oo	magical instrument, amulet	*wr-ḥk3w*

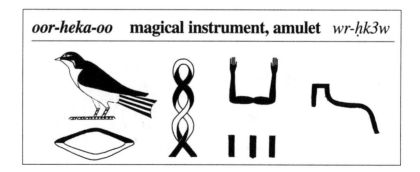

oosekh necklace *wśḫ*

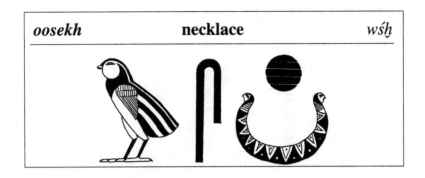

ooshebet answer *wšbt*

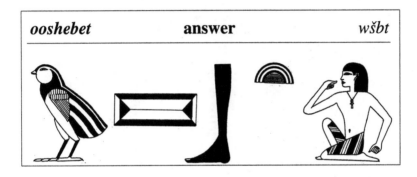

em-bah before, in the presence of *m-b3ḥ*

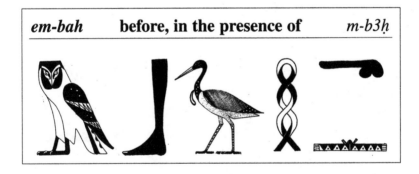

babaw hole(s), the 7 openings of the head *b3b3w*

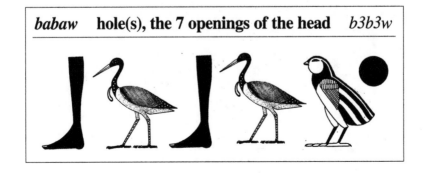

oodjot	the eye of Horus	*wḏ3t*

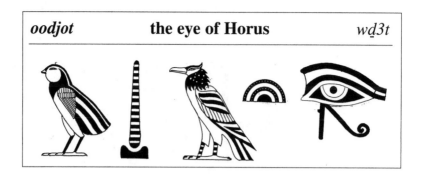

oo-dja	healthy, complete	*wḏ3*

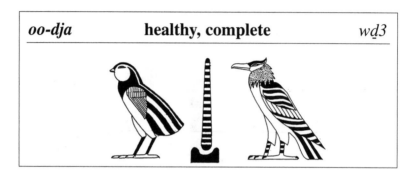

ba-oot	virility	*b33wt*

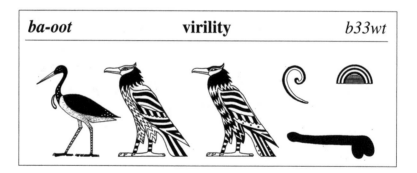

bahbah	to drink	*b^cb^c*

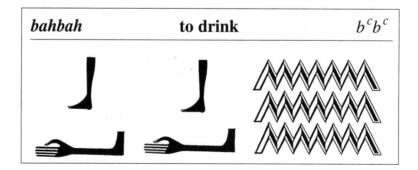

bah	**flood**	$b\,^c\dot{h}$

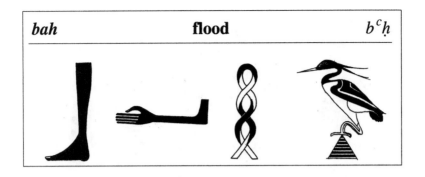

beneroo	**dates**	*bnrw*

beneri	**sweet, mild**	*bnri*

bes	**secret**	*bś*

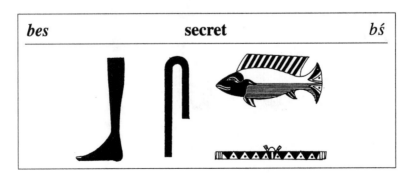

Poont	**the Land of Punt**	*Pwnt*

peroo	**surplus, extra**	*prw*

peherer	**to run**	*pḥrr*

petpet	**to walk, to crush**	*ptpt*

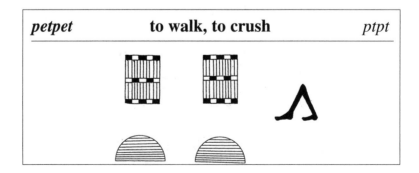

pekher to envelop, to turn round and round *pḫr*

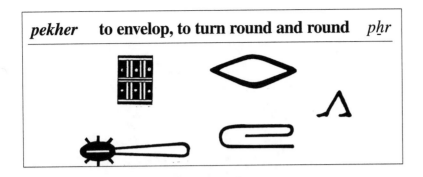

pekheret medication, remedy *pḫrt*

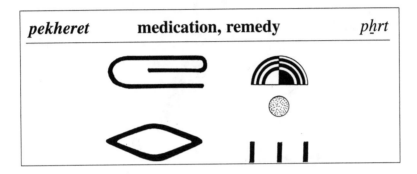

fendjy he with a crooked beak *fnḏy*

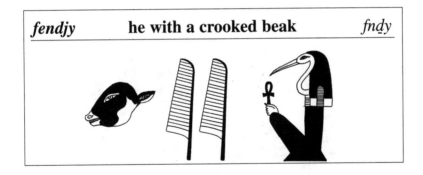

maw-hair mirror *m3w-ḥr*

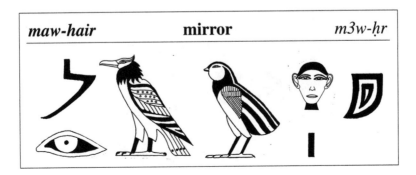

ma-hedj	**oryx**	*m3-ḥḏ*

mahmah	**giraffe**	$m^c m^c$

menoo	**trees, plantation**	*mnw*

meneh	**wax**	*mnḥ*

320

meret	the street	mrt

mesektet	the celestial bark of the night	mśktt

meteret	mid-day	mtrt

mahket	ladder	m3ḳt

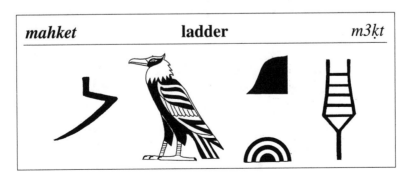

mesoo	**children**	*mśw*

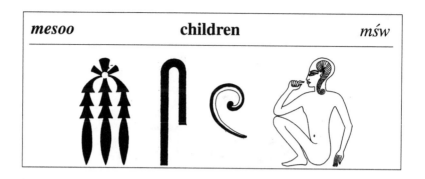

meseka	**skin**	*mśk3*

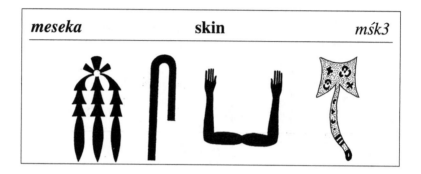

meher	**milk jar**	*mhr*

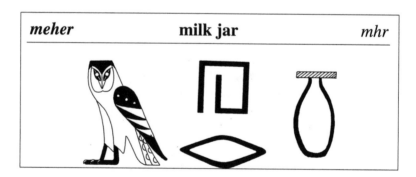

meseket	**Milky Way**	*mśḳt*

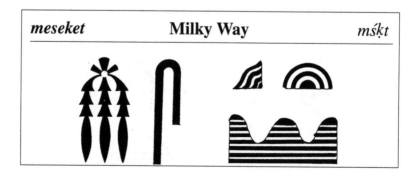

matsh	**granite**	*m3ṯ*

medoo	**to speak**	*mdw*

nee-oot	**city**	*niwt*

nehep	**to copulate**	*nhp*

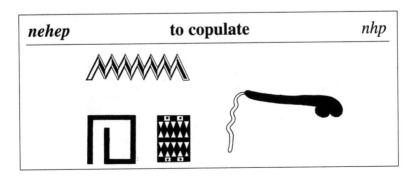

nesheni	rage	nšnì

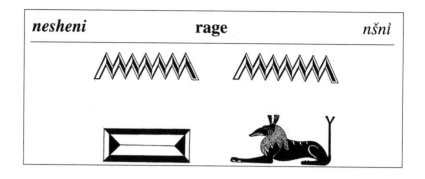

rooty	outside, exterior	rwty

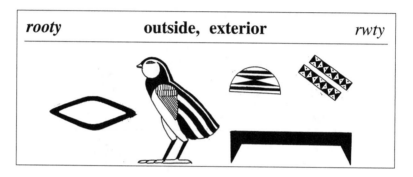

roo-ee	to leave, go	rwi

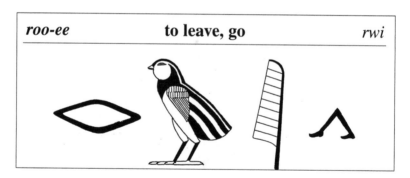

renep	colt	rnp

rekh	**to know**	*rḫ*

rekh	**wise man**	*rḫ*

rekeet	**the King's subjects**	*rḫyt*

redi	**to give**	*rdi*

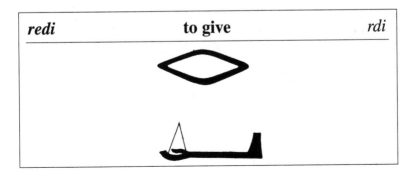

henty	**period of time**	**ḥnty**

Hor	**Horus**	**Ḥr**

henememet	**the people of the sun, humanity**	**ḥnmmt**

hairy	**he who is above (superior)**	**ḥry**

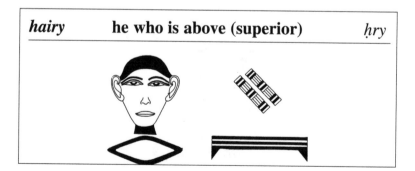

hairy-eeb	in the middle, the center	ḥry-ỉb

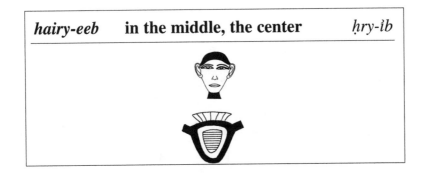

heter	harness, cart	ḥtr

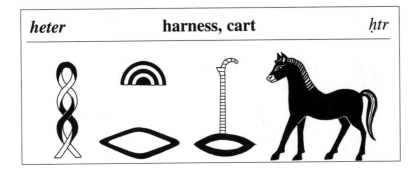

hetshet	hyena	ḫtt

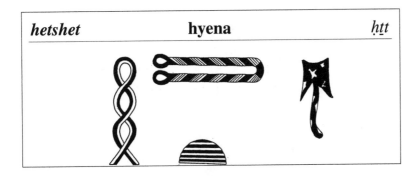

Karoo	Khor, Palestine	Ḫ3rw

327

Khemenoo	**Hermopolis**	*Ḫmnw*

khetemeet	**sealed room**	*ḫtmyt*

seep	**to inspect**	*śỉp*

sahsha	**to police, to police a district**	*śᶜš3*

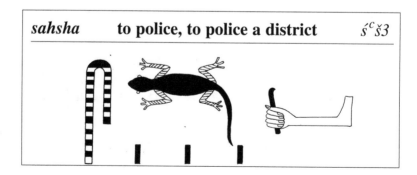

Khonsoo	the god Khonsu	Ḫnśw

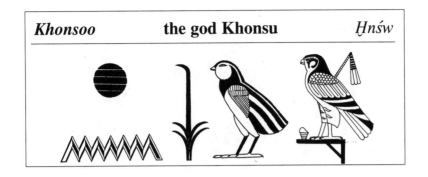

khenes	to go in two directions	ḫns

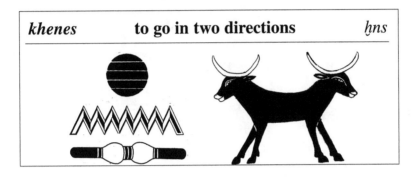

khedi	to navigate northward	ḫdi

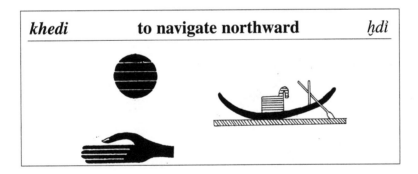

kheret	condition	ḫrt

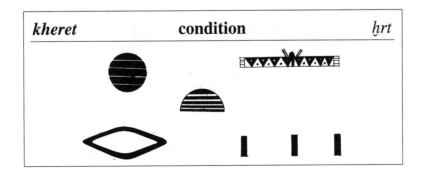

329

| *sayahnkh* | sculptor | *śᶜnḫ* |

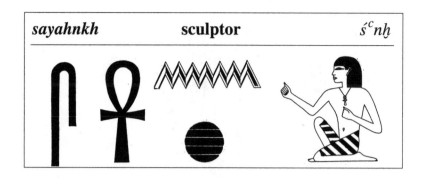

| *sahh* | nobleman, dignitary | *śᶜḥ* |

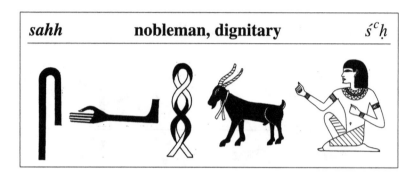

| *sooh* | breeze | *śẉḥ* |

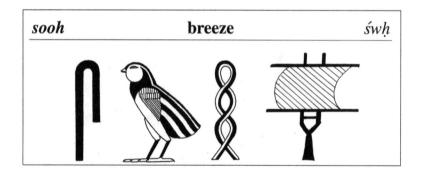

| *sepat* | nome, Egyptian province | *śp3t* |

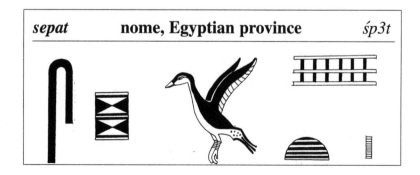

Seshat	**the goddess Seshat**	*Śš3t*

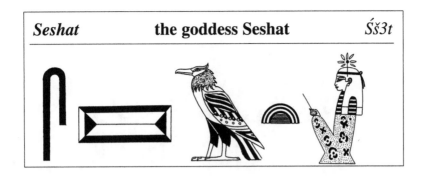

sekheret	**papyrus roll**	*śḫrt*

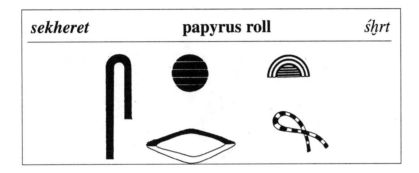

sekher	**plan, advice**	*śḫr*

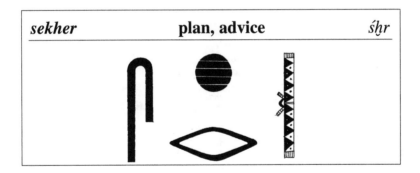

seper	**to complain, request**	*śpr*

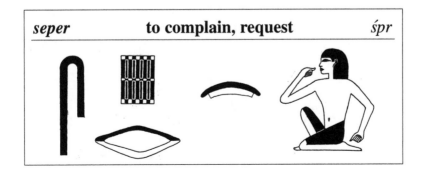

331

seshem	**direct, guide**	*śšm*

shemoo	**traveler**	*šmw*

kot	**height**	*ḳ3t*

kema	**create, develop**	*ḳm3*

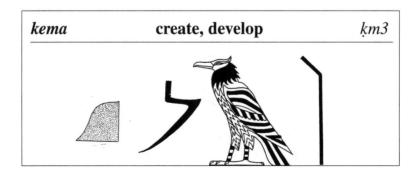

zesh	**scribe**	*sš*

kary	**gardener**	*k3ry*

tep nefer	**a good start**	*tp nfr*

teet	**image**	*tit*

333

desheret **the Crown of Lower Egypt** *dšrt*

dwah-eet **morning** *dw3yt*

dwat **the hereafter** *dw3t*

dwat **praise, adoration** *dw3t*

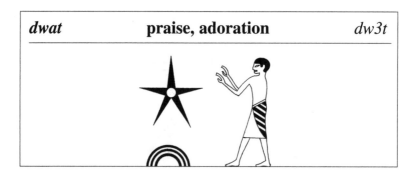

tshenoot	**quantity, return**	*ṯnwt*

da	**copulate**	*d3*

deret / djeret **hand** *drt/ḏrt*	*derep*	**consecrate, offer**	*drp*

dja-eet	**to cross the water**	*ḏ ᶜ ỉ*

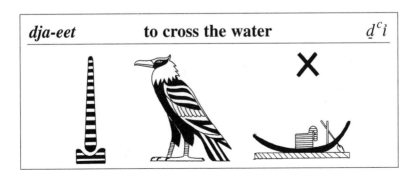

djahm	scepter	\underline{d}^cm

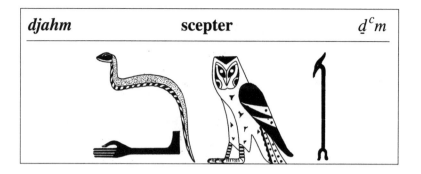

djahmoo	**fine gold**	\underline{d}^cmw

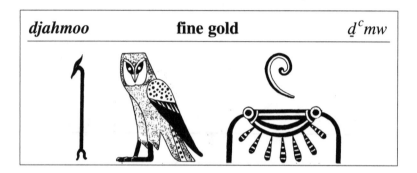

djeroot	**sarcophagus**	$\underline{d}rwt$

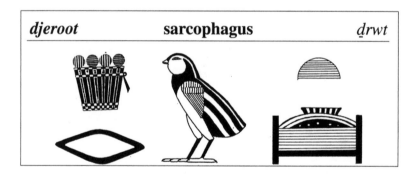

djeser	**holy, sacred**	$\underline{d}\acute{s}r$

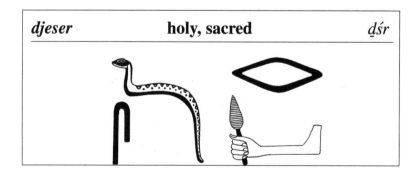

SUMMARY LIST OF HIEROGLYPHIC SIGNS

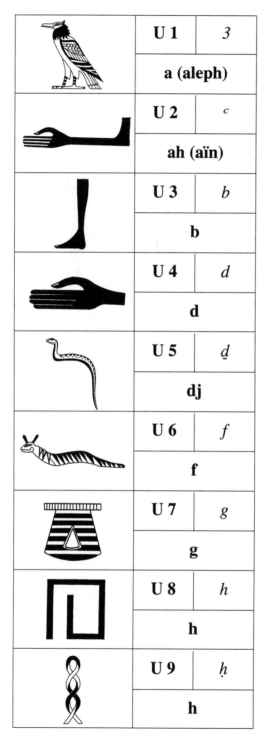

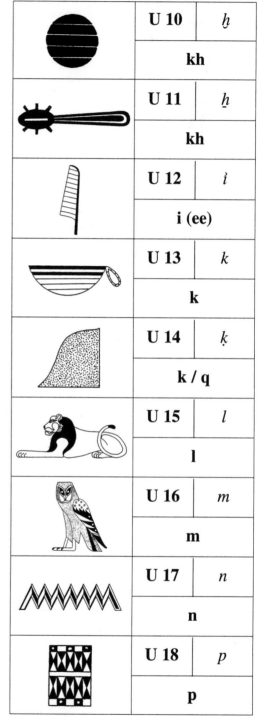

	U 1	*ꜣ*
	a (aleph)	
	U 2	*ꜥ*
	ah (aïn)	
	U 3	*b*
	b	
	U 4	*d*
	d	
	U 5	*ḏ*
	dj	
	U 6	*f*
	f	
	U 7	*g*
	g	
	U 8	*h*
	h	
	U 9	*ḥ*
	h	

	U 10	*ḫ*
	kh	
	U 11	*ẖ*
	kh	
	U 12	*ỉ*
	i (ee)	
	U 13	*k*
	k	
	U 14	*ḳ*
	k / q	
	U 15	*l*
	l	
	U 16	*m*
	m	
	U 17	*n*
	n	
	U 18	*p*
	p	

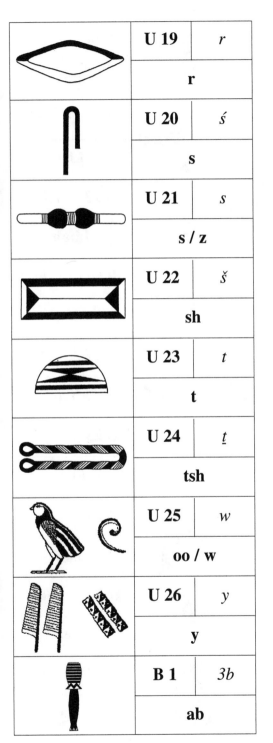

Sign	Code	Transliteration	Pronunciation
	U 19	*r*	r
	U 20	*ś*	s
	U 21	*s*	s / z
	U 22	*š*	sh
	U 23	*t*	t
	U 24	*ṯ*	tsh
	U 25	*w*	oo / w
	U 26	*y*	y
	B 1	*3b*	ab
	B 2	*3ḫ*	akh
	B 3	*3w*	ah-oo
	B 4	*ᶜ3*	ah-a
	B 5	*ᶜḏ*	ahdj
	B 6	*ᶜḳ*	ahk
	B 7	*b3*	bah
	B 8	*bḥ / ḥw*	beh / hoo
	B 9	*ḏ3*	dja
	B 10	*ḏd*	djed

	B 11	_ḏr_
	djer	

	B 12	_ḏw_
	djoo	

	B 13	_gm_
	gem	

	B 14	_ḥ3_
	ha	

	B 15	_ḥḏ_
	hedj	

	B 16	_ḥm_
	hem	

	B 17	_ḥm_
	hem	

	B 18	_ḥn_
	hen	

	B 19	_ḥr_
	her	

	B 20	_ḥś_
	hes	

	B 21	_ḫ3_
	kha	

	B 22	_ḫ ͨ_
	khâh	

	B 23	_ḫt_
	khet	

	B 24	_ḫw_
	khoo	

	B 25	_ẖ3_
	kha	

	B 26	_ẖn_
	khen	

	B 27	_ẖn_
	khen	

	B 28	_ẖr_
	kher	

	B 29	*ỉn*
	een	
	B 30	*ỉr*
	eer	
	B 31	*ỉs*
	ees	
	B 32	*ỉw*
	yoo	
	B 33	*k3*
	ka	
	B 34	*km*
	kem	
	B 35	*ḳd*
	ked	
	B 36	*ḳś*
	kes	
	B 37	*m3*
	ma	

	B 38	*mḥ*
	meh	
	B 39	*mỉ*
	mee	
	B 40	*mn*
	men	
	B 41	*mr*
	mer	
	B 42	*mr*
	mer	
	B 43	*mś*
	mes	
	B 44	*mt*
	met	
	B 45	*mw*
	moo	
	B 46	*nb*
	neb	

	B 47	*nb*
	neb	
	B 48	*nḏ*
	nedj	
	B 49	*nḥ*
	neh	
	B 50	*nm*
	nem	
	B 51	*nn*
	nen	
	B 52	*nś*
	nes	
	B 53	*nt*
	net	
	B 54	*nw*
	noo	
	B 55	*p3*
	pa	

	B 56	*pḥ*
	peh	
	B 57	*pr*
	per	
	B 58	*rw*
	roo	
	B 59	*s3*
	sa / za	
	B 60	*s3*
	za / sa	
	B 61	*ś3*
	sah	
	B 62	*śk*
	sek	
	B 63	*śn*
	sen	
	B 64	*śt*
	set	

	B 65	*św*		**B 74**	*tm*
	soo			**tem**	
	B 66	*š3*		**B 75**	*t̲3*
	sha			**tsha**	
	B 67	*šd*		**B 76**	*t̲s*
	shed			**tshez**	
	B 68	*šn*		**B 77**	*w3*
	shen			**wa**	
	B 69	*šś*		**B 78**	*w^c*
	shes			**wah**	
	B 70	*šw*		**B 79**	*wd̲*
	shoo			**oodj**	
	B 71	*t3*		**B 80**	*wn*
	ta			**oon**	
	B 72	*t3*		**B 81**	*wn*
	ta			**oon**	
	B 73	*tỉ*		**B 82**	*wp*
	tee			**oop**	

(swallow)	**B 83**	*wr*		(jug)	**T 9**	*ḫnm*
	oor				**khenem**	
(flagpole)	**T 1**	*ꜥḥꜥ*		(obelisk)	**T 10**	*iwn*
	ah-hah				**yoon**	
(ankh)	**T 2**	*ꜥnḫ*		(bell)	**T 11**	*mnḫ*
	ahnkh				**menekh**	
(lizard)	**T 3**	*ꜥšꜣ*		(vulture)	**T 12**	*mwt*
	ahsha				**moot**	
(lion)	**T 4**	*ḥꜣt*		(pod)	**T 13**	*nḏm*
	hot				**nedjem**	
(crook)	**T 5**	*ḥkꜣ*		(lute)	**T 14**	*nfr*
	heka				**nefer**	
(offering table)	**T 6**	*ḥtp*		(adze)	**T 15**	*nṯr*
	hetep				**netcher**	
(scarab)	**T 7**	*ḫpr*		(cord/tie)	**T 16**	*rwḏ*
	kheper				**roodj**	
(pestle)	**T 8**	*ḫrw*		(star)	**T 17**	*sbꜣ*
	kheroo				**seba**	

	T 18	*śì3*	**T 25**	*tyw*
	see-ah		**tyoo**	
	T 19	*śḥm*	**T 26**	*w3ḏ*
	sekhem		**wadj**	
	T 20	*śm3*	**T 27**	*w3ḥ*
	sema		**wah**	
	T 21	*śnḏ*	**T 28**	*w3ś*
	senedj		**was**	
	T 22	*šmᶜ*	**T 29**	*wḥm*
	shemah		**oohem**	
	T 23	*šmś*	**T 30**	*wśr*
	shemes		**ooser**	
	T 24	*šsp*		
	shesep			

THE SOUNDS OF THE PSEUDO-ALPHABET

U 1	Sound that is close to our *a* and the Semitic *aleph;* noted by a special sign in international transcription, 3.
U 2	The second *a* is difficult to pronounce: it is a long vowel that is almost stifled; it matches the Semitic *aïn.* We have used *ah* for the transliteration.
U 3 – U 7	Sounds that correspond to the same English letters, even though the notation for *dj* is different.
U 8	An *h* that is almost mute.
U 9	A strongly aspirated *h* as in German.
U 10	*Kh* does not exist in English; it is close to the Spanish *j* or the German *ach-laut.*
U 11	Another *kh* that is close to but not exactly the same as the English "sh" sound; it is more guttural and closer to the Swiss German *ich-laut.*
U 12	Like the English *ee.*
U 13	Very soft *k* sound.
U 14	More pronounced *k,* almost like the *q* sound, without the *u.*
U 15	The pronunciation in later eras was *l* and it could replace the *r.*
U 16 – U 19	Same sounds as in modern English.
U 20	A sibilant *s* like in hiss and like the *ce* in advance.
U 21	The voiced *s* as in his.
U 22	*sh* sound of English.
U 23 & U 24	*t* and *tsh.*
U 25	The English *w* or *oo* sound.
U 26	The *y* sound as in you.

Determinatives are described as they occur.

TRANSLITERATION SYMBOLS AND THEIR IPA EQUIVALENTS

Semitic Symbol	Spelling	Conventional Pronunciation	IPA Symbol*	IPA Description
ꜣ	a (short, aleph)	*a* like *father*	ʔ	glottal stop
ꜥ	ah (long, aïn)	like the *a* in *father*, but longer	ꞇ	voiced pharyngeal fricative
b	b	b	b	voiced bilabial stop
d	d	d	d	voiced alveolar stop
dj	g / j (emphatic)	as in *edge* or *joe*	dž	voiced palatal stop
f	f	f	f	voiceless labiodental fricative
g	g (hard)	g	g	voiced velar stop
h	h (hard)	as in *house*	h	voiceless glottal fricative
ḥ	h (strongly aspirated)	more strongly aspirated than in *house*	ħ	voiceless pharyngeal fricative
ḫ	kh	as in the Scottish word *loch*	ꭓ	voiceless uvular fricative
ẖ	kh	as in Swiss German *ich*	ç	voiceless palatal fricative
i	i (short)	*ee* like *meet*, or *y* like *young*	j / i	palatal approximant
k	k	k	k	voiceless velar stop
ḳ	kr / q (qof)	as in *quorum*	q	voiceless uvular stop
l / (r)	l / (r)	l	l	alveolar lateral approximant
m	m	m	m	nasal bilabial stop
n	n	n	n	nasal alveolar stop
p	p	p	p	voiceless bilabial stop
r	r	r	r	voiced lateral trill
ś	s	s	ṣ	sibilant voiceless alveolar fricative
s / z	s / z	s	s	alveolar fricative
š	sh	*sh* as in *sheet*	š	voiceless post-alveolar fricative
t	t	t	t	voiceless alveolar stop
tch	ch / tsh	as in *choice*	tš	voiceless palatal stop
w	oo / w	*w* like *work*, or *oo* like *pool*	w / u	voiced bilabial glide
y	y	*y* like *young*, or *ee* like *meet*	j / i	palatal approximant

*IPA—International Phonetic Alphabet

Note: The sequence of the different letters is not standard in Egyptology, but one we adopted to facilitate the use of this book.

CHRONOLOGICAL AND CULTURAL MILESTONES

The following table focuses more on the cultural than the political aspects of classical Egyptian civilization. Special emphasis has been put on the writing and on texts in general. Only the most prominent sovereigns, works, and events are listed.

3300 – 2800
B.C.E.
approx.

Archaic Period – Dynasties 1 and 2
– **Kings:** Narmer (Menes), Djed, Ka.
– **Architecture:** Brick mastabas (Abydos, Saqqara).
– **Writing:** First writing appears on rudimentary stela.

2800 – 2200
B.C.E.
approx.

Old Kingdom – Dynasties 3 – 6
Dynasty 3
– **King:** Djoser.
– **Architecture:** The Step-Pyramid, Saqqara — architect: Imhotep.
Dynasty 4
– **Kings:** Cheops, Chephren, Mycerinus.
– **Architecture:** Great pyramids and the sphinx at Giza.
Dynasty 5
– **Kings:** Unas, Sahure (first King known as "Son of the Sun").
– **Architecture:** Royal solar temples at Heliopolis; mastabas for the courtiers; various pyramids; Old Kingdom at its zenith.
– **Writing:** Appearance of first pyramid texts (Unas at Saqqara), autobiographical texts in the tombs of lofty dignitaries.
Dynasty 6
– **Kings:** Teti, Pepi I and II, pharaoh-queen Nitocris.
– **History:** Expeditions to Nubia and Asia; central power falls into decadence; tyranny of nomarchs.
– **Architecture:** Pyramids of the kings and queens.

– Writing: Main pyramid texts (Teti I, Pepi I and II, Merenre, and queens); religious texts (*The Memphis Theology*), moral texts, "instructions" passed on through copies made in the Middle and New Kingdom. The most famous are the "Advice on Wisdom": for Kagemni, Ptah-hotep.

2200 – 2060 B.C.E. approx.	**First Intermediate Period – Dynasties 7 – 11** **Dynasties 7 and 8:** Era of anarchy and social upheavals. **Dynasty 7 may be fictitious** **Dynasty 8** **– Kings:** Ibi **– Architecture:** Pyramid at Saqqara. **– Writing:** Last texts of the pyramids. **Dynasties 9, 10 and beginning of 11** **– Kings:** Reign of parallel dynasties: To the North: King Khety in Heracleopolis; tombs; texts: instructions for Merikare. To the South: King Antef in Thebes; first rock tombs (West-Thebes). **– Writing:** Biographical inscriptions in tombs; stelae (prayers of Antef). First *Coffin Texts.*
2060 – 1785 B.C.E. approx.	**Middle Kingdom – end of Dynasty 11 and 12 Theban dynasties** **Dynasty 11** **– Kings:** Montuhotep kings extend their power over all of Egypt and Nubia; Thebes becomes the capital. **– Architecture:** Montuhotep funerary temple at Dér-el-Bahari; fortresses in Lower Nubia. **Dynasty 12** **– Kings:** Several Sesostris and Montuhotep; Pharaoh-queen: Sobeknefru. **– History:** Submission of Nubia; expeditions to Syria; relations with Palestine. **– Architecture:** Hawara labyrinth, pyramids that have disintegrated over time, urban design for Fayoum. **– Writing:** Various royal texts, a vast number of stelae in the temple of Osiris in Abydos, wisdom texts, prophecies (Neferti), themes from philosophy (*Man and his Ba*); tales and novels; *The Eloquent Peasant, The Shipwrecked Sailor, Sinuhe, Three Marvels under Cheops* (copy: Westcar papyrus), satires, songs, hymns to the gods; *Coffin Texts*. It is the period of the classical language.

1785 – 1580 B.C.E. approx.	**Second Intermediate Period – Dynasty 13 to the beginning of Dynasty 17**

Second Intermediate Period – Dynasty 13 to the beginning of Dynasty 17

– **History:** Collapse of central power; invasion by foreign Hyksos princes. The native puppet kings become vassals to the Hyksos. Nomarchs acquire power. Hyksos kings: several Sebekhotep.

– **Architecture:** No major monuments.

– **Writing:** Texts: autobiographical texts in tombs of Nomarch-kings (El-Kab).

1580 – 1090 B.C. approx.

New Kingdom – Dynasties 17 – 20: Golden age of the Pharaohs

End of Dynasty 17

– **Kings:** Tao and Kamose expel the Hyksos Kings; the last kings of the dynasty (Ahmose) establish the 18th Dynasty. Thebes again becomes the capital.

Dynasty 18

– **Kings:** Thutmosis, Amenhotep, and pharaoh-queen Hatshepsut, Akhenaten, Tutankhamun, Haremheb.

– **History:** Aten heresy under Akhenaten, then the restoration of the cult of Amun, god of the Empire; expedition to Punt (Hatshepsut); campaigns by Thutmosis III; period of the largest extension of the Egyptian empire in the Middle East and in Nubia.

– **Architecture:** Major construction in East Thebes: temples of Amun and Mut (Karnak, Luxor); in West Thebes: royal funerary temples: Amenhotep III (Memnon colossi) Thutmosis III and Hatshepsut (Dér el-Bahari), tombs in the Valley of the Kings, necropolis of the nobles, Tell el-Amarna; temple of Amada (Nubia) obelisks; chapels, etc.

– **Writing:** Texts: annals of Thutmosis III (military campaigns), Edict of Haremhab, stelae (sphinx, boundary stelae), dedications and hymns to the gods (Amun, Aten), prayers, school-texts, biographies; funerary texts: *Book of Hours, Book of the Dead, Book of the Caverns,* a. s. o., frequently recopied.

Dynasties 19 and 20

– **History:** Era of Ramses and his descendants. Ramses II, a long and glorious reign; peace with the Hittites. After Ramses III, there was political and military decline: strikes; pillaging of tombs.

– **Kings:** The Seti, Ramses (I to XI), and the pharoah-queen Tausert.

- **Architecture:** Temples at Abydos and Gurnah; in East Thebes: Karnak, Luxor: beautification projects in West Thebes: Ramesseum (R II); Medinet Habu (R III), underground palace tombs in the Valley of the Kings (Seti I and Ramses) and the Valley of the Queens (Nefertari). Nubian rock cliff temples (Abu Simbel).
- **Writing:** Temple and tomb inscriptions: religious texts (tombs); astronomical texts (Seti I and Ramses), calendar (Medinet Habu); historic texts (Israel stelae; Abu Simbel: the battle of Kadesh); novels and fables: *The Destruction of Men, The Doomed Prince, The Two Brothers,* etc., poetry and romantic literature; Neo-Egyptian gains its letters of nobility.

1085 – 663 B.C.E.

Third Intermediate Period – Dynasties 21 – 25

- **History:** The decline of central power progresses; parallel dynasties and effective separation between the North (Dynasty 21: Tanite Kings: Psusennes) and the South (the priest-kings of Amun): Herihor, Pinedjem) the sack of Thebes (Assurbanipal, 663).

Dynasties 22 and 23
- **Kings:** Dynasties of Libyan origin: the Shoshenq, Osorkon, Takelot.
- **Architecture:** Wealthy royal tombs in Tanis.

Dynasty 24
Princes of Sais, Delta.

Dynasty 25
- **Kings:** Kings of Ethiopian origin (the Black Pharaohs): Piankhy, Shabaka, Taharqa; *The Divine Consorts,* Amun's mystic spouses rule over Upper Egypt.
- **Architecture:** Little construction during this difficult time.
- **Writing:** Biographical texts in tombs and on sarcophagi; royal steale (the victory of Piankhy); historical novel: *The Misadventures of Wenamun* (21st Dynasty).

663 – 525 B.C.E.

Saite Epoch – Dynasty 26

- **Kings:** National uprising of the Delta princes who found a new dynasty and rule over all of Egypt: the Psammetichus
- **Architecture: and statuary:** Foundation of the Serapeum at Memphis; archaic style: search for roots in a happier time; Nile–Red Sea canal.
- **Writing:** Appearance of demotic texts; numerous administrative documents; copies of old texts which are thus preserved.

525 – 333 B.C.E.	**Persian Invasions and the last indigenous dynasties** **Dynasty 27** – **Kings:** Persian Kings: Cambyses, Darius, and Xerxes. **Dynasties 28 – 30** – **Kings:** Last indigenous kings expelled by the second Persian invasion; Amyrteos, Nectanebo (Egyptian); Artaxerxes, Darius II (Persian). Second sack of Thebes, the brilliant city will never recover; the cities of Karnak and Luxor are two of its former quarters. – **Architecture:** Construction of temples in the oases of Thebes: Kharga, Dakhla. – **Writing:** Appearance of demotic texts; numerous administrative documents; copies of old texts that are thus preserved.
333 – 30 B.C.E.	– **History:** Alexander the Great delivers Egypt from Persian domination The country was then ruled by the Ptolemies, the new Pharaohs of Greek origin, and pharaoh-queens, including Cleopatra VII who was the last woman pharaoh (committed suicide in 30 B.C.). – **Architecture:** Construction of the grandiose sanctuaries in Edfu, Dendara, Kom-Ombo, Philae, Esna…foundation of Alexandria. – **Writing:** Monumental and stelae inscriptions (the Rosetta Stone).
30 B.C.E – 500 A.D. (approx.)	– **History:** Egypt is ruled by the Roman Emperor Pharaohs who passed power on to the Byzantine emperors, whose rise marked the end of the ancient civilization. – **Architecture:** Roman pharaohs continue temple construction. Under the rule of Byzantium, partial destruction of temples and their conversion into churches. Greek and Roman styles prevail. Coptic art. – **Writing:** Monumental inscriptions (the last royal cartouche written in hieroglyphs is that of Decius, in 249 A.D.); Christian Coptic writings: last form of the language of the pharaohs, written in Greek letters.
30 B.C.E	– **History:** Arab conquest of Egypt.

INDEX OF HIEROGLYPHIC IMAGES

354

enemies, 292–293
enemy, 258–259
engrave, 118–119
enter, 84–85
entourage, 100–101, 288–289
envelop, 319
epagomenal days, 110–111
escape, to, 204–205
Esna, 262–263
essence, of Osiris, 162–163
eternity, 34–35, 170–171;
 on earth, 26–27
evening, 48–49
evil, 96–97, 144–145
exact moment, 160–161
excellence, 264–265
excellent, 312
exclamations, 68–69,
 224–225
exhaust, to, 232–233
expedition, 230–231
exterior, 324
extra, 318
eye, 132–133; of Horus, 316
eyes, the 2
 (sun and moon), 76–77

F

face, 110–111
facing, 250–251
falcon, 22–23
fall asleep, 172–173
fan, to, 120–121
fat, 38–39
fatigued, to be, 174–175
favor, to, 112–113
favored one, 112–113
favorites, 112–113
fear, to, 284–285
feast, 34–35
feather, 212–213
feed, to, 206–207
female genitals, 138–139,

206–207
figs, 138–139
find, to, 98–99
finish, to, 140–141
firmament, 114–115
fish, 54–55; to, 100–101;
 tilapia, 130–131
flame, 176–178
flax, 286–287
flee, to, 204–205
flock, to, 260–261
flood, to, 317
flooding, 136–137
flounder, to, 196–197
flower, 110–111, 234–235;
 to, 18–19
fly, 313; to, 182–183
foliage, 98–99
follow, 288–289
followers, 288–289
following, 194–195
food, 60–61, 234–235
force, vital, 138–139
foreigner, 94–95, 114–115,
 124–125
forever, 170–171
form, 256–257
friend, 198–199; close,
 84–85
friendly, 296–297
friends, 84–85, 154–155
frightened, 284–285
frontier, 94–95, 216–217
frontward, 250–251
fruits, 138–139
fulfilled, 254–255
function, 309
funeral: attire, 116–117;
 bed, 210–211;
 procession, 288–289

G

garden, 34–35, 138–139

gardener, 333
gate, 276–277
gazelle, 30–31
Geb, the god, 30–31
general, 224–225
genitals: female, 138–139,
 206–207; male, 108–109,
 128–129
gifts, 78–79, 168–169
giggle, to, 30–31
giraffe, 320
give, 325; birth to, 48–49,
 104–105; gift or donation,
 168–169
go, 60–61, 324; in two
 directions, 329;
 out, 186–187
goats, 234–235
god, 50–51, 272–273;
 servant of, 106–107; *see*
 individual names of gods
goddess, 228–229, 272–273;
 see individual names of
 goddesses
gold, 166–167; fine, 336;
 necklace, 166–167;
 set in, 130–131
Golden, the, 166–167
good, 270–271; will,
 264–265
governor, 252–253
gracious, 311
grain, 296–297; grind,
 168–169
granite, 323
grasp, to, 18
grate, to, 168–169
great, 80–81
green, 294–295; to turn, 18–19
greenery, 294–295
greet a person, 168–169
greetings to you, 292–293
grind grain, to, 168–169

INDEX

ACKNOWLEDGMENTS

The authors first intended to prepare a sampling of hieroglyphics as a bouquet for the Year of Egypt. Thanks to the du Rocher Publishers, the bouquet grew into a festoon of flowers that many will come to pick. Our sincere thanks go out to Mr. Jean-Paul Bertrand, the director of this publishing house, who graciously and immediately included our book in the "Champollion" collection, upon the recommendation of Christiane Hachet, his editorial advisor. She showed great vigilance in overseeing the completion of both this work and its computerized version; to her we extend our sincere gratitude. It is an equally pleasant duty to thank the entire editorial team for its conscientious work and continual availability.

We owe a special debt of gratitude to Béatrice Antelme and to Wilfred Lauhon for their spontaneous and unfailing technical assistance, without which it would have been most difficult for us to bring this project to fruition in the way we intended.

Ruth Schumann-Antelme
Stéphane Rossini

ABOUT THE AUTHORS

Ruth Schumann-Antelme, Egyptologist, is a honorary research fellow of the French Scientific Research Center (C.N.R.S.), a former professor at the Ecole du Louvre and belonged to the scientific staff of the Egyptian Department of the Louvre Museum. She also conducted field work for many years in Upper Egypt (Ramesseum, Valley of the Queens).

Stéphane Rossini is a professional designer specializing in the science and the drawing of hieroglyphics and armorial bearings.